Put any picture you want on any state book cover. Makes a great gift. Go to www.america24-7.com/customcover

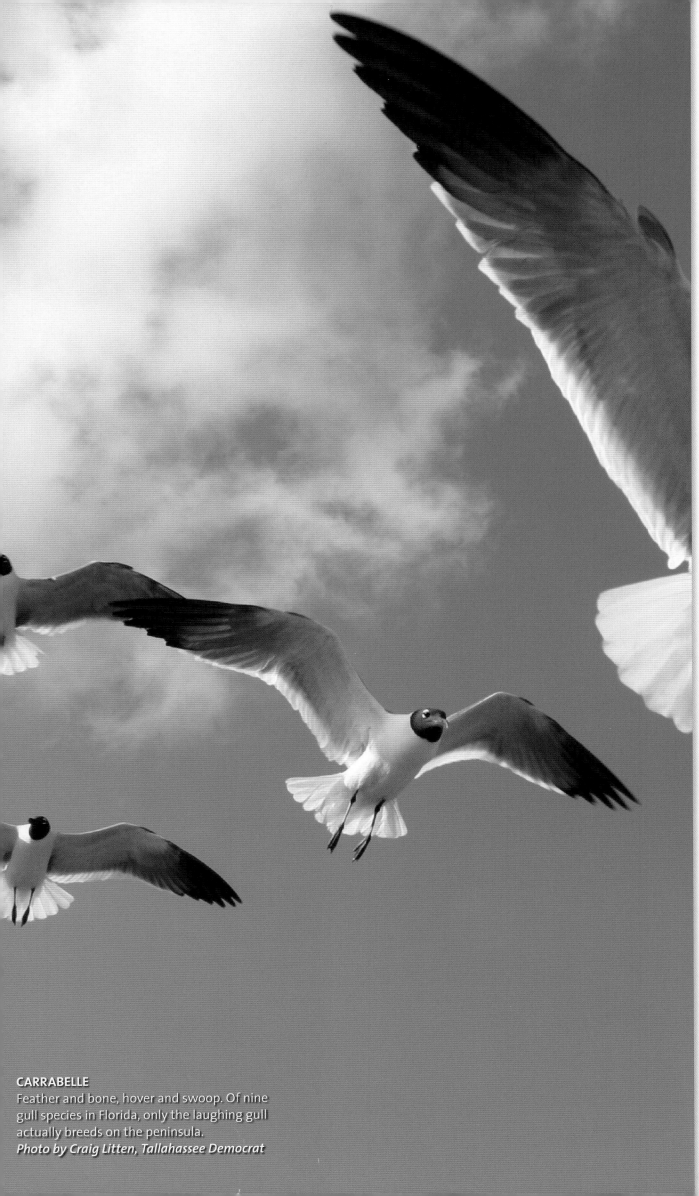

Florida 24/7 is the sequel to *The New York Times* bestseller *America 24/7* shot by tens of thousands of digital photographers across America over the course of a single week. We would like to thank the following sponsors, the wonderful people of Florida, and the talented photojournalists who made this book possible.

CARRABELLE
Feather and bone, hover and swoop. Of nine gull species in Florida, only the laughing gull actually breeds on the peninsula.
Photo by Craig Litten, Tallahassee Democrat

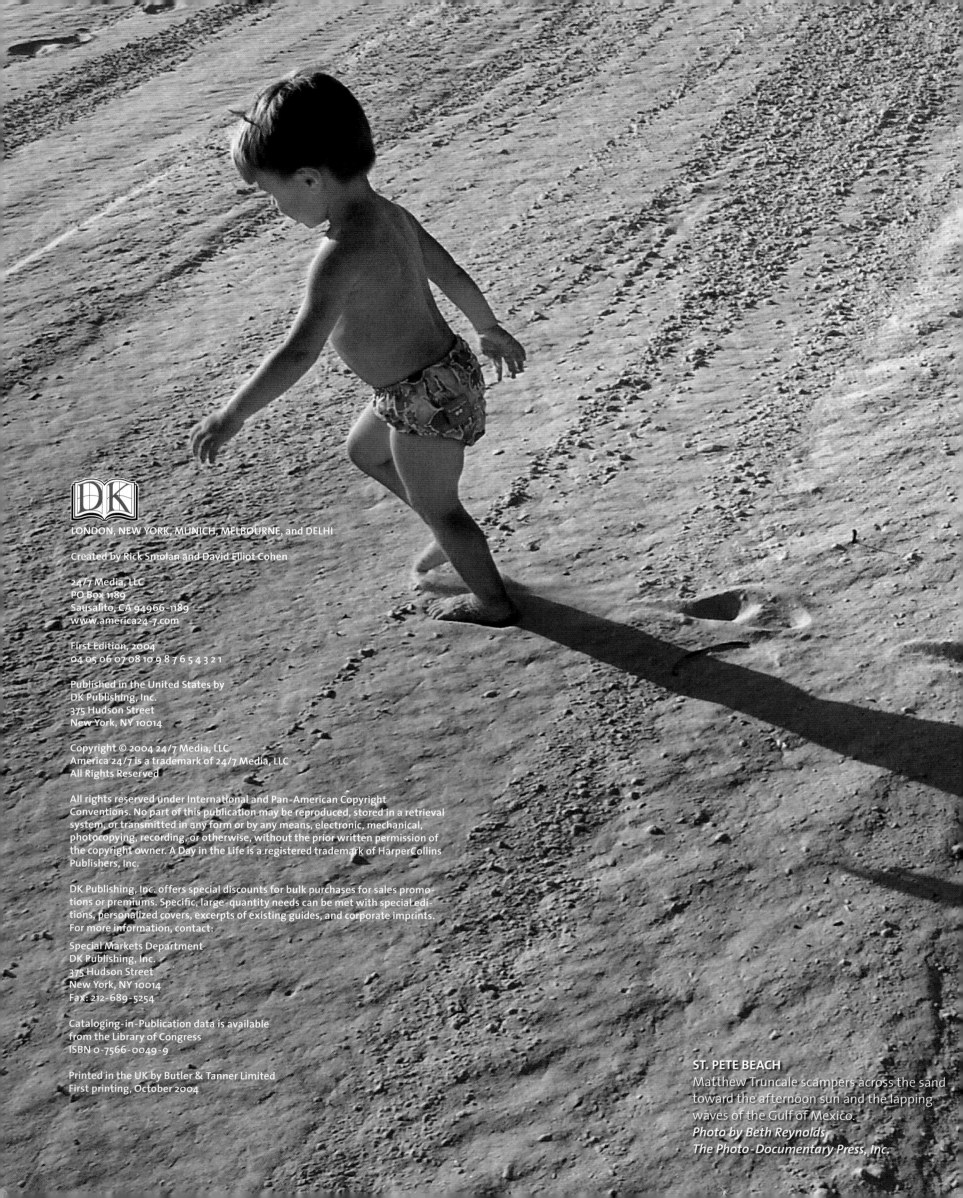

DK

LONDON, NEW YORK, MUNICH, MELBOURNE, and DELHI

Created by Rick Smolan and David Elliot Cohen

24/7 Media, LLC
PO Box 1189
Sausalito, CA 94966-1189
www.america24-7.com

First Edition, 2004
04 05 06 07 08 10 9 8 7 6 5 4 3 2 1

Published in the United States by
DK Publishing, Inc.
375 Hudson Street
New York, NY 10014

DK Publishing, Inc. offers special discounts for bulk purchases for sales promo-
tions or premiums. Specific, large-quantity needs can be met with special edi-
tions, personalized covers, excerpts of existing guides, and corporate imprints.
For more information, contact:

Special Markets Department
DK Publishing, Inc.
375 Hudson Street
New York, NY 10014
Fax: 212-689-5254

Cataloging-in-Publication data is available
from the Library of Congress
ISBN 0-7566-0049-9

Printed in the UK by Butler & Tanner Limited
First printing, October 2004

ST. PETE BEACH
Matthew Truncale scampers across the sand
toward the afternoon sun and the lapping
waves of the Gulf of Mexico.
Photo by Beth Reynolds,
The Photo-Documentary Press, Inc.

FLORIDA 24/7

24 Hours. 7 Days.
Extraordinary Images of
One Week in Florida.

Created by Rick Smolan and David Elliot Cohen

DK Publishing

About the America 24/7 Project

A hundred years hence, historians may pose questions such as: What was America like at the beginning of the third millennium? How did life change after 9/11 and the ensuing war on terrorism? How was America affected by its corporate scandals and the high-tech boom and bust? Could Americans still express themselves freely?

To address these questions, we created *America 24/7*, the largest collaborative photography event in history. We invited Americans to tell their stories with digital pictures. We asked them to shoot a visual memoir of their lives, families, and communities.

During one week in May 2003, more than 25,000 professionals and amateurs shot more than a million pictures. These images, sent to us via the Internet, compose a panoramic yet highly intimate view of Americans—in celebration and sadness; in action and contemplation; at work, home, and school. The best of these photographs, more than 6,000, are collected in 51 volumes that make up the America 24/7 series: the landmark national volume America 24/7, published to critical acclaim in 2003, and the 50 state books published in 2004.

Our decision to make America 24/7 an all-digital project was prompted by the fact that in 2003 digital camera sales overtook film camera sales. This technological evolution allowed us to extend the project to a huge pool of photographers. We were thrilled by the response to our challenge and moved by the insight offered into American life. Sometimes, the amateurs outshot the pros—even the Pulitzer Prize winners.

The exuberant democracy of images visible throughout these books is a revelation. The message that emerges is that now, more than ever, America is a super-sized idea. A dreamspace, where individuals and families from around the world are free to govern themselves, worship, read, and speak as they wish. Within its wide margins, the polyglot American nation manages to encompass an inexplicably complex yet workable whole. The pictures in this book are dedicated to that idea.

—*Rick Smolan and David Elliot Cohen*

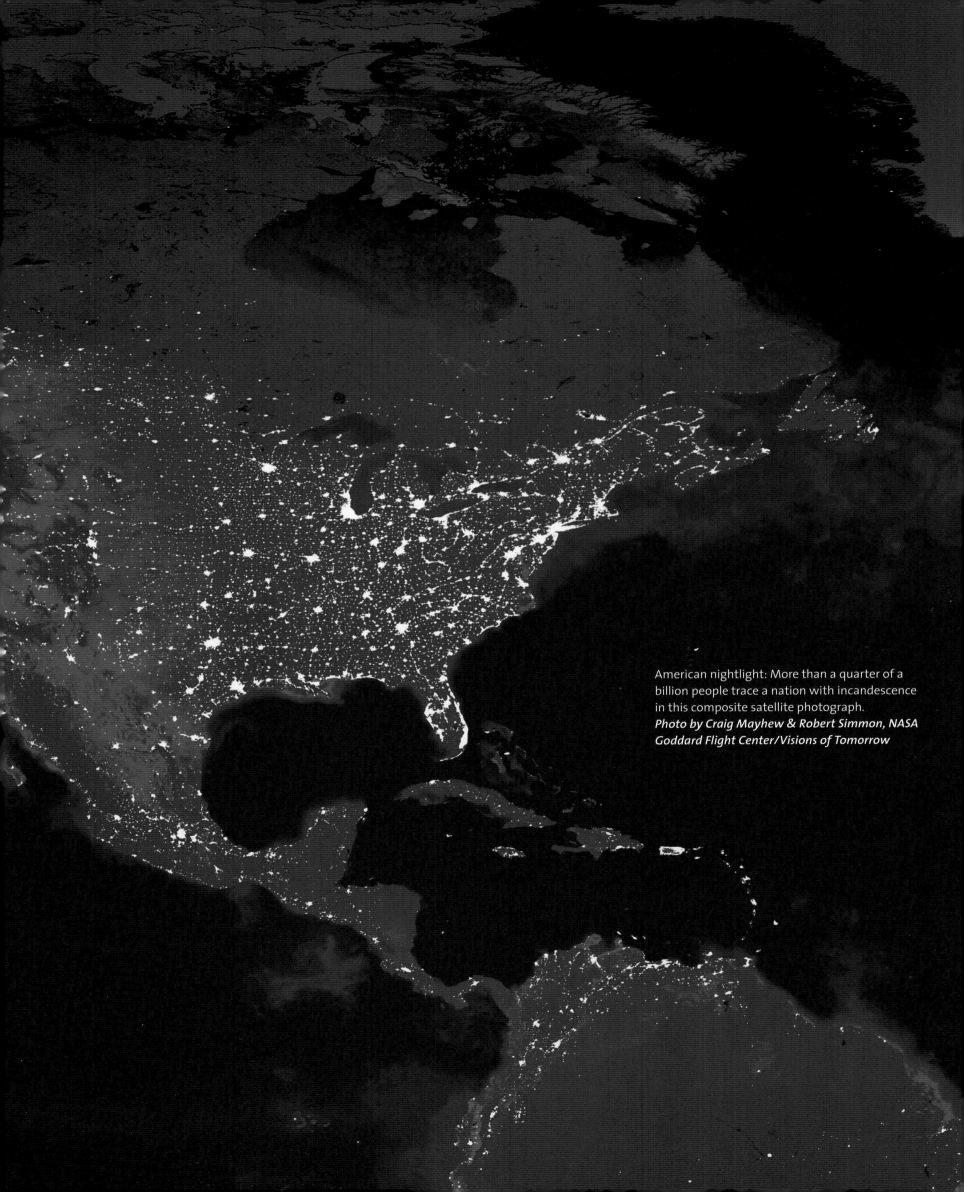

American nightlight: More than a quarter of a
billion people trace a nation with incandescence
in this composite satellite photograph.
Photo by Craig Mayhew & Robert Simmon, NASA
Goddard Flight Center/Visions of Tomorrow

The Magic Kingdom

By Elinor J. Brecher

Since its earliest mosquito-infested, pre–air conditioner days, Florida has been an irresistible temptation and an implied promise. Juan Ponce de Leon landed on the east coast in 1513, seeking the mythical Fountain of Youth. In 2003, 12 Cubans in a 1951 Chevy truck, fitted with a propeller, chugged across the Florida Straits seeking the glories of democracy.

By now, Florida is as much a rite of passage as a geographical location. The childhood visit to a fantasy kingdom of cartoon mice and fairy princesses? Mandatory. The lure of wet T-shirts, beach volleyball, and margaritas? A spring break imperative. Balmy days and palm trees in February, when up North it's all ice storms and broken hips? Retirement paradise.

Florida is sunshine, sand, fishing, and golf. It's South Beach models, Daytona racers, Ocala cowboys, Pensacola sailors, Cassadega psychics, Indian River citrus growers, Homestead orchid growers, Tarpon Springs sponge divers, Seminole alligator wrestlers, and Naples tennis pros. It's flamingos rising at dawn over the Everglades, the sunset over a Key West pier, and island-bound mega-cruise ships. Come to Florida and visit Cuba and Haiti without actually going there. Come to Florida and we give you the world: Disney World, Reptile World, SeaWorld. We lead you to South America's front door and greet you— buenos dias!—in the language of North America's future.

What America hears about Florida is so often shaped by its disasters, natural and manmade. Hurricane Andrew's nuclear-blast devastation. The 2000 presidential election's hanging-chad chaos. Exploding space shuttles. Swampland development scams. Gator attacks in the suburbs and shark attacks in the surf. More people get hit by lightning here than anywhere else in the states.

The extremes of wealth and poverty are on unguarded—if not unique—display in Florida. An hour apart, Belle Glade migrant laborers cut sugar cane while Rolls-driving Palm Beach millionaires set the American gold standard for luxury. In 2004, royalty moved to Fort Lauderdale: the Queen Mary 2, the world's largest passenger vessel. Twenty miles south, Miami remains the nation's poorest large city.

Florida's national clout can't be overestimated. Cuban-exile politics influence foreign policy as if the Cold War never ended. Island culture weaves reggae and soca into mainstream pop music. "Floribbean" cuisine has made mangoes, guavas, and papayas recipe staples.

On the pages of this book, you will see how America relaxes when it's on vacation—and how 17 million Floridians live when they aren't. A polyglot peninsula, Florida is Old South in the north, new Latin America in the south and Sunbelt expansion nearly everywhere else. It's a state growing so fast that it can't keep up with its own evolving identity. Which makes it a lot like a big, quirky, often fractious family: the immigrant, tradition-bound granny; sister's weird new boyfriend; the daffy old uncle; thoroughly modern Mom; mischievous little brother; and Dad, that lovable bumbler.

There's no end to the dinner-table squabbling about politics, religion, music, education, sports, money, and sex. But when the next Category 5 storm hits, they'll all jam into the bathtub together with a mattress over their heads. Because this is Florida: One state, under the sun, with time-shares and theme parks for all.

ELINOR BRECHER *began her journalism career at* The Courier-Journal *in Lousiville, Kentucky, and has been a* Miami Herald *reporter since 1989. She was a Nieman Fellow at Harvard University in 1988.*

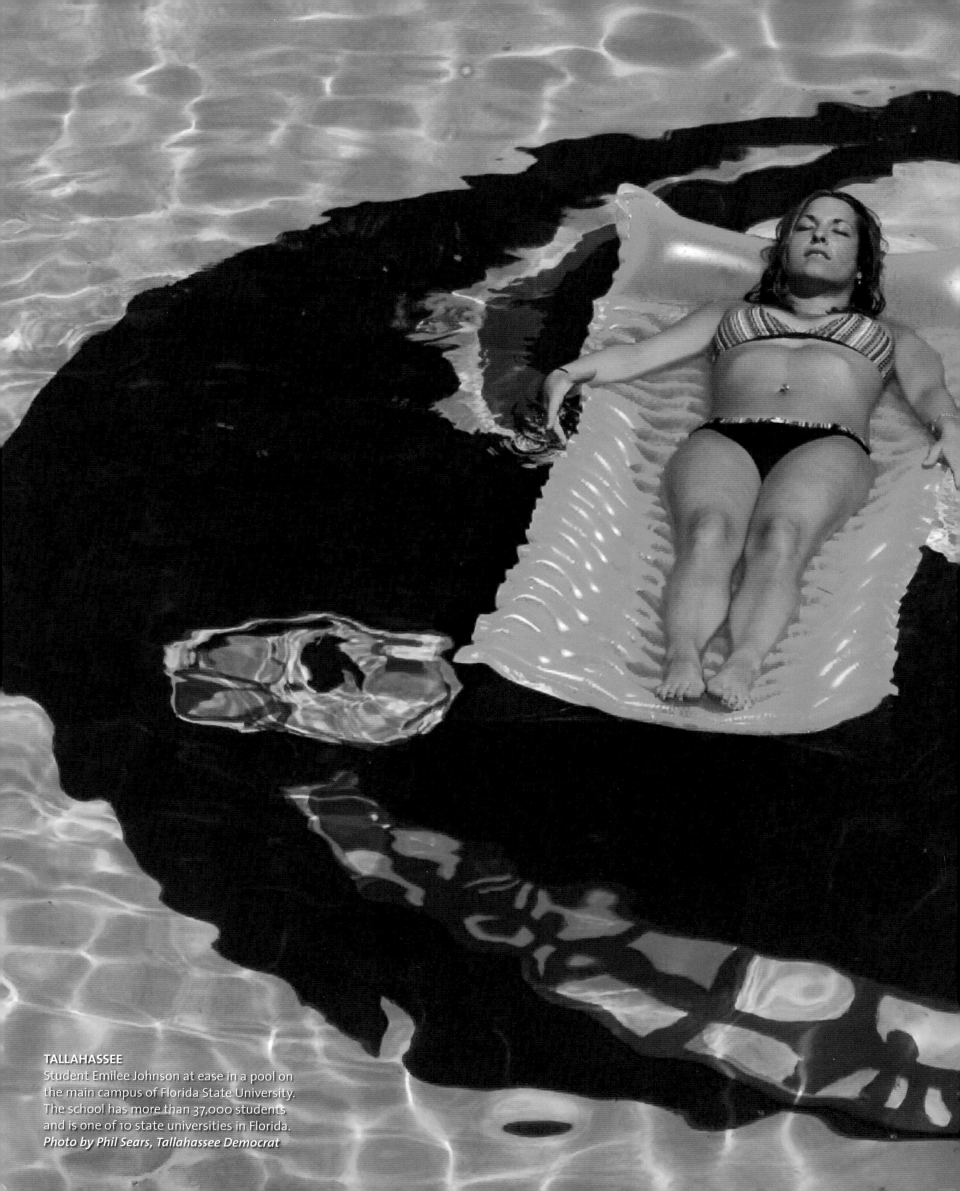

TALLAHASSEE
Student Emilee Johnson at ease in a pool on
the main campus of Florida State University.
The school has more than 37,000 students
and is one of 10 state universities in Florida.
Photo by Phil Sears, Tallahassee Democrat

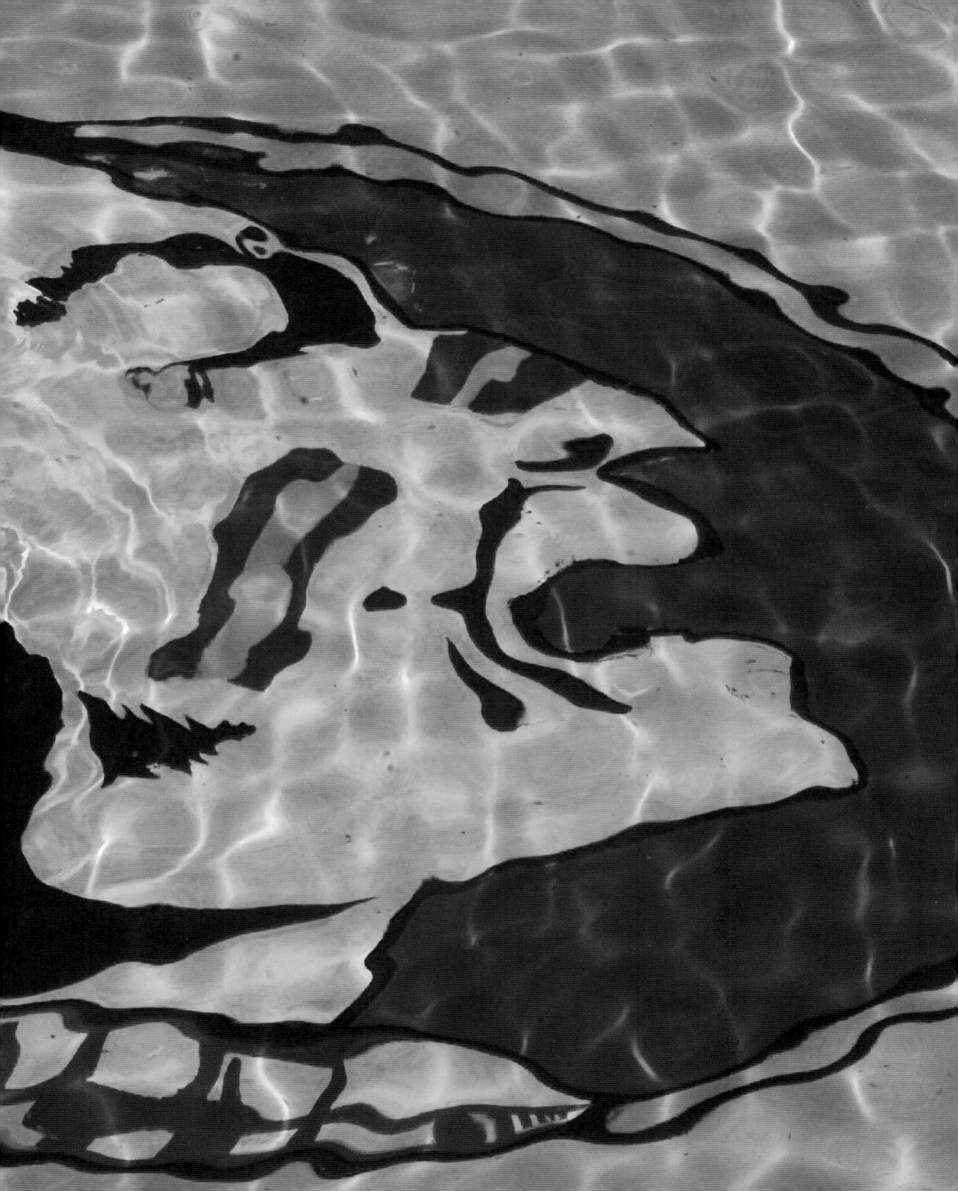

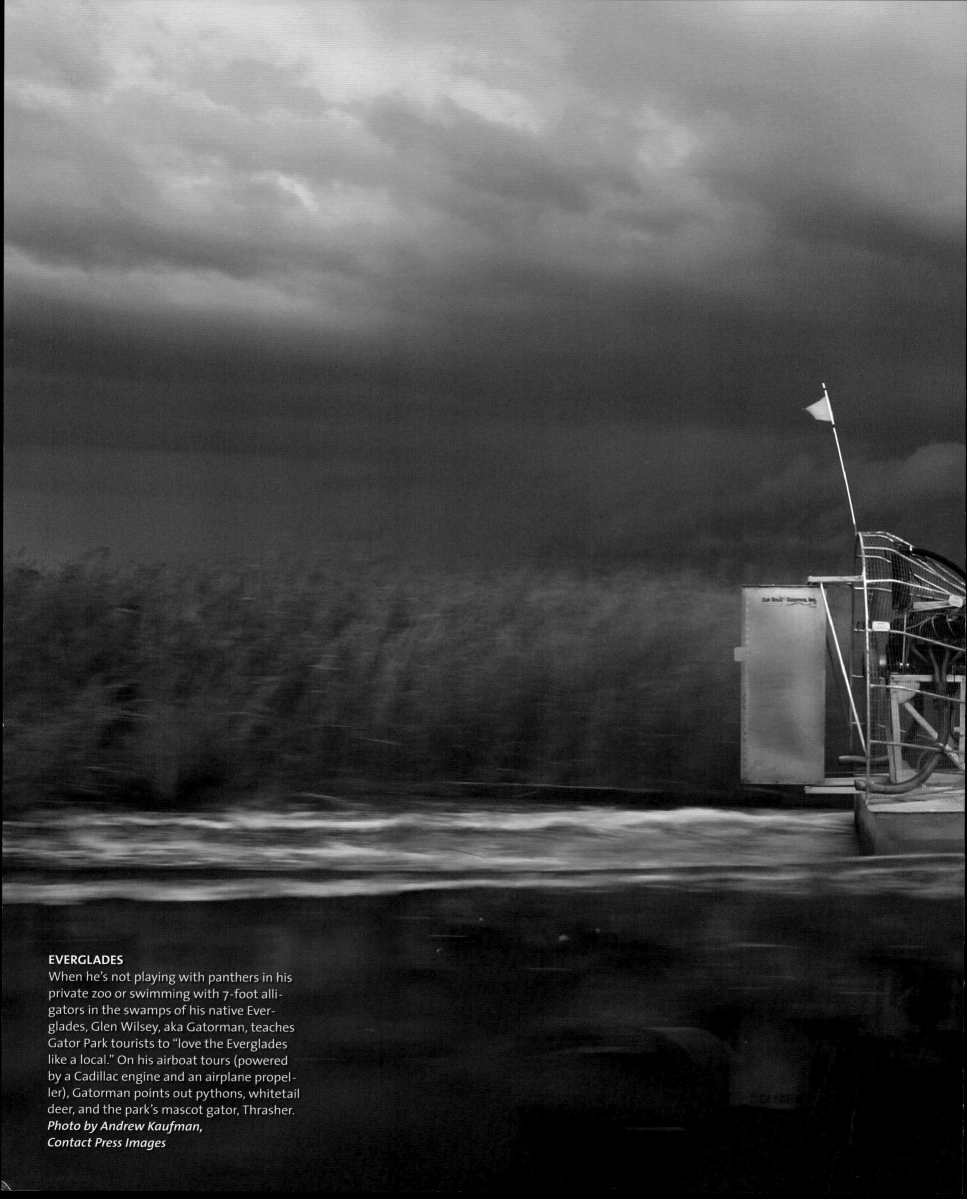

EVERGLADES

When he's not playing with panthers in his private zoo or swimming with 7-foot alligators in the swamps of his native Everglades, Glen Wilsey, aka Gatorman, teaches Gator Park tourists to "love the Everglades like a local." On his airboat tours (powered by a Cadillac engine and an airplane propeller), Gatorman points out pythons, whitetail deer, and the park's mascot gator, Thrasher.
Photo by Andrew Kaufman,
Contact Press Images

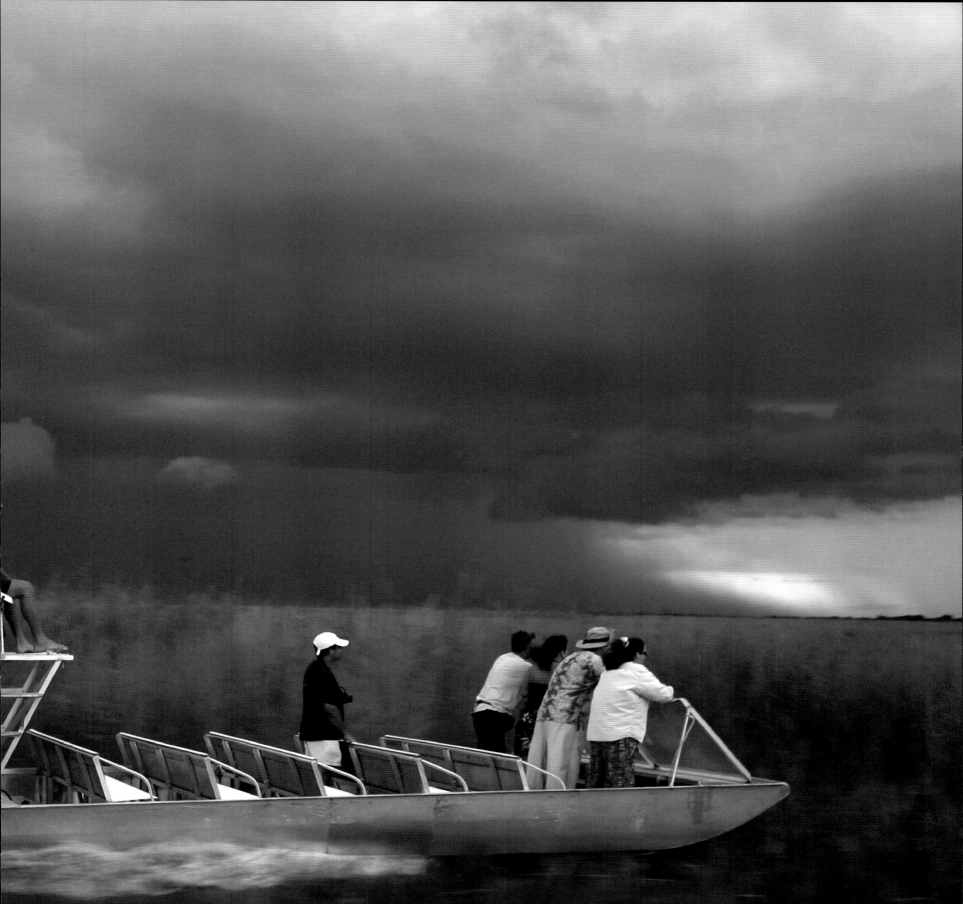

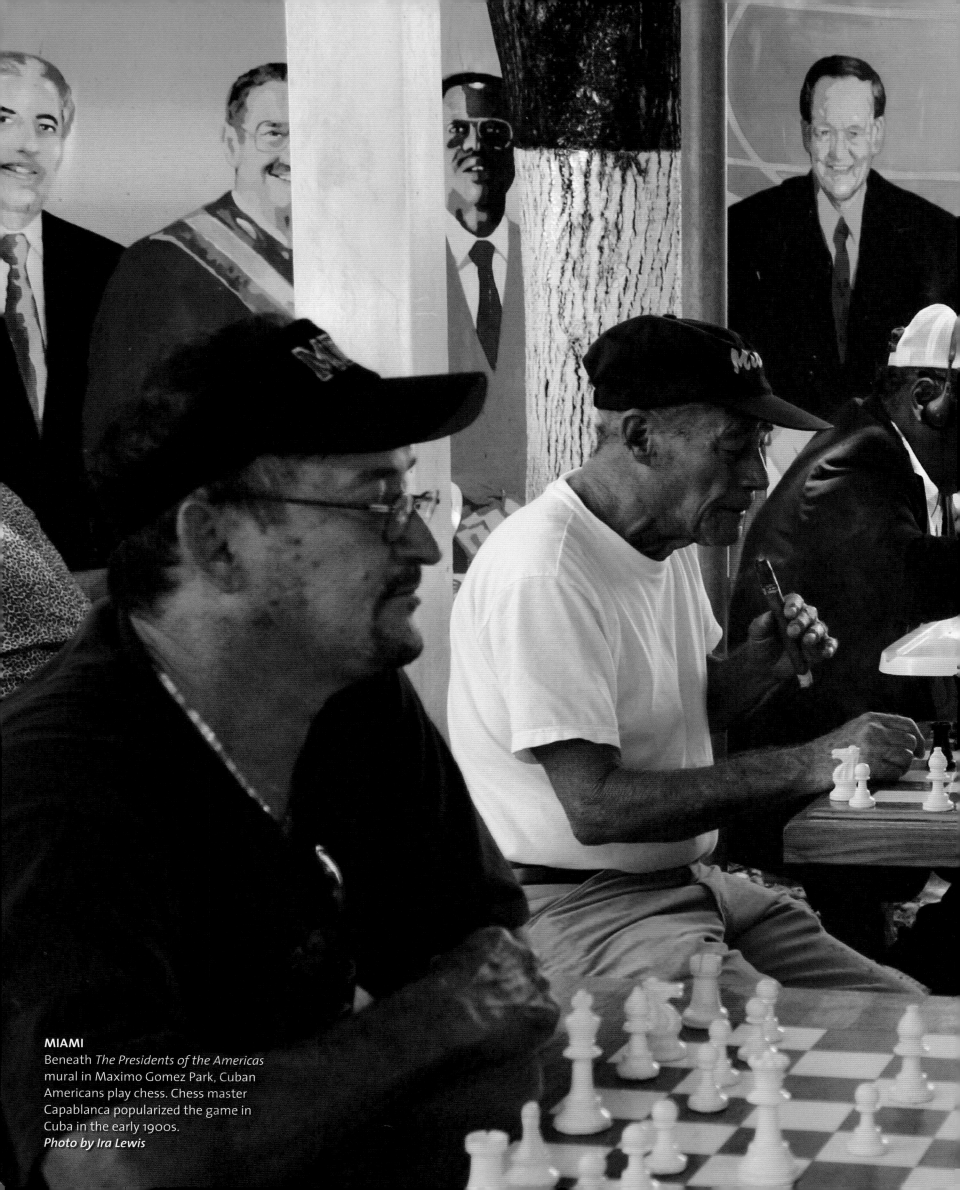

MIAMI
Beneath *The Presidents of the Americas* mural in Maximo Gomez Park, Cuban Americans play chess. Chess master Capablanca popularized the game in Cuba in the early 1900s.
Photo by Ira Lewis

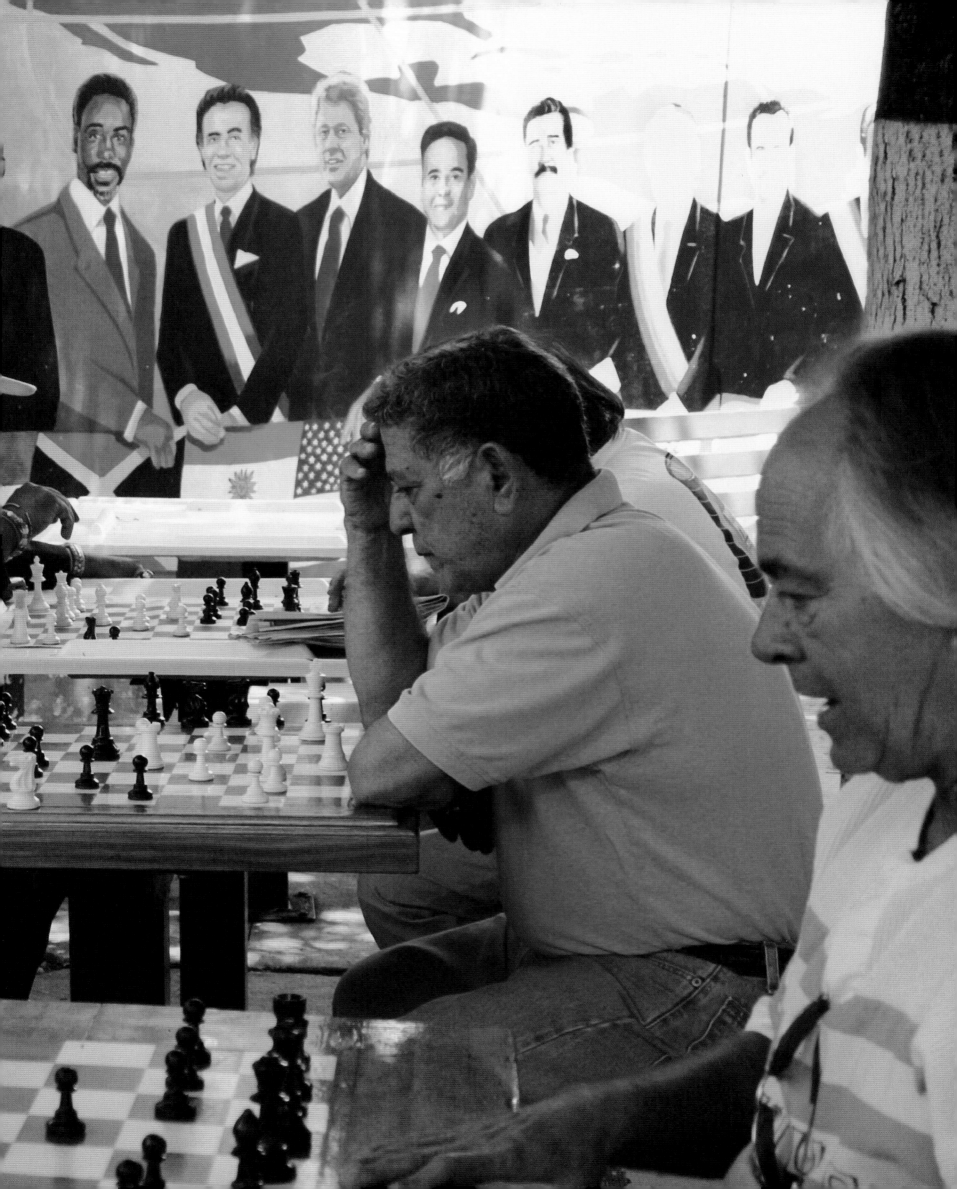

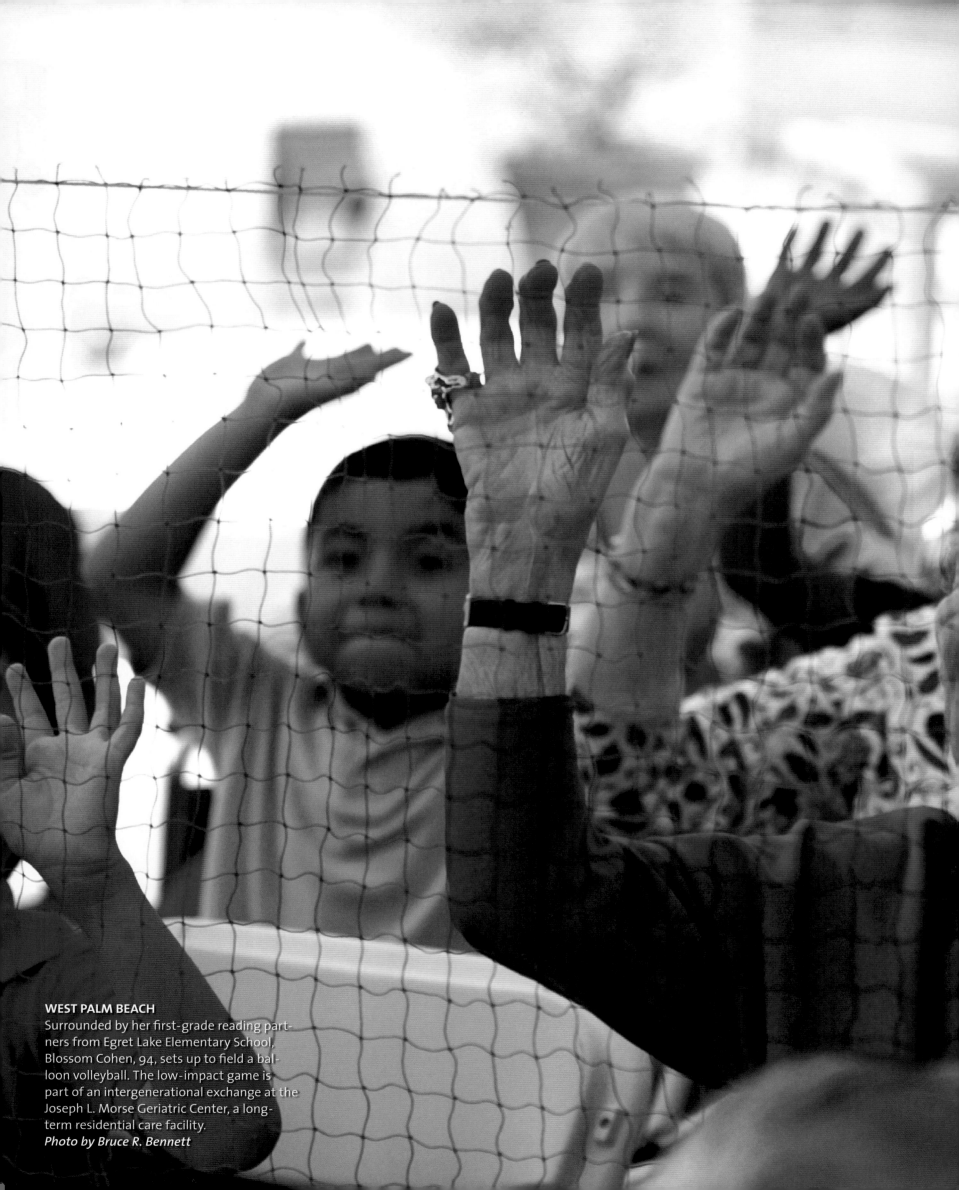

WEST PALM BEACH
Surrounded by her first-grade reading partners from Egret Lake Elementary School, Blossom Cohen, 94, sets up to field a balloon volleyball. The low-impact game is part of an intergenerational exchange at the Joseph L. Morse Geriatric Center, a long-term residential care facility.
Photo by Bruce R. Bennett

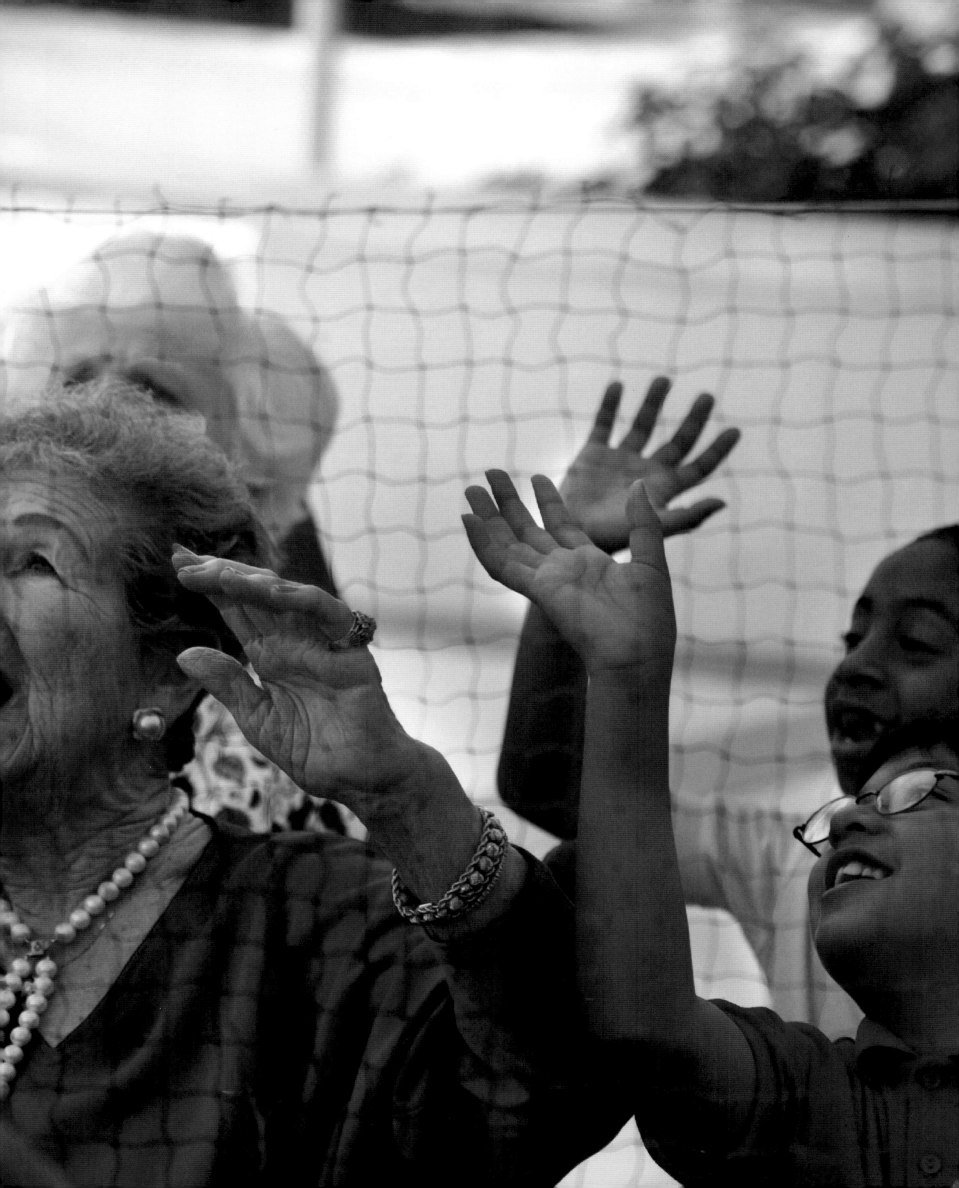

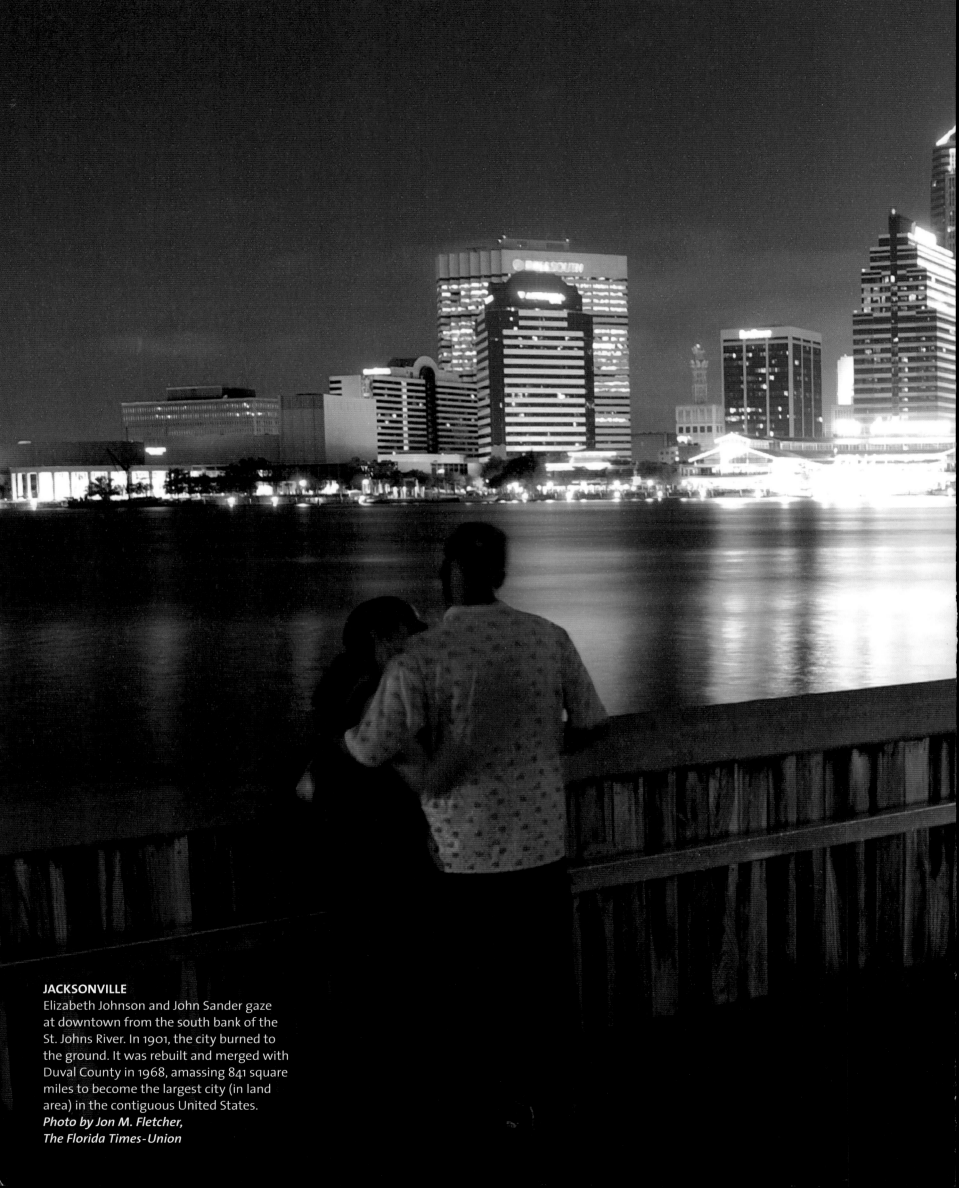

JACKSONVILLE
Elizabeth Johnson and John Sander gaze
at downtown from the south bank of the
St. Johns River. In 1901, the city burned to
the ground. It was rebuilt and merged with
Duval County in 1968, amassing 841 square
miles to become the largest city (in land
area) in the contiguous United States.
Photo by Jon M. Fletcher,
The Florida Times-Union

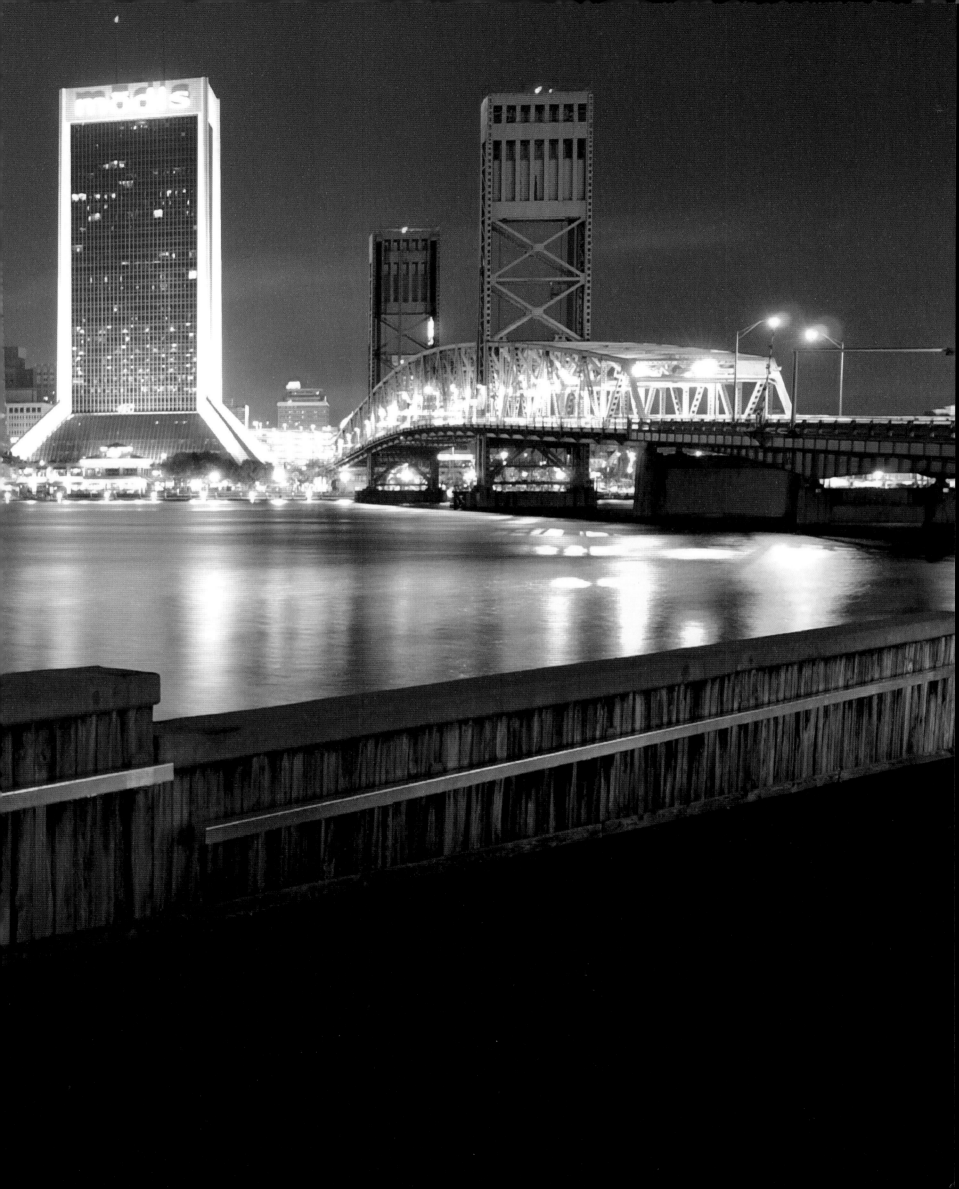

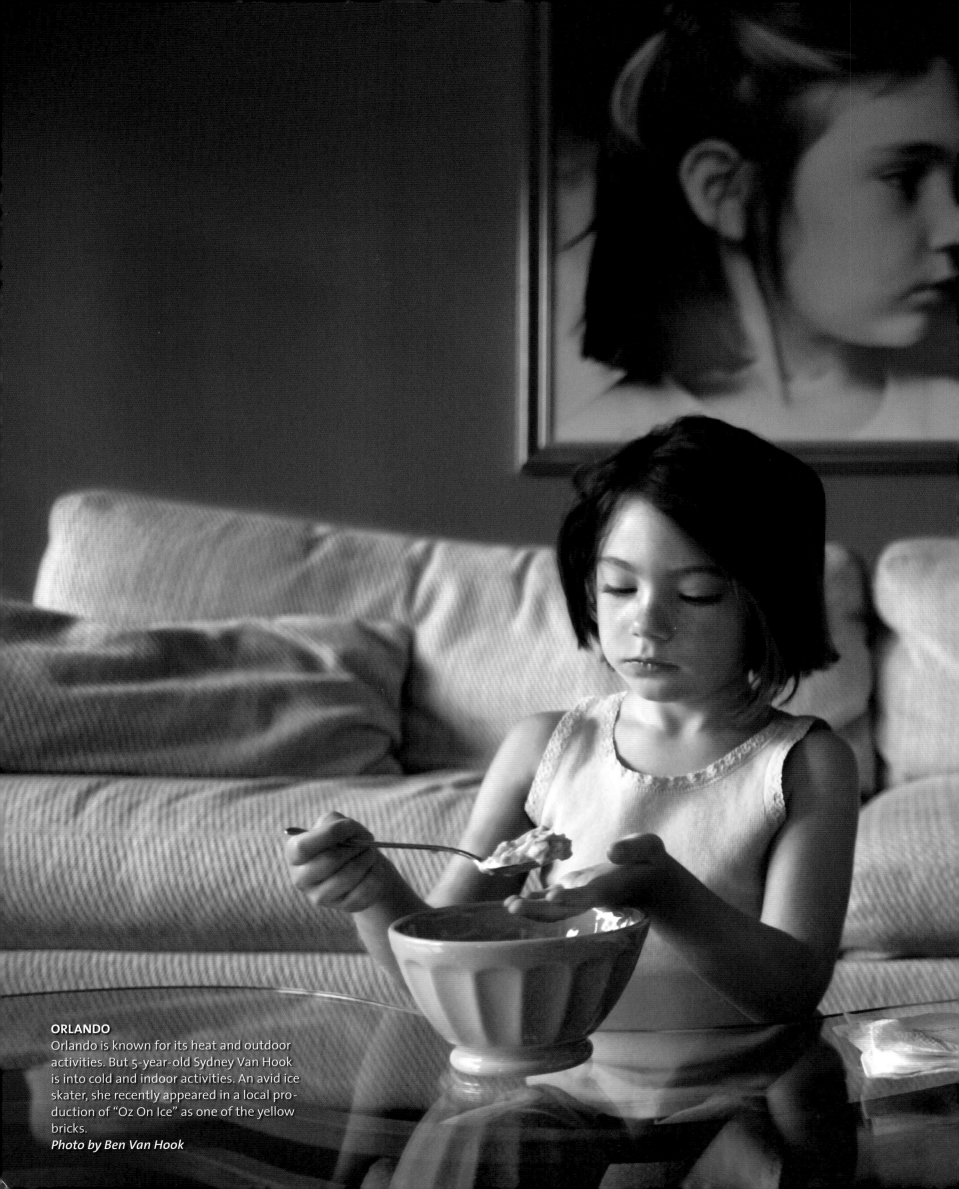

ORLANDO
Orlando is known for its heat and outdoor activities. But 5-year-old Sydney Van Hook is into cold and indoor activities. An avid ice skater, she recently appeared in a local pro-duction of "Oz On Ice" as one of the yellow bricks.
Photo by Ben Van Hook

Hearth & Home

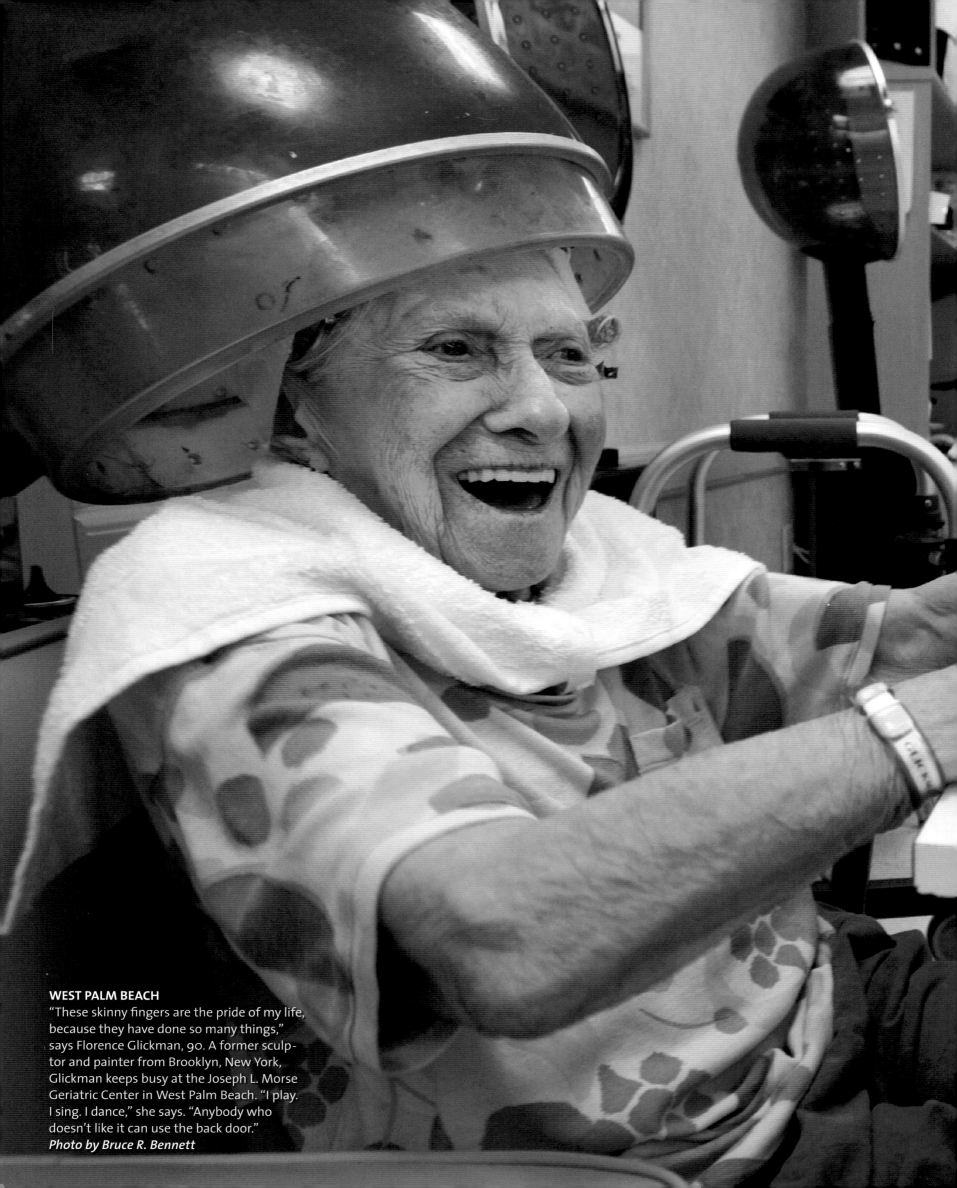

WEST PALM BEACH
"These skinny fingers are the pride of my life, because they have done so many things," says Florence Glickman, 90. A former sculptor and painter from Brooklyn, New York, Glickman keeps busy at the Joseph L. Morse Geriatric Center in West Palm Beach. "I play. I sing. I dance," she says. "Anybody who doesn't like it can use the back door."
Photo by Bruce R. Bennett

DELRAY BEACH
Dr. Gail Cooney, medical director of Hospice of Palm Beach County, visits with Antoinette Milne after an at-home appointment with Milne's husband, Gordon, who has lung cancer. "It is important to have a doctor who knows her patients," says Antoinette. "That's why we love Dr. Cooney."
Photo by Jacek Gancarz, Palm Beach Daily News

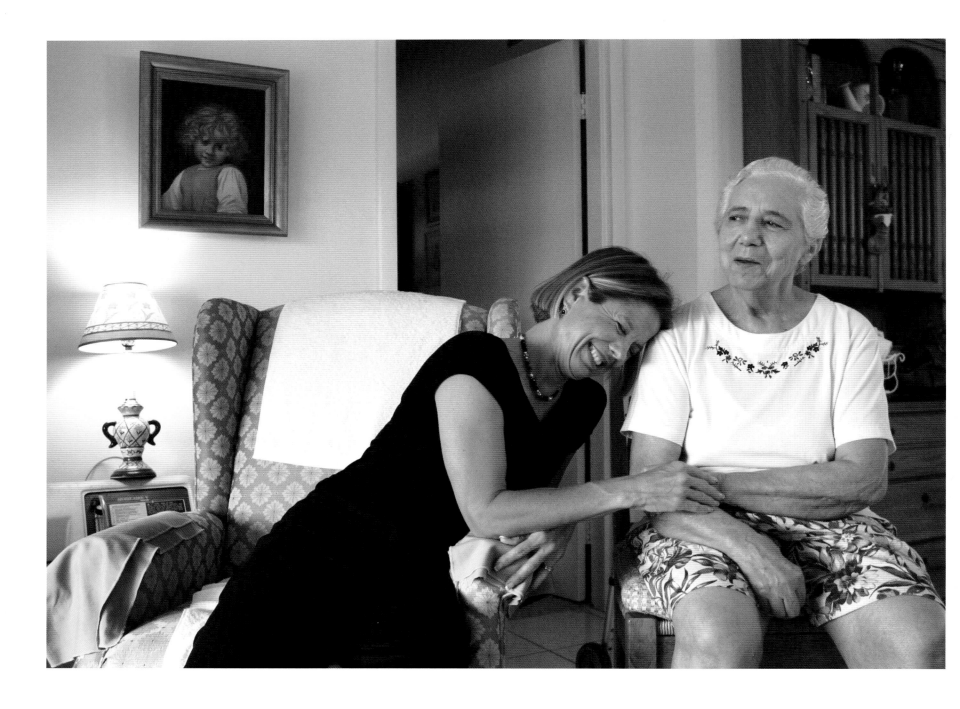

DAYTONA BEACH
Eight million visitors flock to Daytona Beach each year. These are five of them, from Lincoln, Nebraska: Karina Chaman and sister Diana Martinez holding her 18-month-old daughter Chloe, and mother Modesta and grandmother Yadviga Chaman.
Photo by Ben Van Hook

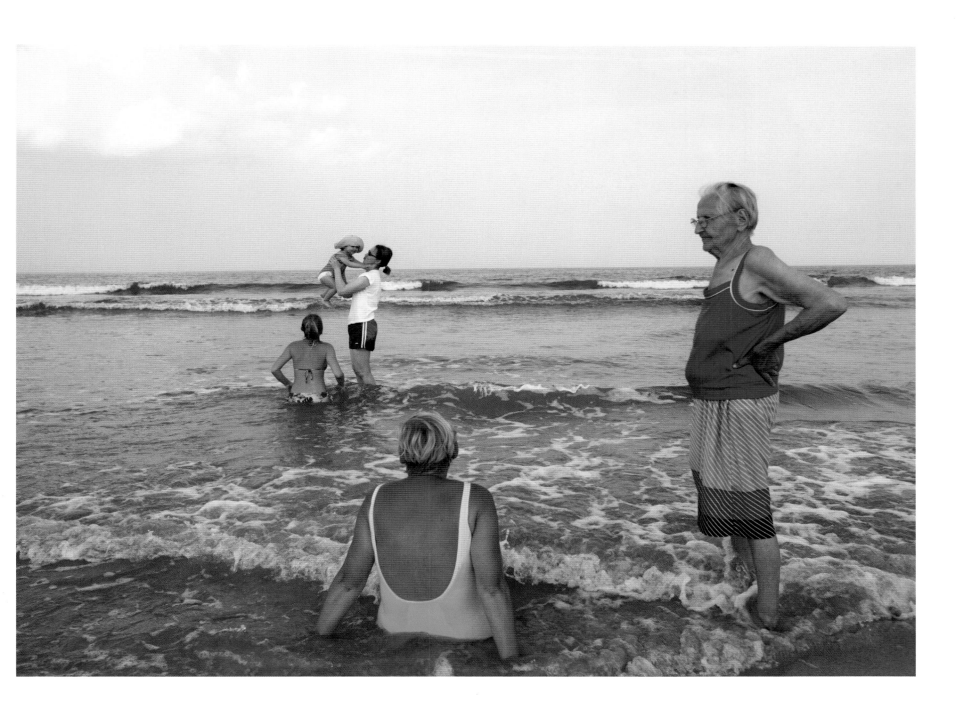

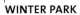

NAPLES

Rafael Martinez holds up daughter Natalie for a buss from her sister Nicole. A Cuban exile who left his homeland in 1986, Rafael lived in the Canary Islands for three years before settling in west Florida where he works as a carpenter.
Photo by Lisa Krantz, Naples Daily News

WINTER PARK

He's not deaf, but 9-month-old August Gimenez is learning American Sign Language. His mom Rebekah started him on lessons after learning that signing can enhance language skills. Of course, she and her husband take lessons, too. "It really helps him get what he needs and cuts down on his frustration level," says Gimenez.
Photo by Ben Van Hook

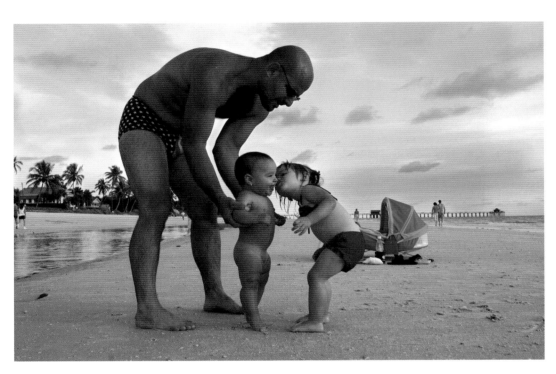

NAPLES

Future Mark Spitz? Dayna Webre has no lofty plans for son Brady, 14 months. She just wants him to become comfortable in the water and learn the basics. She enrolled him in the YMCA's swimming program when he was 8 months old.
Photo by Dan Wagner

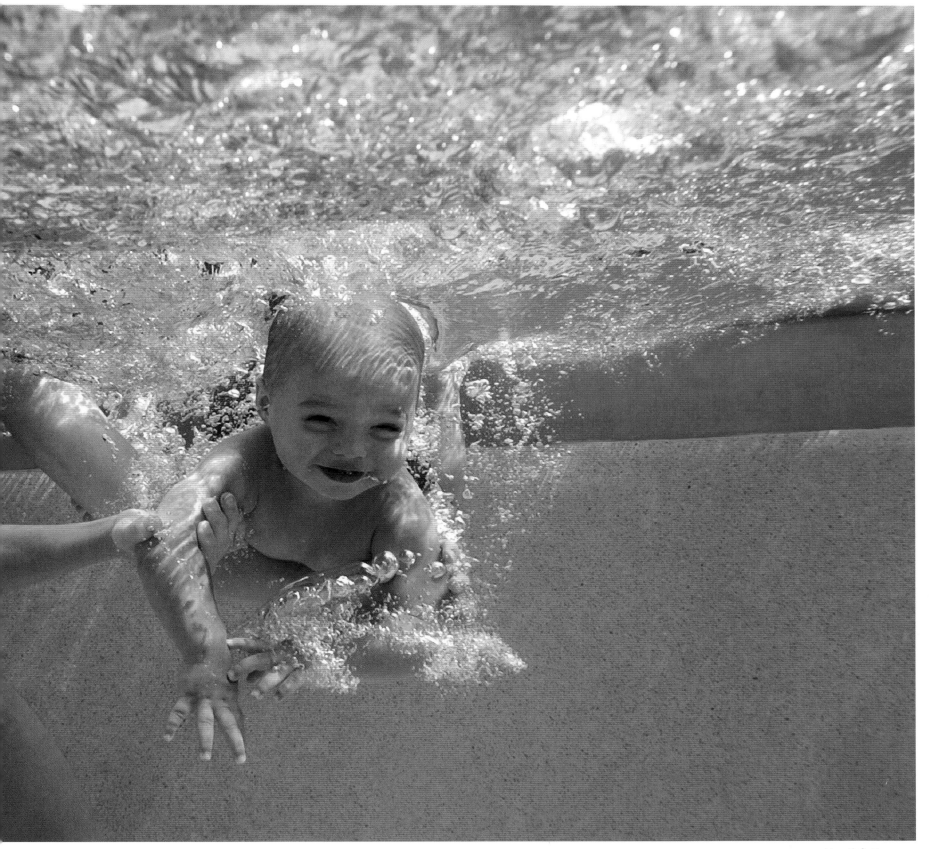

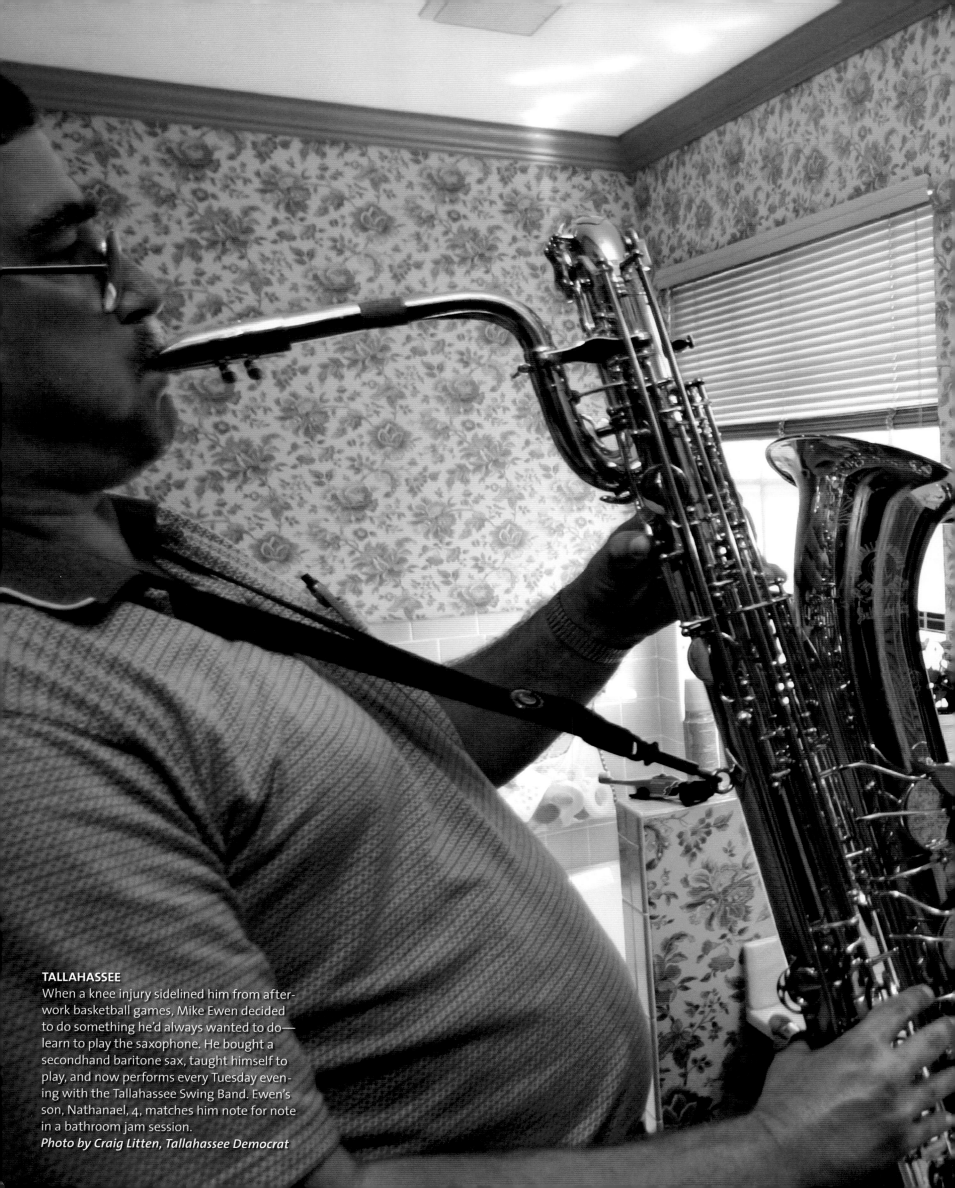

TALLAHASSEE

When a knee injury sidelined him from after-work basketball games, Mike Ewen decided to do something he'd always wanted to do—learn to play the saxophone. He bought a secondhand baritone sax, taught himself to play, and now performs every Tuesday evening with the Tallahassee Swing Band. Ewen's son, Nathanael, 4, matches him note for note in a bathroom jam session.

Photo by Craig Litten, Tallahassee Democrat

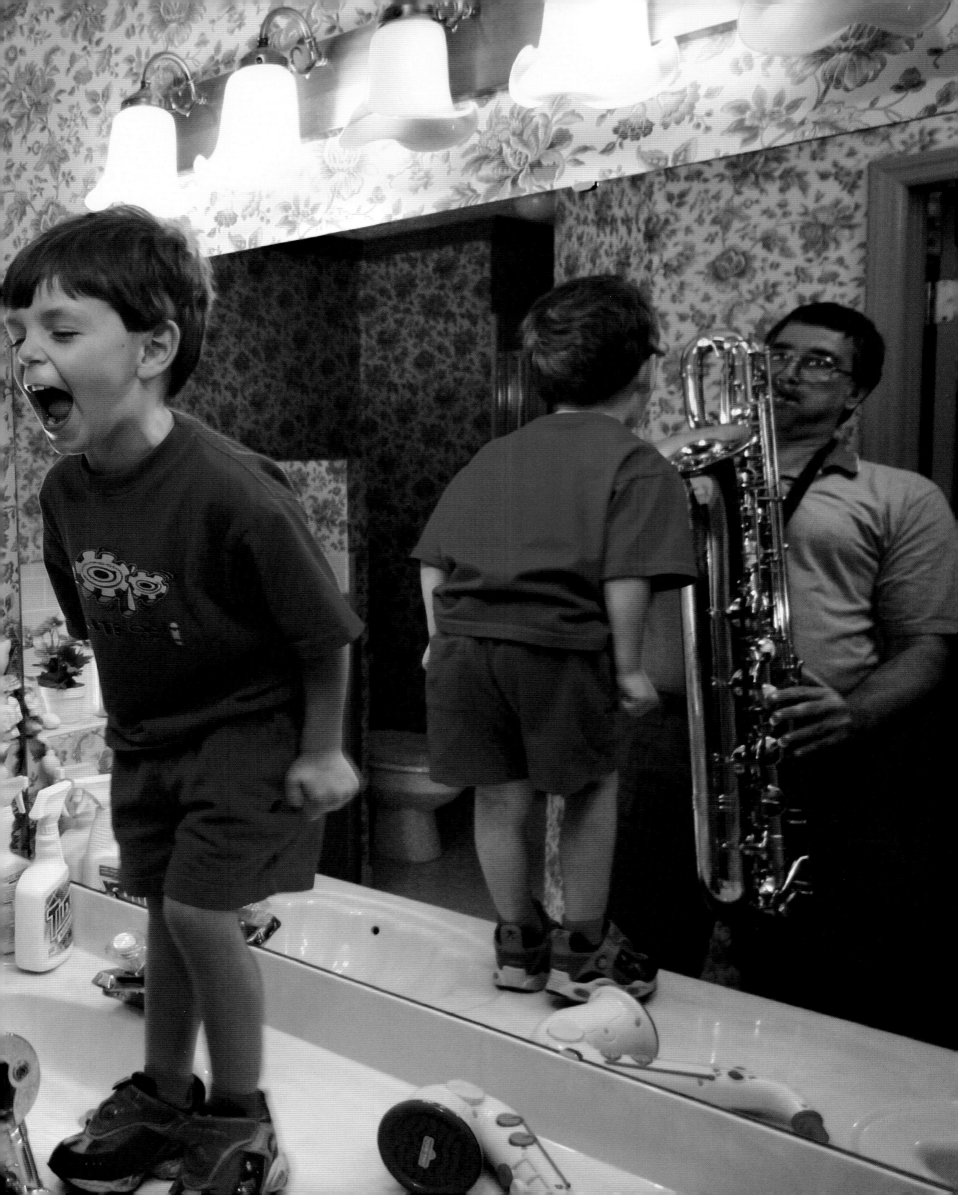

PALM BEACH
How many people does it take to keep this 25-foot-high ficus hedge looking shipshape? Four gardeners working nine times a year for eight hours. Employees from Scott Lewis Gardening & Trimming tend to a 5-acre estate on the posh island of Palm Beach.
Photo by Jacek Gancarz, Palm Beach Daily News

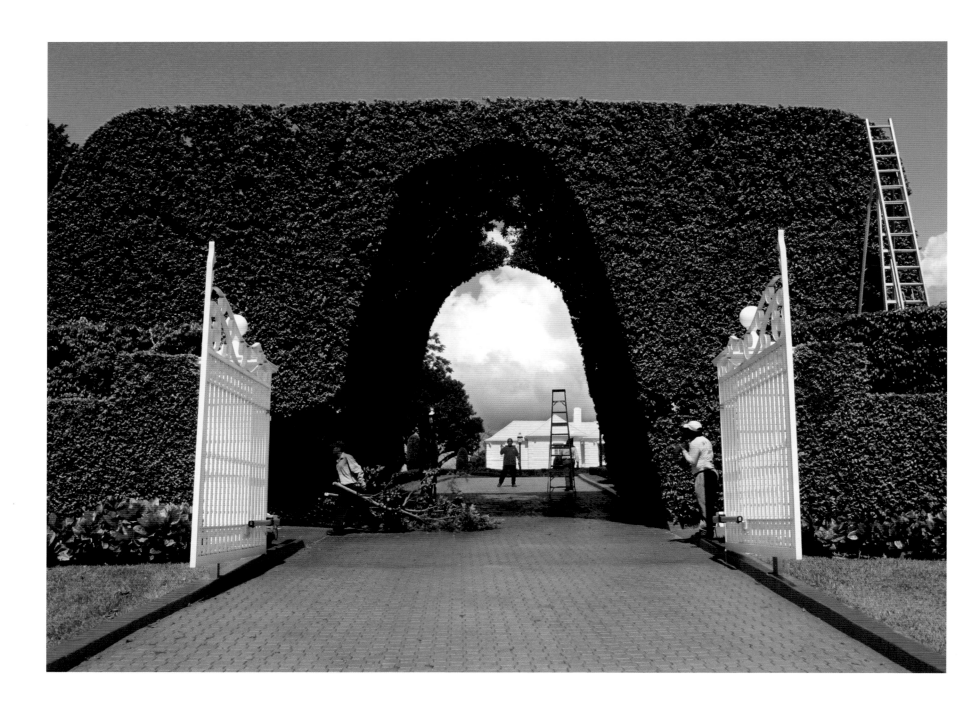

WINTER GARDEN

The oranges, tangerines, and tangelos that Jack Mask sells come from the trees on his family's 4-acre property. His parents gave the 11-year-old the sales job to teach him responsibility. "But when his friends show up, he takes off—and we end up doing a lot of the work," says his dad.
Photo by Gary Bogdon

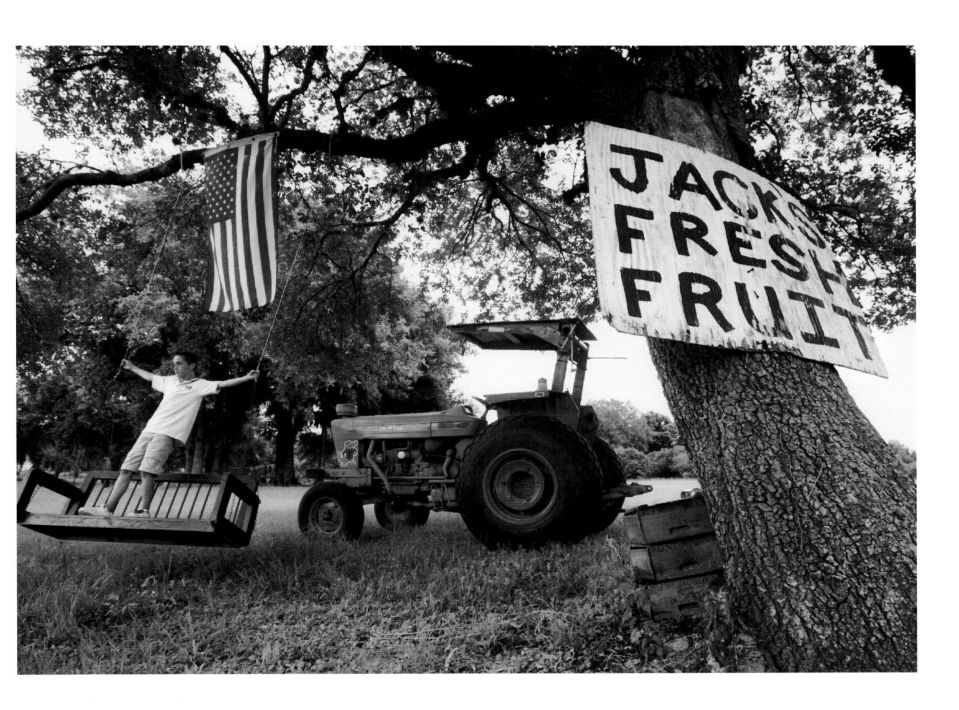

IMMOKALEE

A video of Haitian carnival reconnects these children to their musical heritage. Large-scale emigration from Haiti to Florida began in the 1950s when skilled professionals fled Papa Doc Duvalier's bloody repression. The migration continued in waves, as Haitian refugees of lesser means relocated to the U.S. between the 60s and 80s.
Photos by Lisa Krantz, Naples Daily News

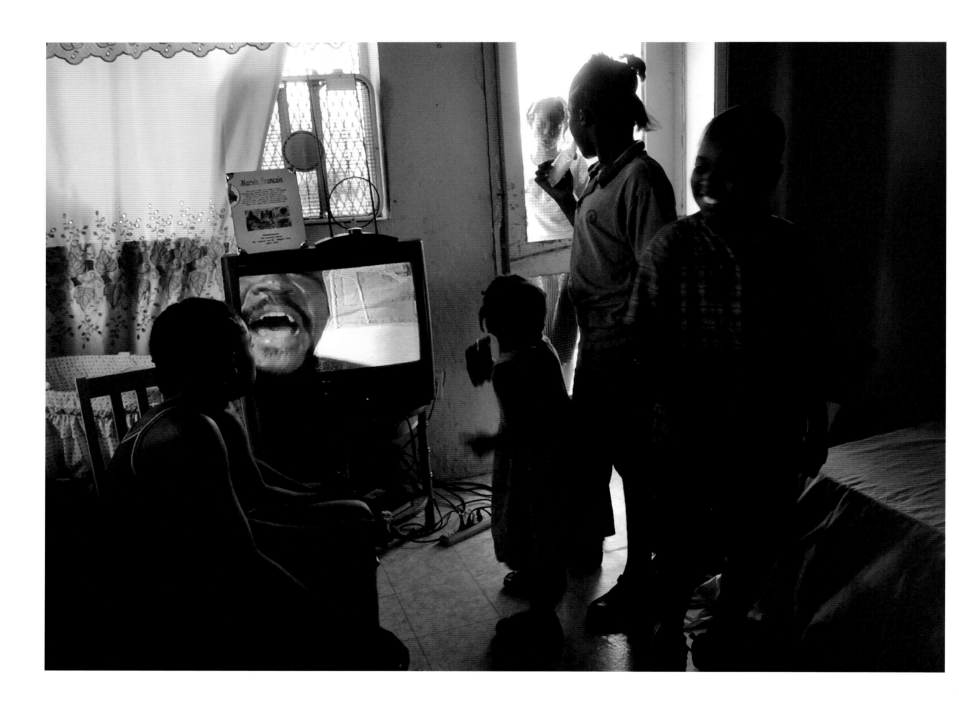

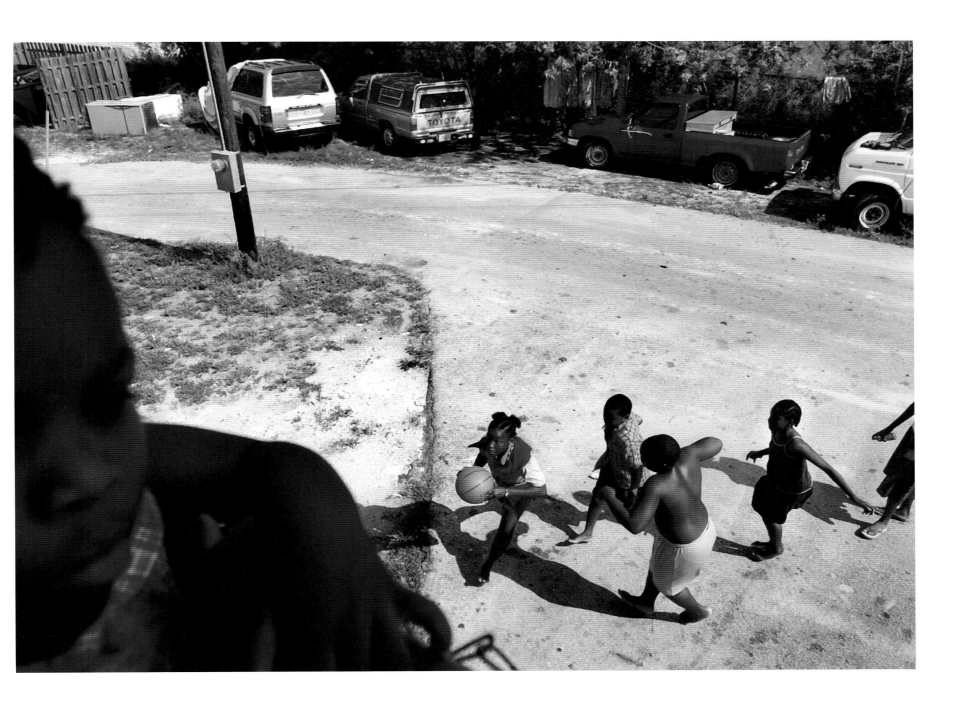

IMMOKALEE

An all-Haitian housing complex is home and community, and the parking lot does double duty as a basketball court for the kids. Most Haitians arriving in South Florida stay close to their point of entry, congregating in large en-claves in Miami-Dade, Broward, and Palm Beach counties. More than 200,000 Haitians live in the state.

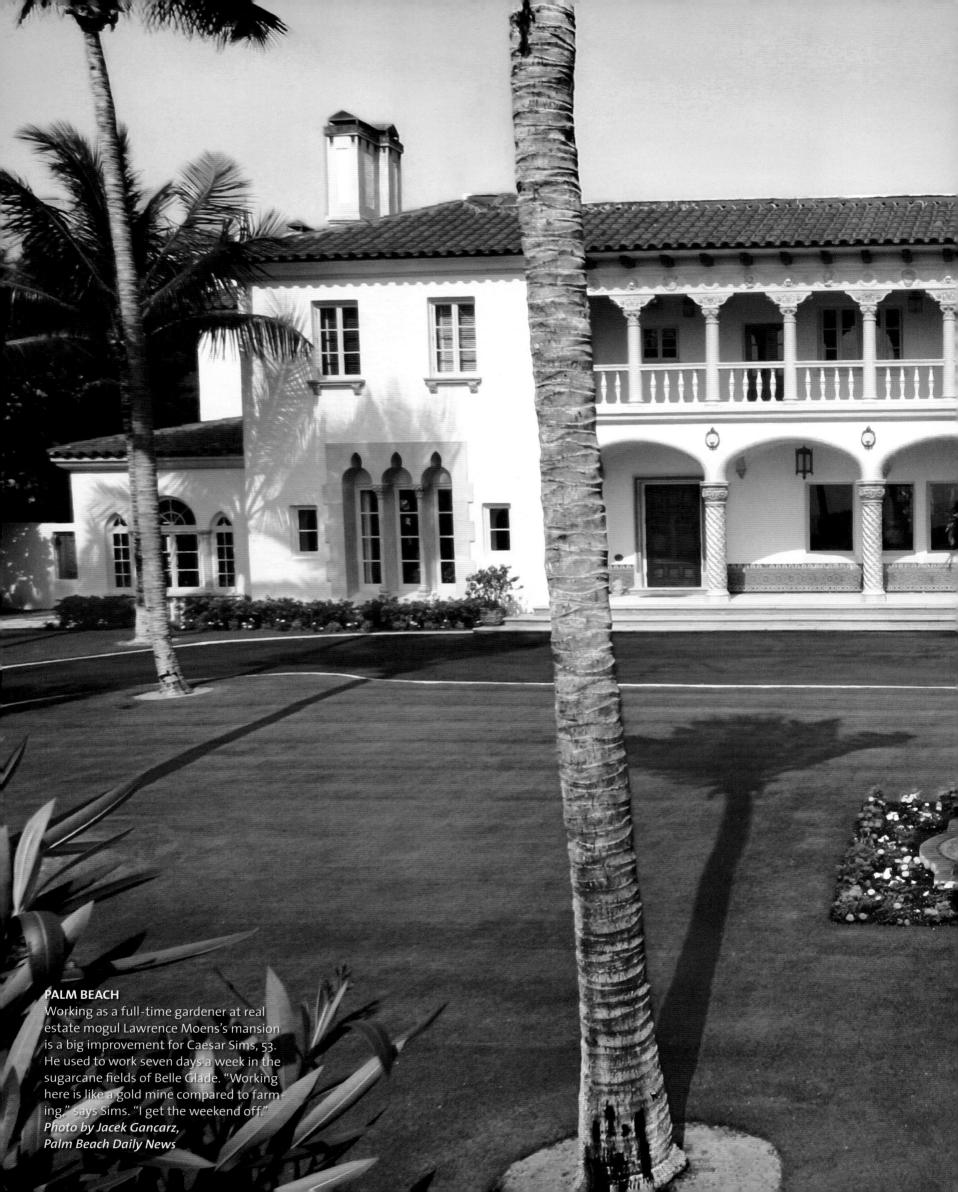

PALM BEACH
Working as a full-time gardener at real estate mogul Lawrence Moens's mansion is a big improvement for Caesar Sims, 53. He used to work seven days a week in the sugarcane fields of Belle Glade. "Working here is like a gold mine compared to farming," says Sims. "I get the weekend off."
Photo by Jacek Gancarz,
Palm Beach Daily News

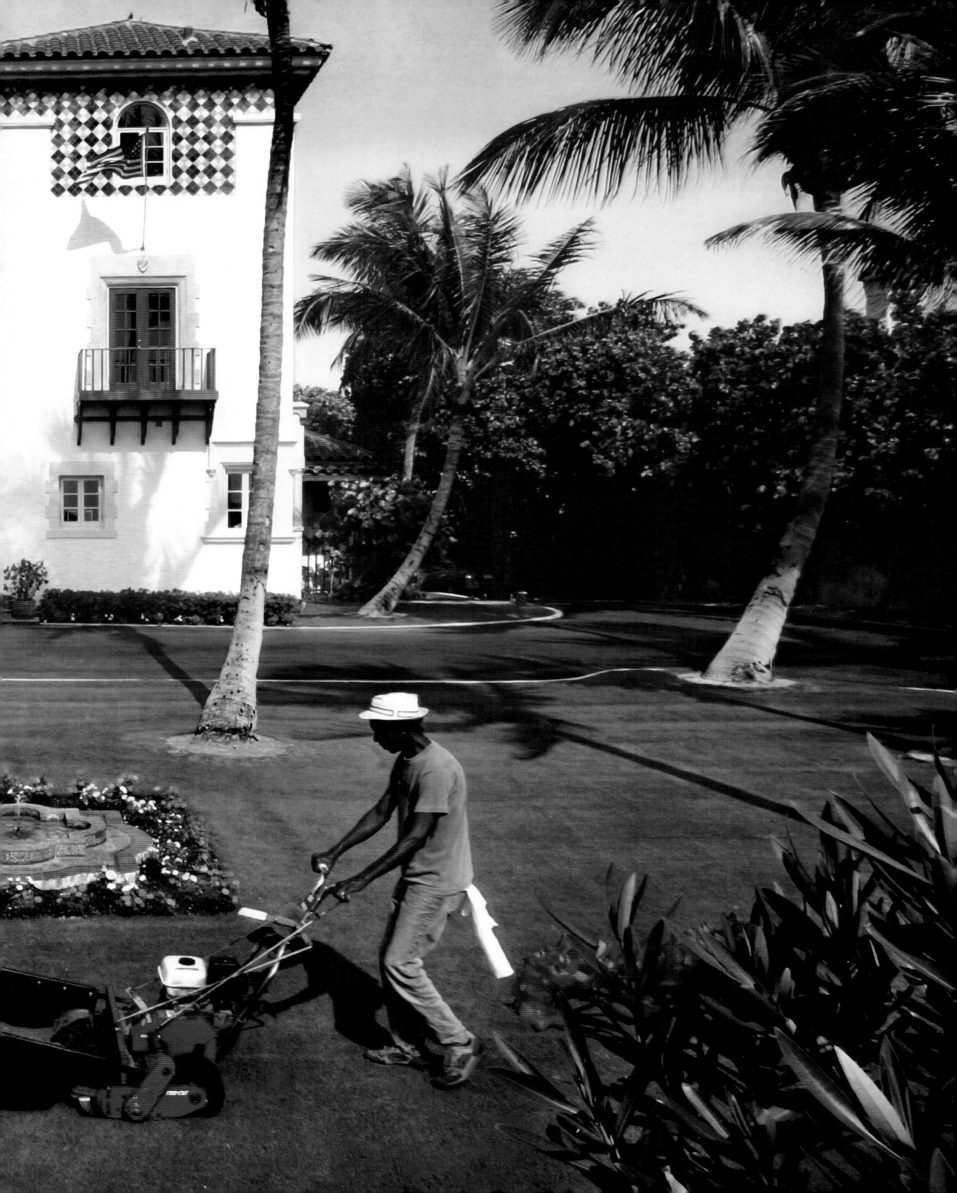

LAKE WORTH
Mojo is a fastidious fellow. He grooms himself in the bathroom sink and coughs up his fur balls right into the wastebasket.
Photo by Bruce R. Bennett

SARASOTA
Surf shorts, spa robes, pajamas, jeans. They're all part of Vicki "Tiki" Beauzay's clothing line for dogs, Gidget-Gear By Tiki. Her inspiration was her Bedlington terrier, Gidget. Beauzay, who sells her original designs out of a small storefront in a converted motel along Tamiami Trail, has a much grander vision. She's taking her handiwork to trade shows hoping to wow the bowwow market.
Photo by Chip Litherland, Sarasota Herald-Tribune

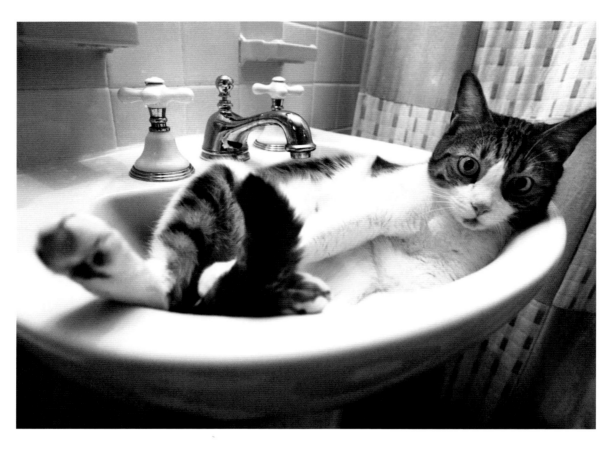

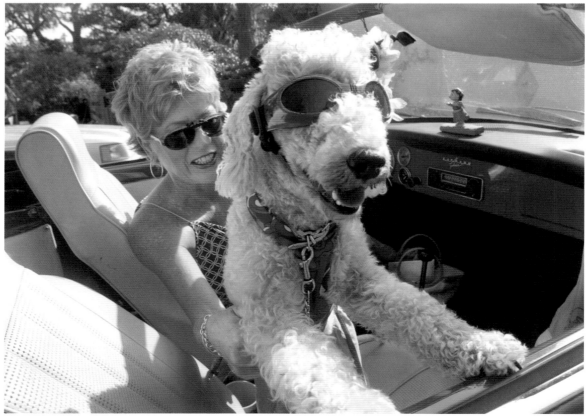

FORT LAUDERDALE
Daisy the Dalmatian is between gigs as a therapy dog. It's a job that has her cheering up patients at area hospitals. Daisy has appeared in a beer commercial and is, her owner Thomas Tobin says, an official member of the Screen Actors Guild.
Photo by Lori Bale

LOWER KEYS
Rocky, a 9-year-old golden retriever, seeks the shade after a long afternoon spent chasing bait-fish near Marvin Key.
Photo by Rob O'Neal

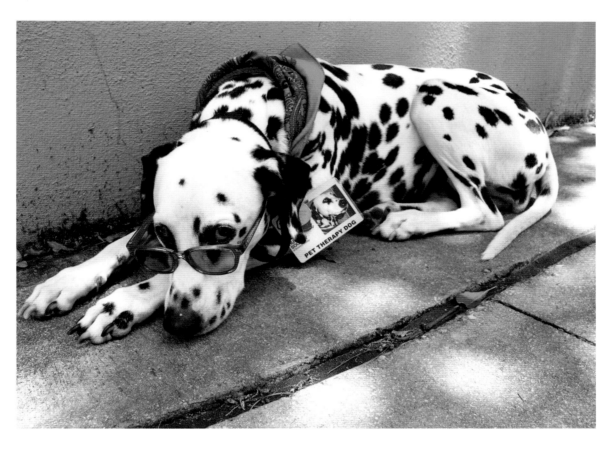

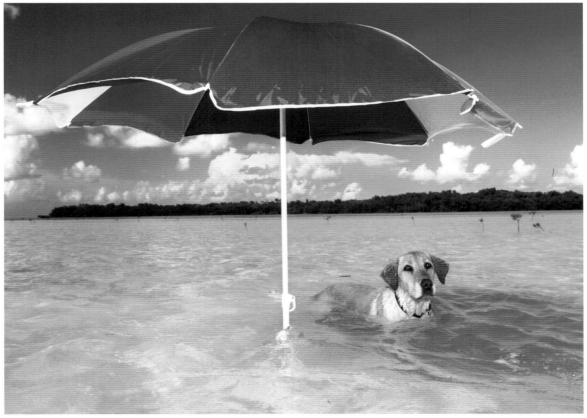

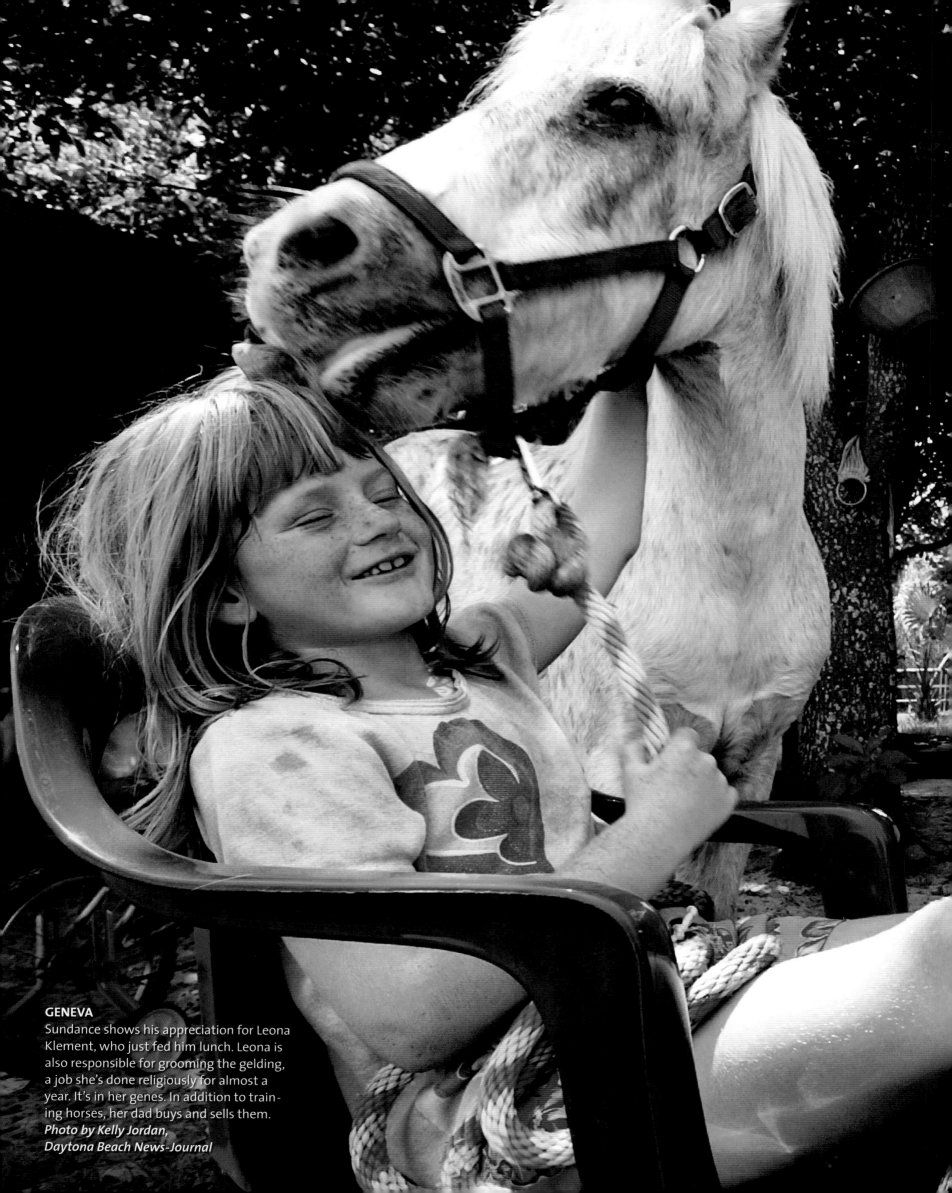

GENEVA
Sundance shows his appreciation for Leona Klement, who just fed him lunch. Leona is also responsible for grooming the gelding, a job she's done religiously for almost a year. It's in her genes. In addition to training horses, her dad buys and sells them.
Photo by Kelly Jordan,
Daytona Beach News-Journal

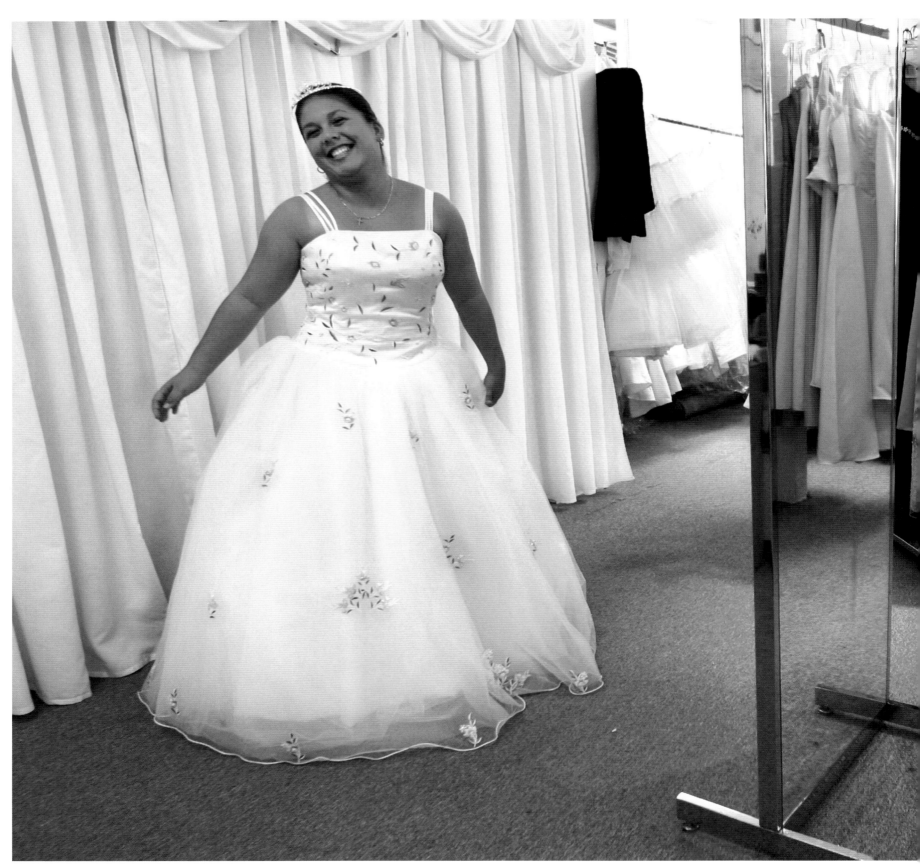

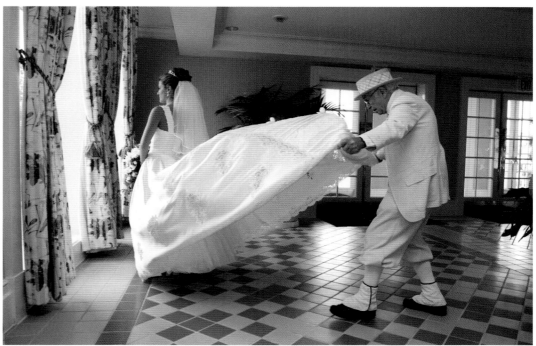

LAKE BUENA VISTA

Today may be the happiest day for Lucy Coates of Lindenhurst, Illinois, but for Richard Gerth, official Fairy Tale Wedding greeter at Walt Disney World's Grand Floridian Resort, it's just another day in the kingdom. Gerth, 77, brings wedding dresses to life with the "dress fluff" he perfected 12 years ago. He estimates he's fluffed 3,400 gowns.

Photo by Preston Mack

LAKE BUENA VISTA

Cinderella's wedding coach—powered by six white Shetland ponies—rolls Lucy Coates and her bridal party to the Wedding Pavilion at Walt Disney World. Coates knew she wanted to have Disney's Fairy Tale Wedding, even before getting engaged last year. "For a bride, it's a dream come true," says the Illinois resident.

Photo by Preston Mack

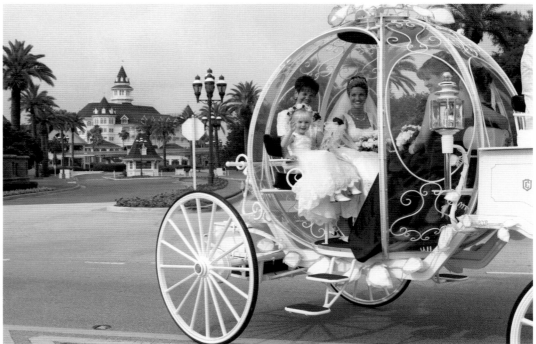

KEY WEST
Shane and Nikki McLarty of Memphis, Tennessee,
share a post-wedding kiss at Fort Zachary Taylor
Historic State Park on the western tip of Key
West. On average, there are three beachside, sun-
set weddings every day at the park during the
busy seasons (January through April and Septem-
ber through November).
Photo by Rob O'Neal

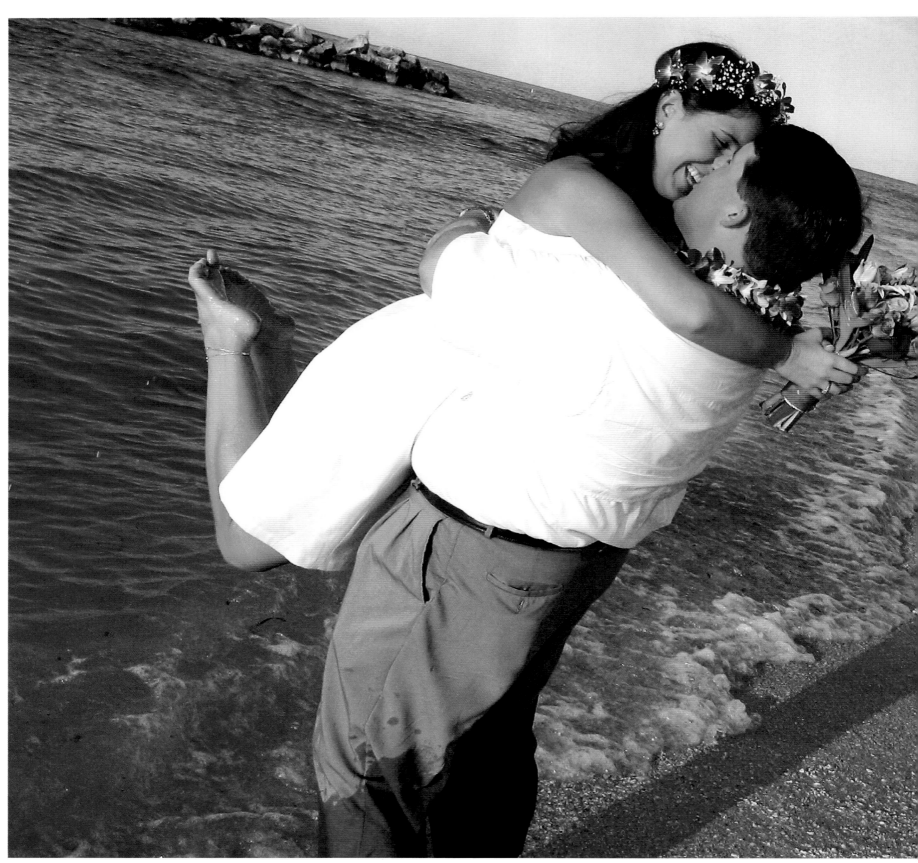

ORLANDO

In her apartment, Leigh Marek gets some assistance from two of her bridesmaids, high school friend Nicole Kaney and sister-in-law Betsy Odin. At the reception, the garter was thrown to a throng of single men, but no one wanted to catch it.

Photo by Ben Van Hook

FORT LAUDERDALE

What could be more romantic than getting married on the beach? For Ranee and Mark Croft (goofing around with the groomsmen), it was everything they had hoped it would be—except that the beach borders traffic-heavy A1A and the noise drowned out the ceremony. Not wanting to cheat their guests, the couple typed up their vows and sent them to everyone.

Photo by Melissa Lyttle

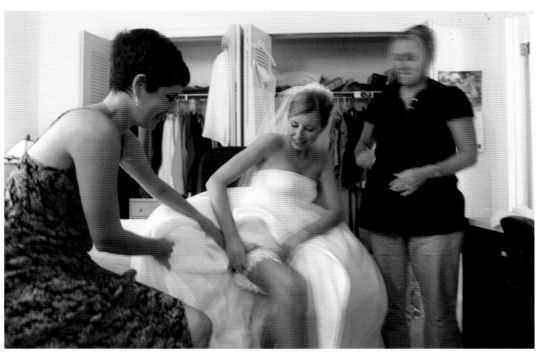

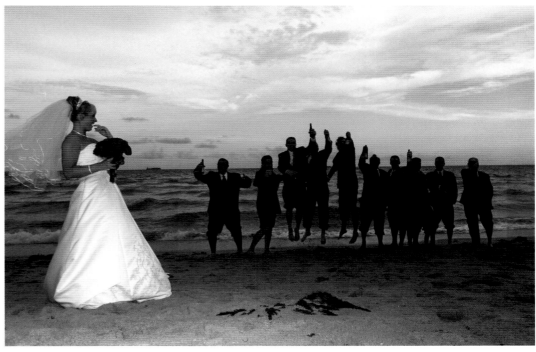

The year 2003 marked a turning point in the history of photography: It was the first year that digital cameras outsold film cameras. To celebrate this unprecedented sea change, the *America 24/7* project invited amateur photographers—along with students and professionals—to shoot and, via the Internet, submit digital images. Think of it as audience participation. Their visions of community are interspersed with the professional frames throughout this book. On the following four pages, however, we present a gallery produced exclusively by amateur photographers.

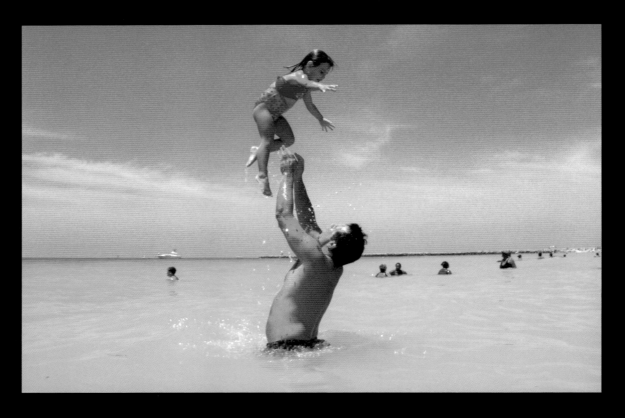

CLEARWATER With an average spring temperature of 75 degrees and 74-degree water, what's Clearwater's average spring fun quotient? One hundred percent. *Photo by John Flood*

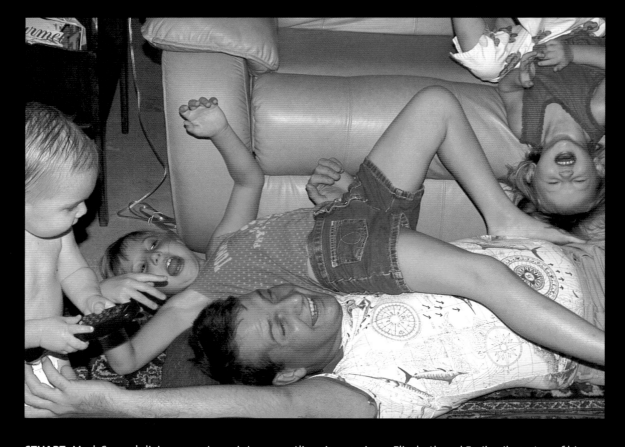

STUART Mark Spears's living room turns into a wrestling ring as nieces Elizabeth and Emily pile on top of him. Son Matthew just wants to change the channel. *Photo by Katie Spears*

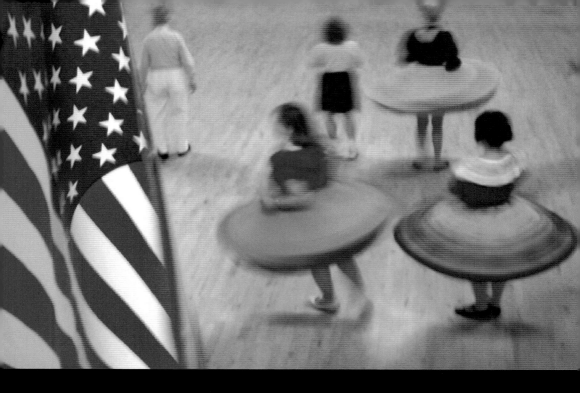

ORLANDO At the Whirl & Twirl Square & Round Dance Club, people of all ages come dressed to the nines to earn their do-si-dos. *Photo by Julian Olivas*

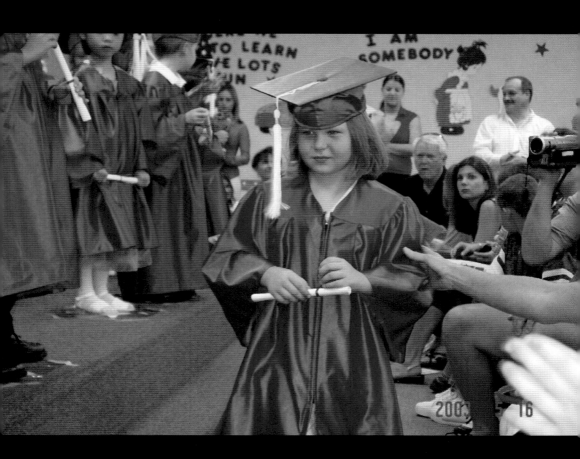

ORLANDO Special pre-K: Kyra Farkas, 5, graduates from Kiddie U prekindergarten class. She and 25 of her classmates begin the rigors of kindergarten in August. *Photo by Joe Farkas*

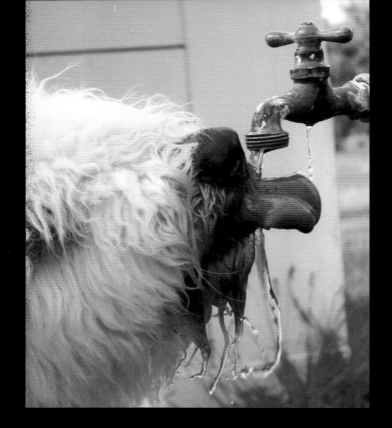

HAMPTON Lasne, a Hungarian komondor sheepdog, is bred to blend. His coat "felts and cords" to look like his flock—something he'll never see in the Florida burbs. *Photo by Brian Fogarty*

PACE Li'l Babies beats the heat with a cool drink of pool water at her home on the "redneck Riviera" near Pensacola. *Photo by Raven Stone*

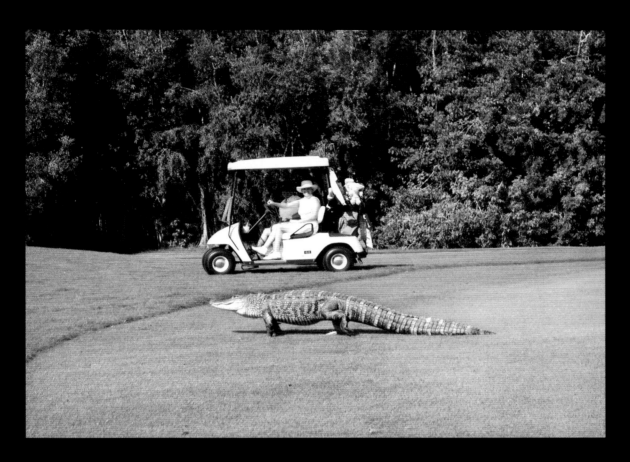

NAPLES Carving golf courses out of swampland has its hazards. This one commands the 9th fairway at the Classics Golf and Country Club. *Photo by Pete Gabardini*

ST. JAMES CITY Free lunch: Harry, a great blue heron, has unerring instincts. Every time someone fishes in Phillips Canal, he shows up for a handout. *Photo by Lynn Berreitter*

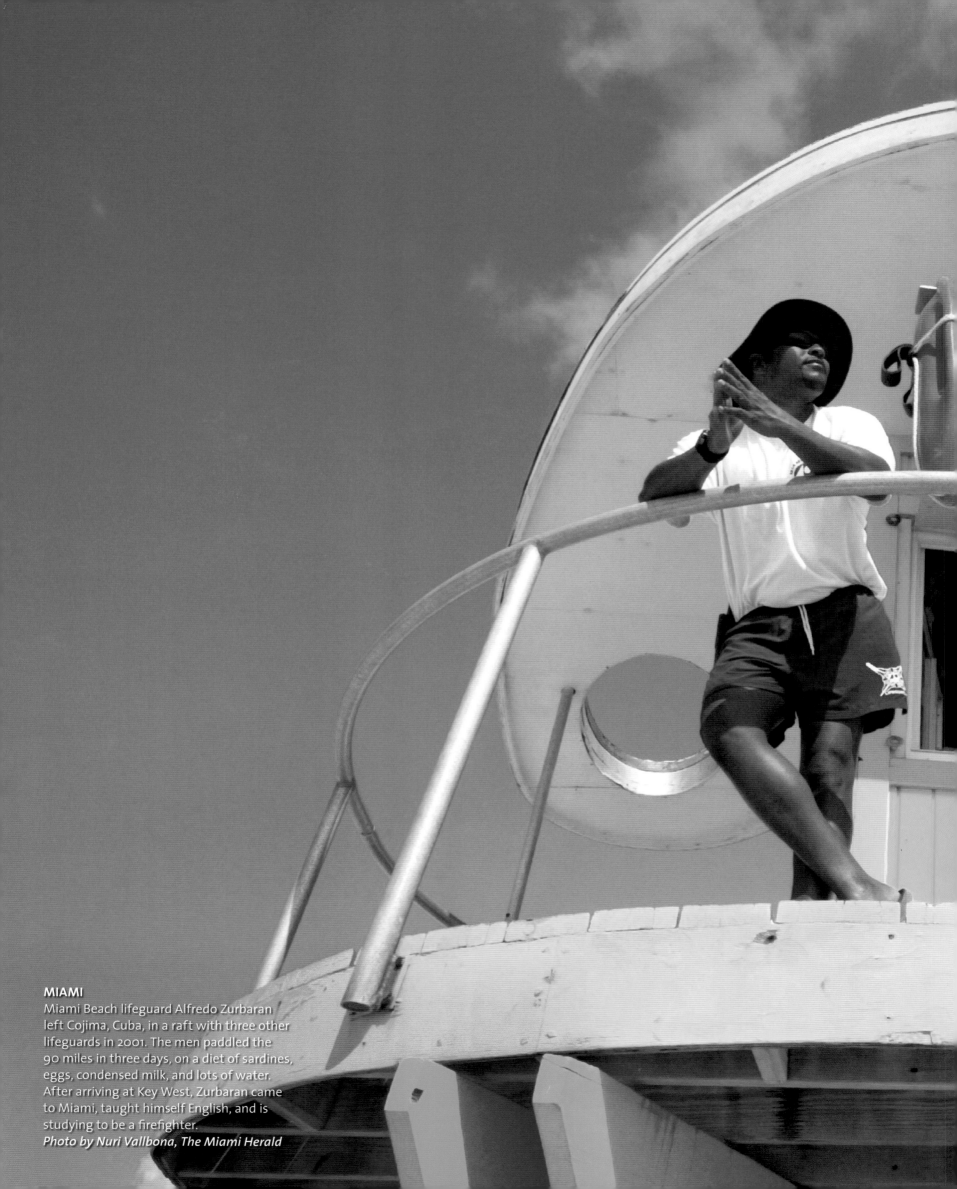

MIAMI

Miami Beach lifeguard Alfredo Zurbaran
left Cojima, Cuba, in a raft with three other
lifeguards in 2001. The men paddled the
90 miles in three days, on a diet of sardines,
eggs, condensed milk, and lots of water.
After arriving at Key West, Zurbaran came
to Miami, taught himself English, and is
studying to be a firefighter.
Photo by Nuri Vallbona, The Miami Herald

Hard At Work

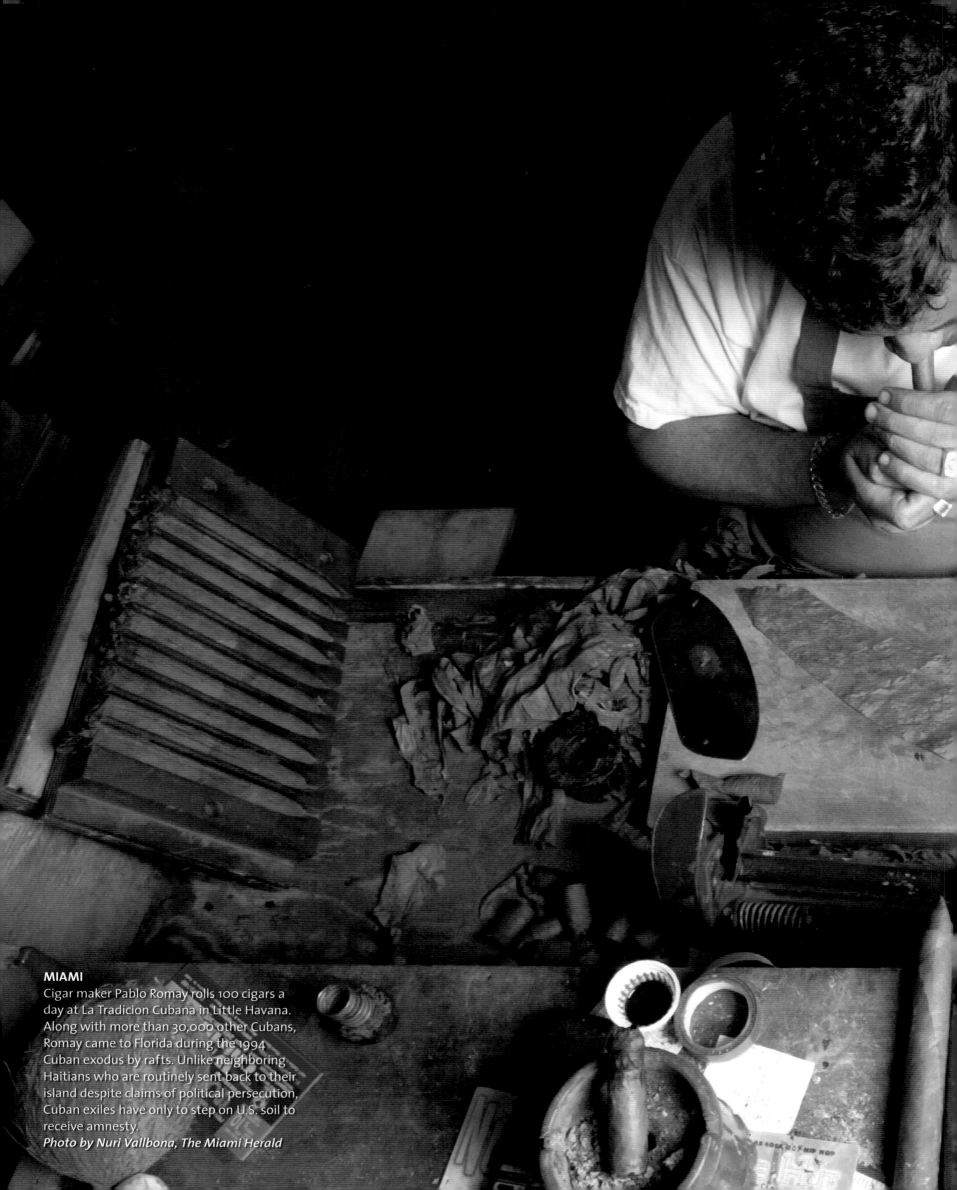

MIAMI
Cigar maker Pablo Romay rolls 100 cigars a day at La Tradicion Cubana in Little Havana. Along with more than 30,000 other Cubans, Romay came to Florida during the 1994 Cuban exodus by rafts. Unlike neighboring Haitians who are routinely sent back to their island despite claims of political persecution, Cuban exiles have only to step on U.S. soil to receive amnesty.
Photo by Nuri Vallbona, The Miami Herald

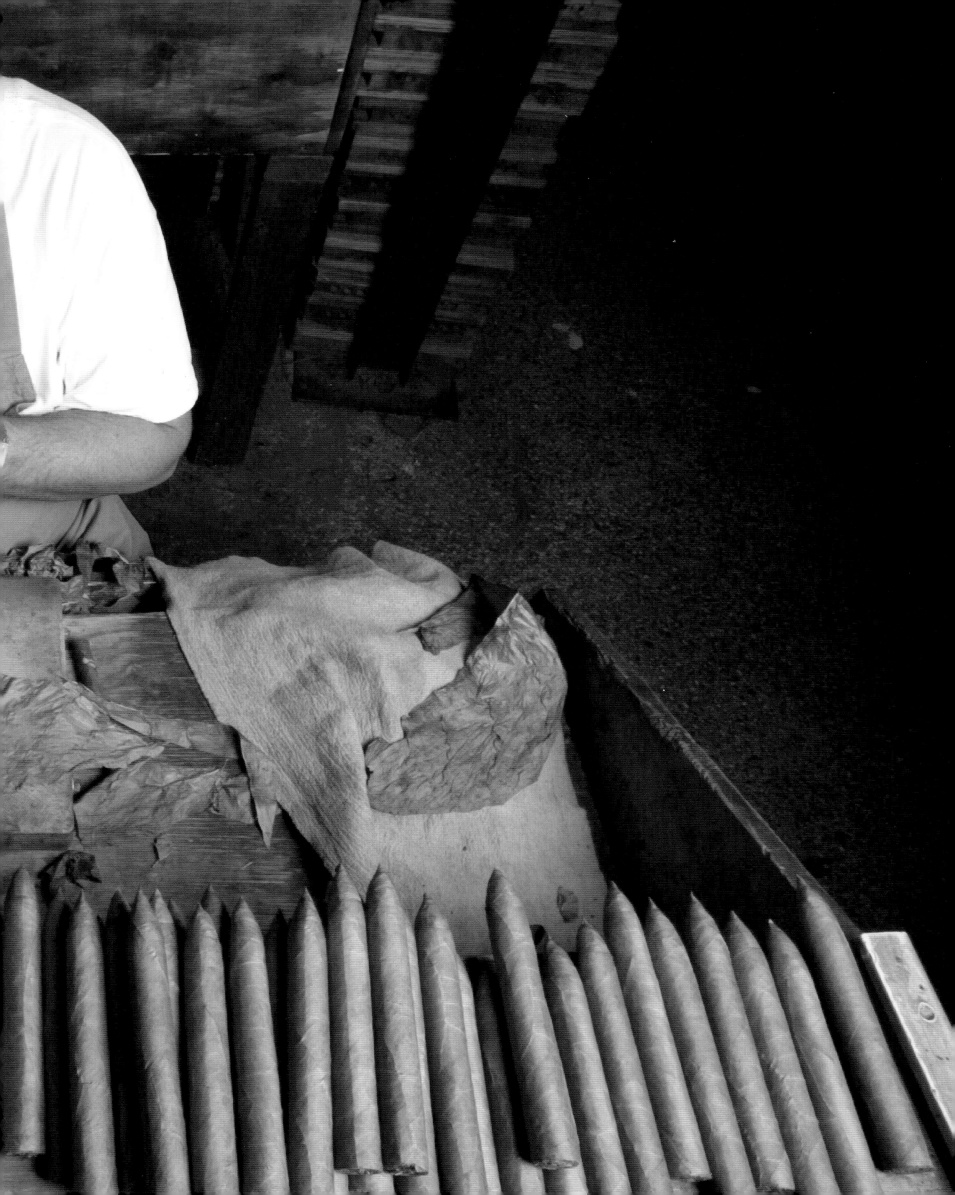

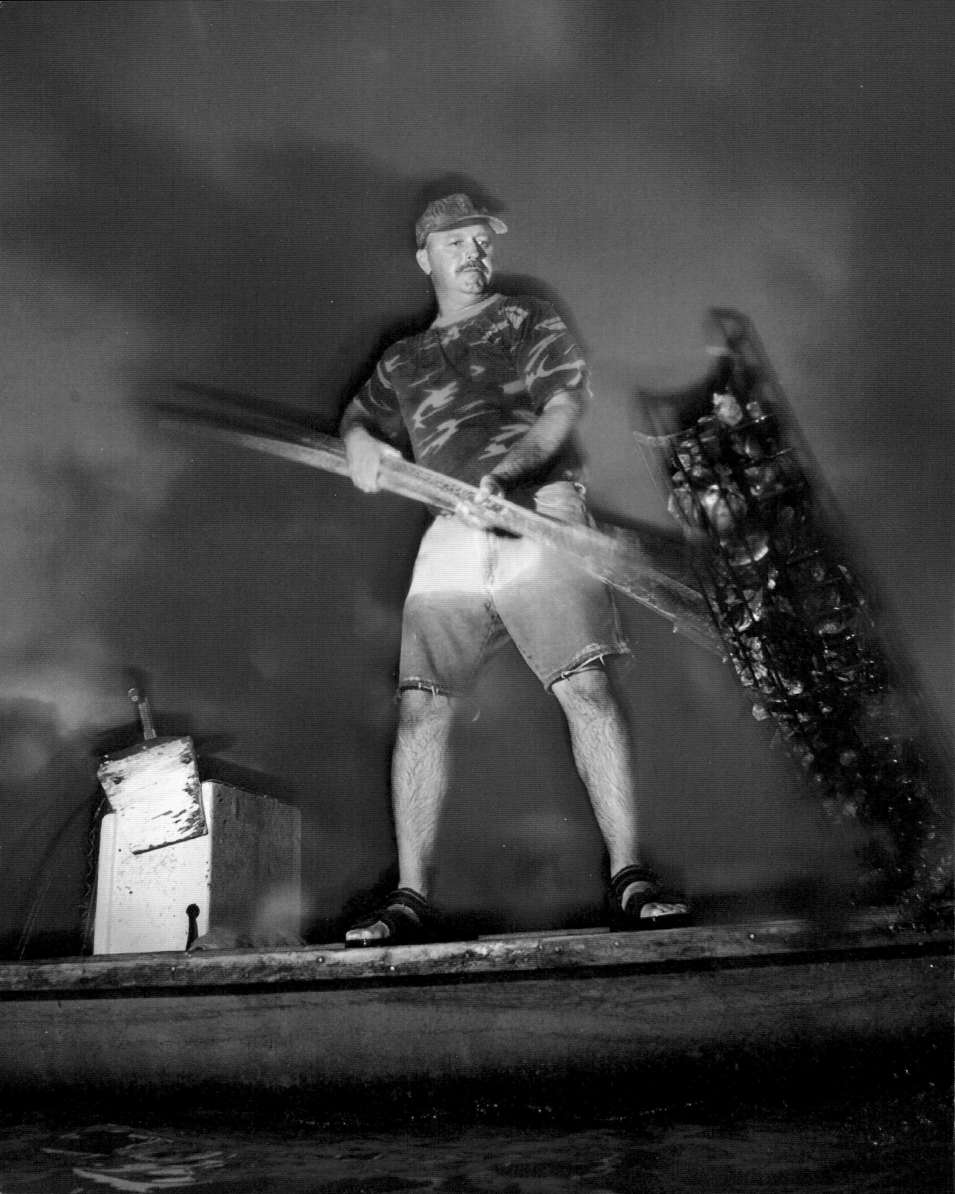

EASTPOINT

Scott Shiver's father showed him his first oyster-laden sandbar at age 12. Dad said if Scott liked harvesting oysters, he could do it for a living; if not, he didn't have to. Nearly 30 years later, Shiver is still at it, scooping up the bivalves in Apalachicola Bay, home to more than 90 percent of Florida's oysters.
Photo by Phil Sears,
Tallahassee Democrat

APALACHICOLA

Shrimp boat crews repair gear, while their nocturnal prey burrow into the Gulf's bottom sediment. With cheap farm-raised imports threatening their industry, Florida shrimpers got a $7 million federal disaster relief grant and are lobbying consumers to buy "wild-caught" American shrimp.
Photo by Craig Litten,
Tallahassee Democrat

PENSACOLA

Prior to selling the day's catch to wholesaler Allen Williams Seafood, a Vietnamese woman sorts through shrimp on the deck of her boat, the *Gulf Star*. Sixty percent of the 50 fishing boats in the area are owned or leased by Vietnamese families.
Photo by Gary McCracken,
Pensacola News Journal

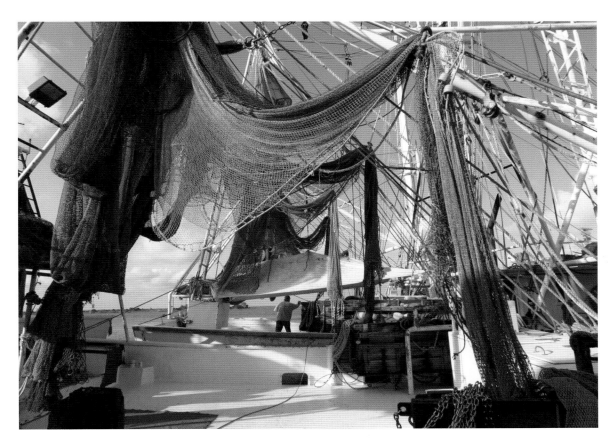

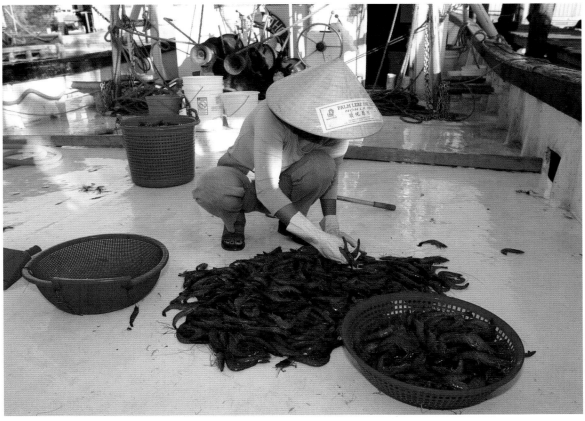

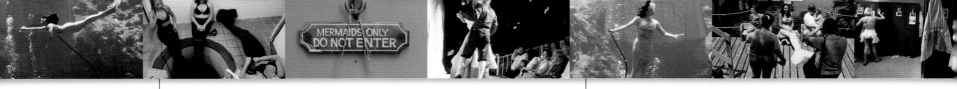

WEEKI WACHEE

Mermaids Stayce McConnell, Amy Fobell, and Stacey Linn wait for Meagan Bryda to zip into her tail before popping into the 60-foot tube that leads to the underwater theater. The promise of "real" mermaids has been drawing car loads of tourists to the tiny Gulf town, an hour north of Tampa, since 1947.
Photos by Gary Bogdon

WEEKI WACHEE

The underwater theater at Weeki Wachee is not a tank but a natural 72-degree artesian spring. Stacey Linn, playing the Little Mermaid, breathes by using an air hose and two airlocks, one of which is in the castle behind her. Newton Perry, a former U.S. Navy frogman, perfected "hose breathing" during experiments at Weeki Wachee in 1946.

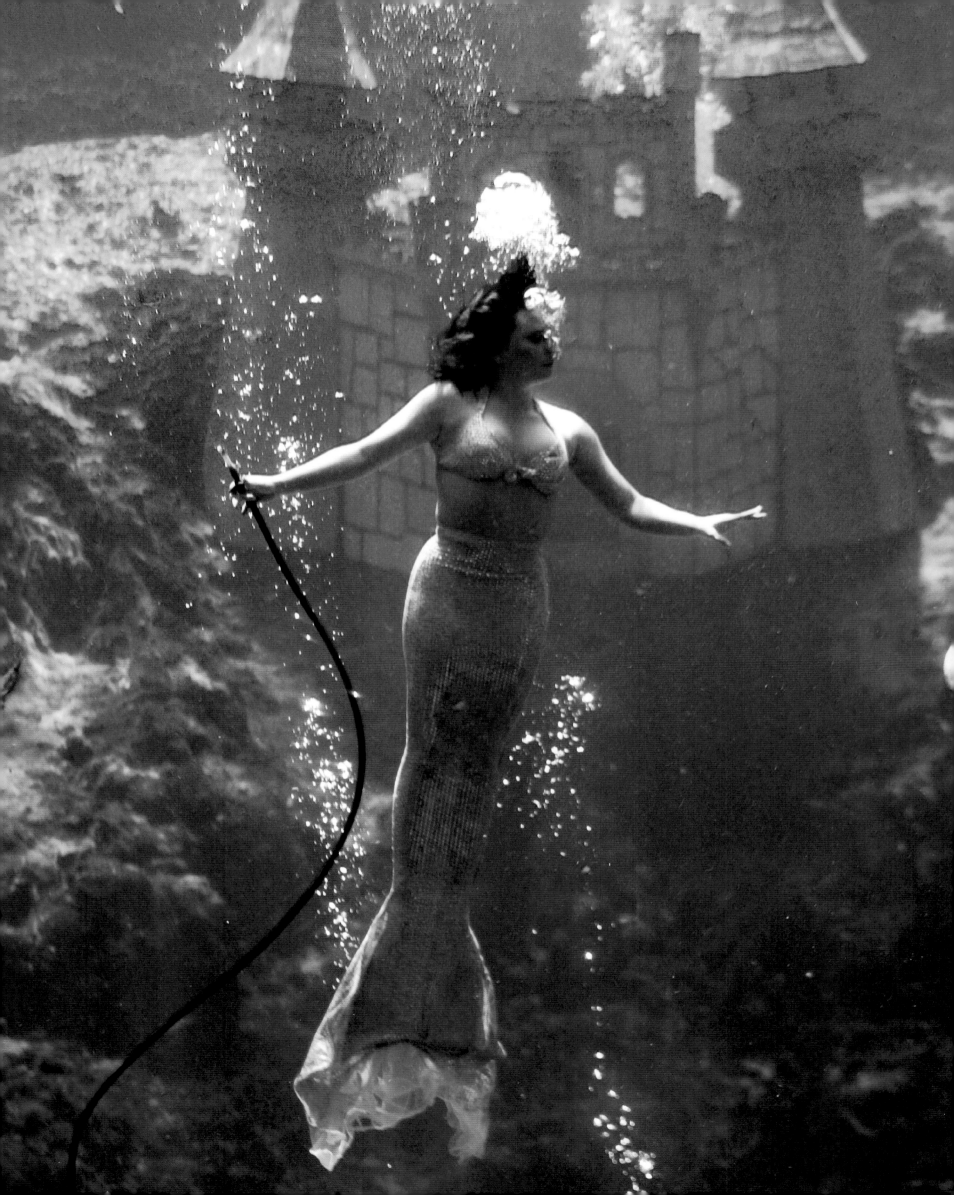

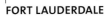

FORT LAUDERDALE
Firefighters brace themselves to tackle the next phase of their training: a six-story building that's been converted into a faux disaster zone. Over the next few hours, these fireman will confront the structure's various mazes and traps.
Photos by Andrew Kaufman, Contact Press Images

FORT LAUDERDALE
Allison Dunne, a firefighter with Broward Sheriff's Office, repels from a six-story building during a training exercise. Dunne continually takes classes to add skills. "I'm working towards getting on the HazMat team," says Dunne, referring to the elite squads that will be key first-responders in the event of biological and chemical emergencies.
Photo by Andrew Kaufman, Contact Press Images

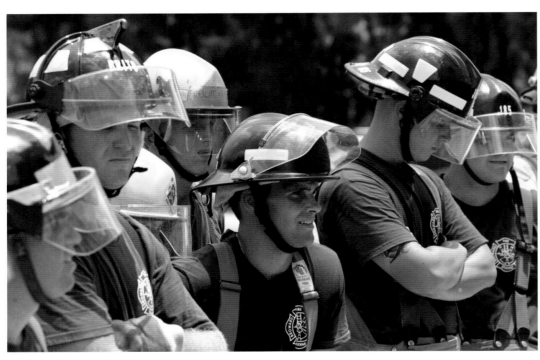

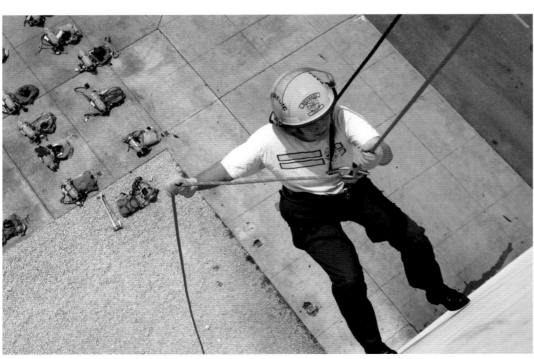

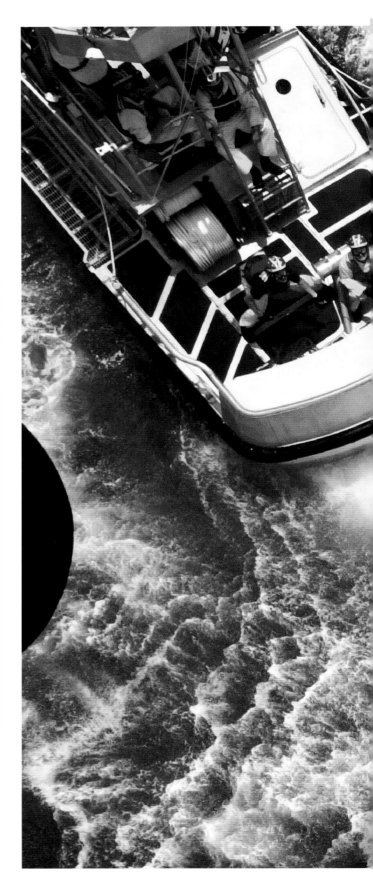

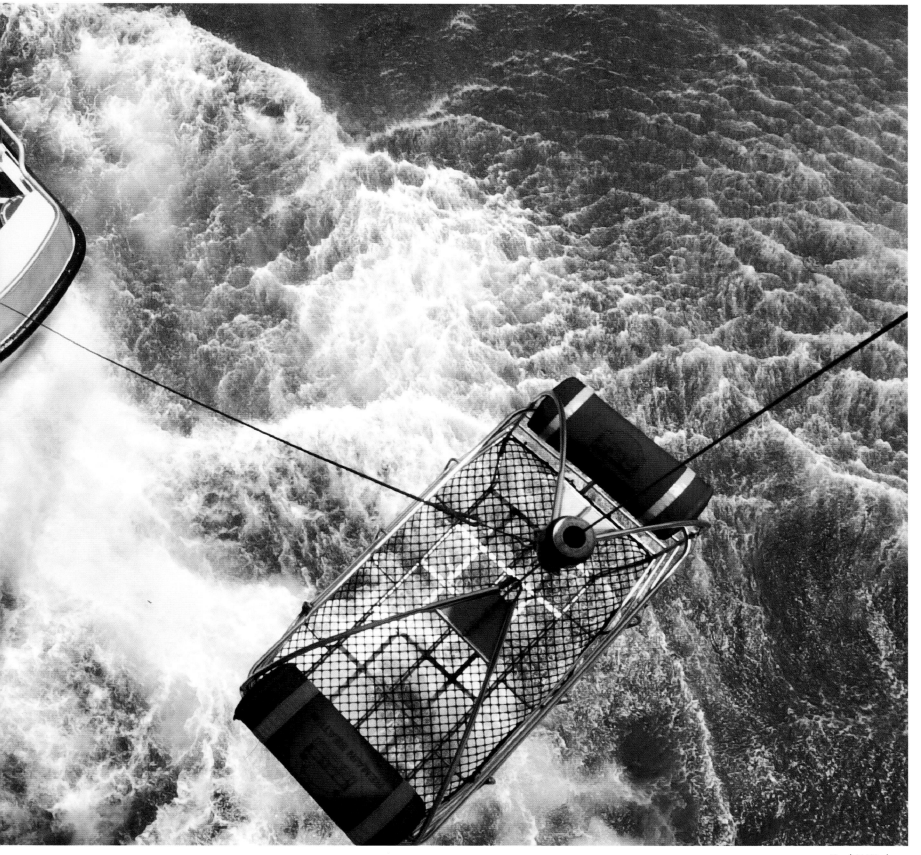

CLEARWATER

A U.S. Coast Guard crew from the Small Boat Station at Sand Key does rescue training. From a hovering Jayhawk helicopter, the crew practices landing a basket onto a vessel at sea.

Photo by Beth Reynolds,
The Photo-Documentary Press, Inc.

OCHOPEE
Environmentalist and landscape photographer Clyde Butcher is well known for his large-format, black-and-white Florida wilderness photos. He occasionally leads groups on "muck-abouts," submerged swamp walks, through Big Cypress National Preserve where he has found many of his pictures.
Photo by Jacek Gancarz, Palm Beach Daily News

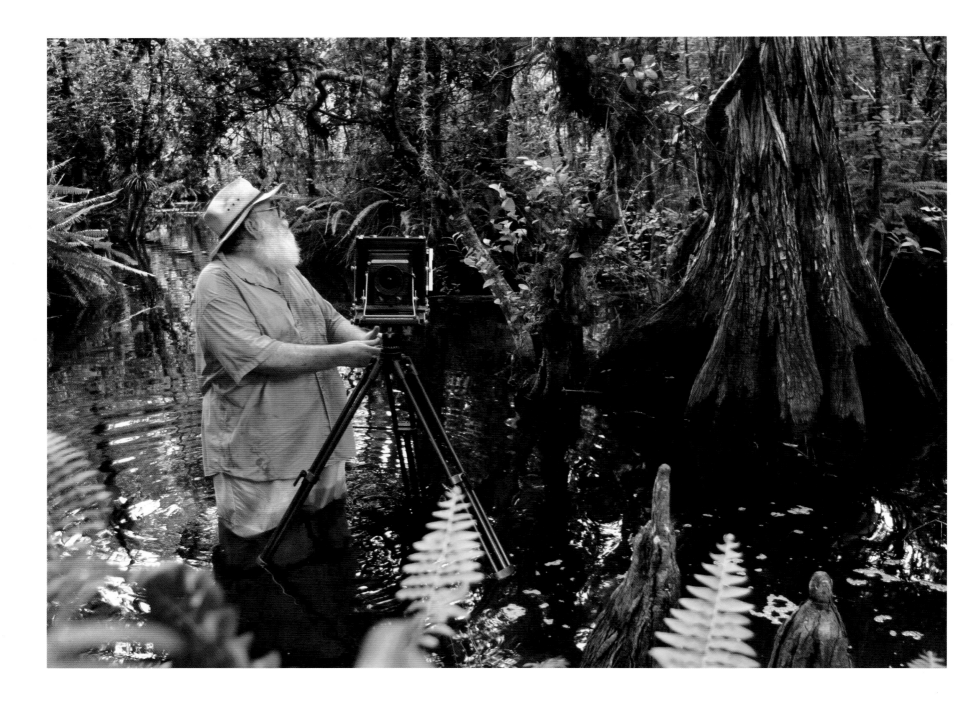

ISLAMORADA

The colors of Lower Matecumbe Key inspire John David Hawver. The clear water amplifies the vivid greens, purples, and blues of the coral reef and beds of sea grass. Hawver has been painting since he was a child and now makes his living from it. "Art was kind of a baby-sitter when I was little," he says.

Photo by Carol Ellis, Little Salt

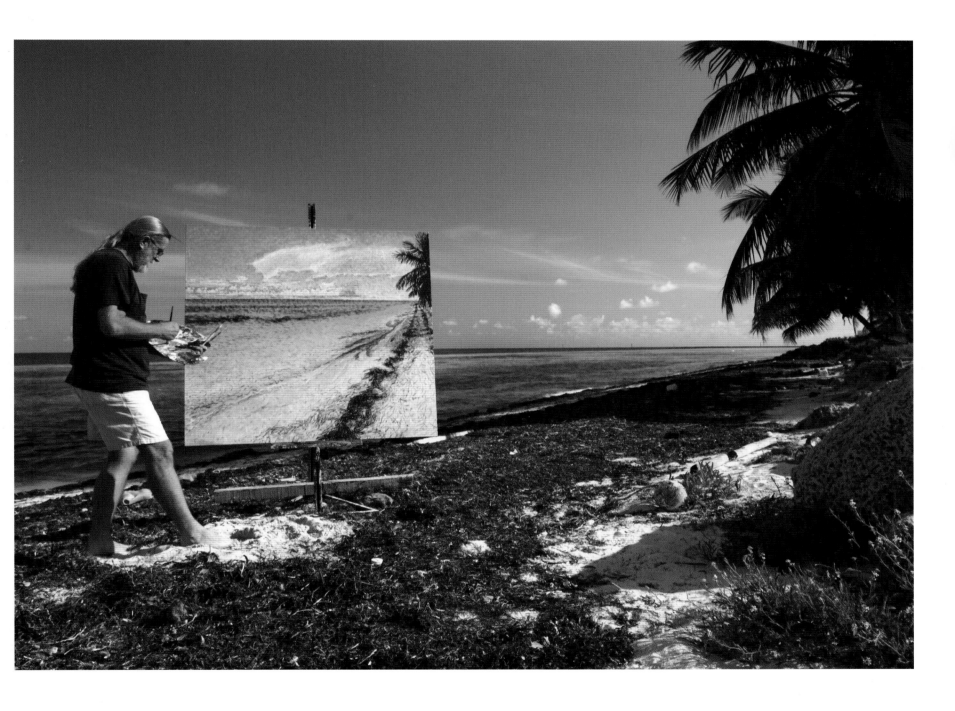

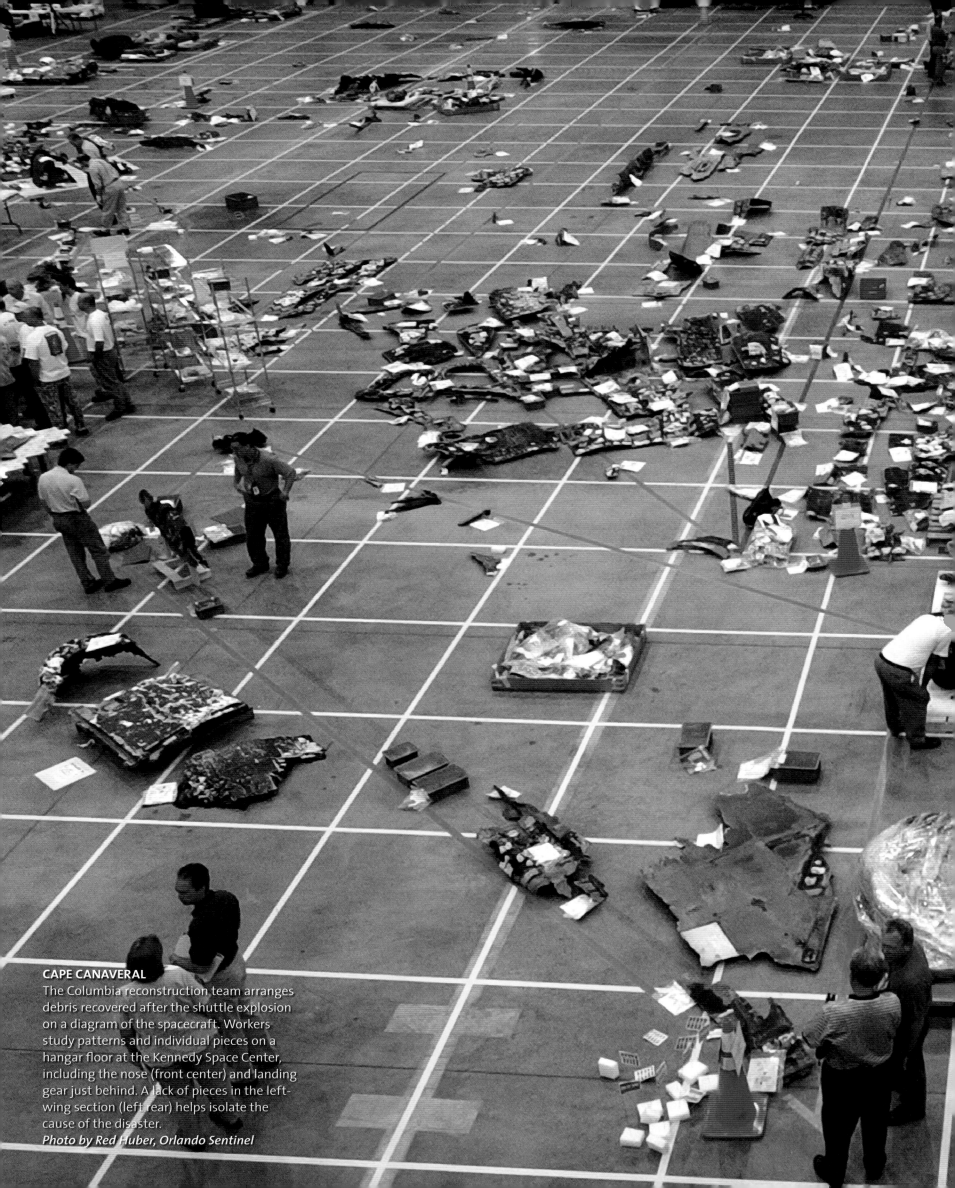

CAPE CANAVERAL
The Columbia reconstruction team arranges debris recovered after the shuttle explosion on a diagram of the spacecraft. Workers study patterns and individual pieces on a hangar floor at the Kennedy Space Center, including the nose (front center) and landing gear just behind. A lack of pieces in the left-wing section (left rear) helps isolate the cause of the disaster.
Photo by Red Huber, Orlando Sentinel

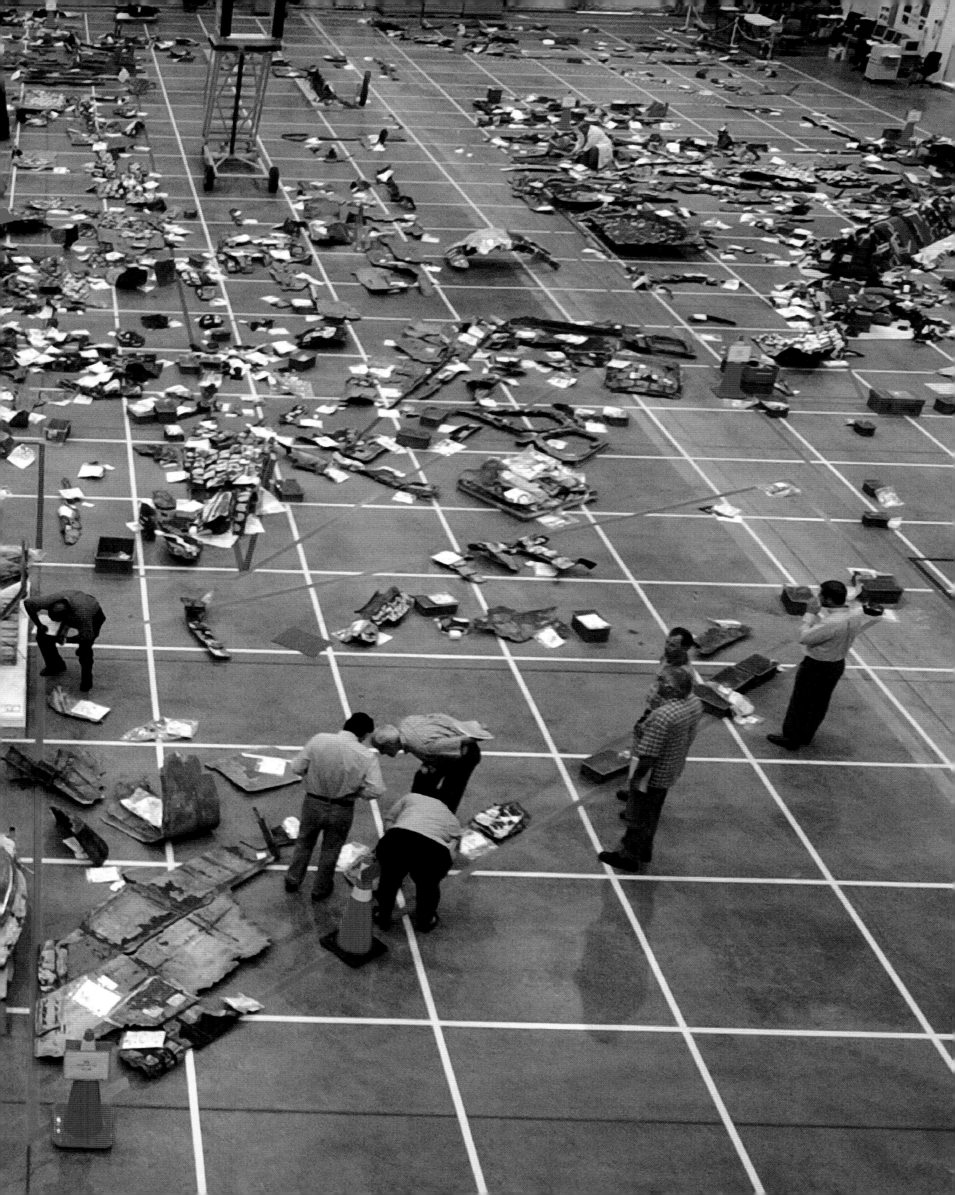

CAPE CANAVERAL
Shift change at Hi-Bay 1, part of NASA's Orbiter Processing Facility where work is being done on the shuttle *Atlantis*. Emblems from past space missions are displayed above the doorway—each mission has a patch designed from suggestions by the astronauts.
Photos by Red Huber, Orlando Sentinel

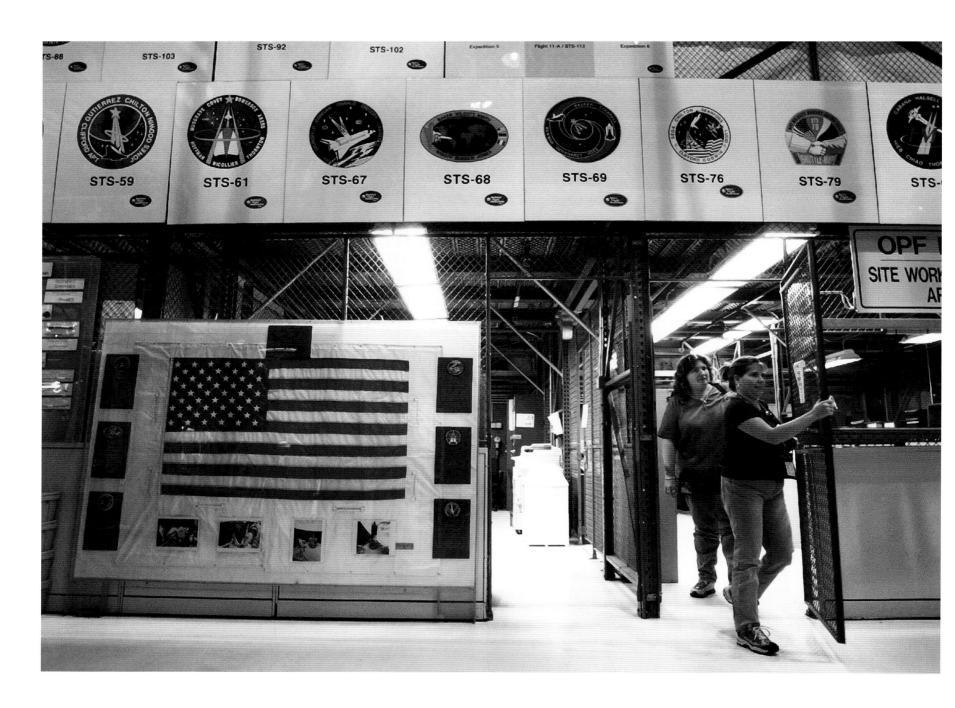

Technicians Dan Cochran and Nancy Long prefit a heat tile replacement under the right wing of space shuttle Endeavour for United Space Alliance, a shuttle processing contractor.

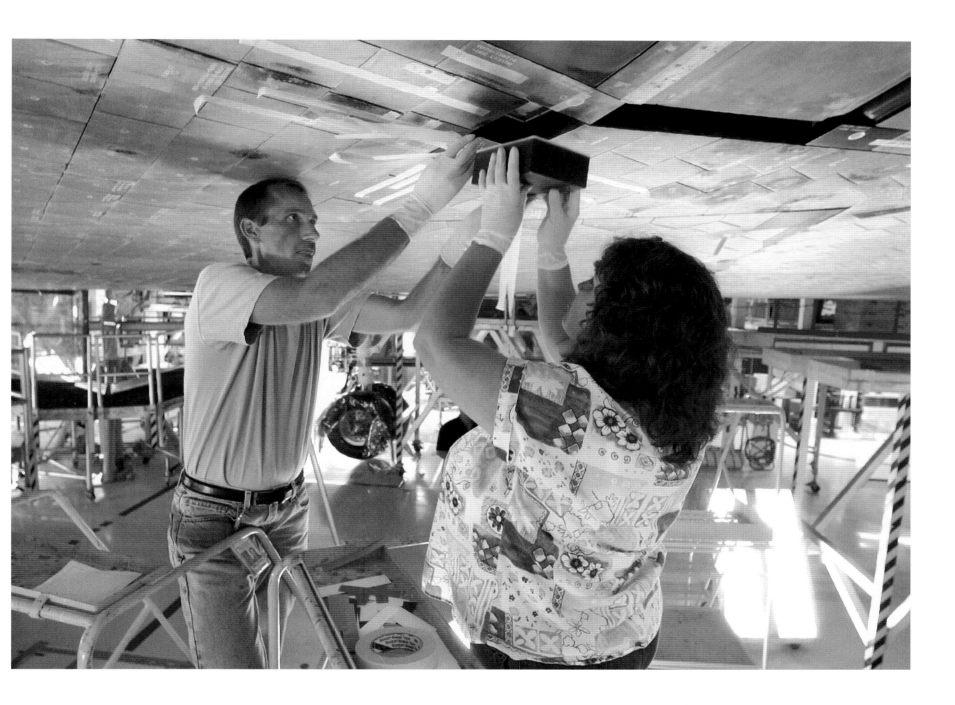

JACKSONVILLE

When Charles Lovelady (left) started working at *The Florida Times Union* as an apprentice pressman in 1972, a single letterpress printed the daily paper. Both technology and Lovelady have advanced. Now night manager on the pressroom floor, he examines pages coming off one of the four offset presses that run 24/7.
Photos by Jon M. Fletcher,
The Florida Times-Union

JACKSONVILLE

Larry Steele drives up to 100 miles during his graveyard shift delivering *The Florida Times-Union*. "I drive all over the Jacksonville area—Gateway, Orange Park, Centerpoint, Beacon, Kernan—you name it, I've driven through it," says Steele.

JACKSONVILLE

Stacked up four-stories tall, the presses spew out 60,000 newspapers every hour on a clamp conveyer system. "Margin man" Rip Baker checks the vertical and horizontal margins during a final press run, just after 1 a.m.

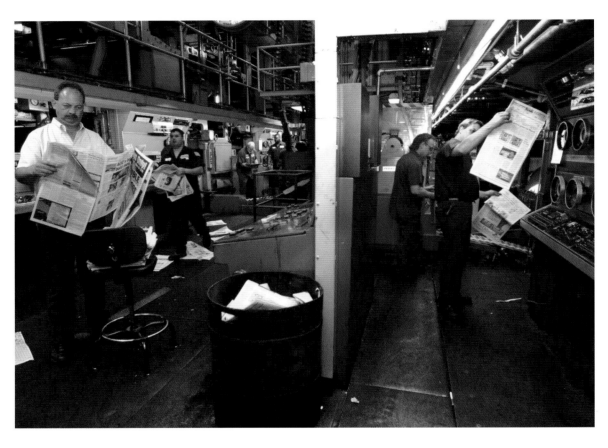

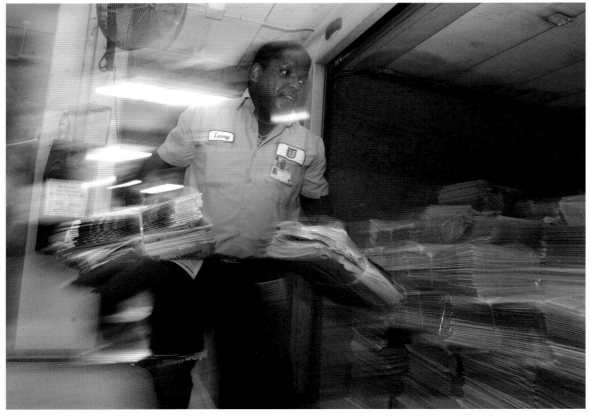

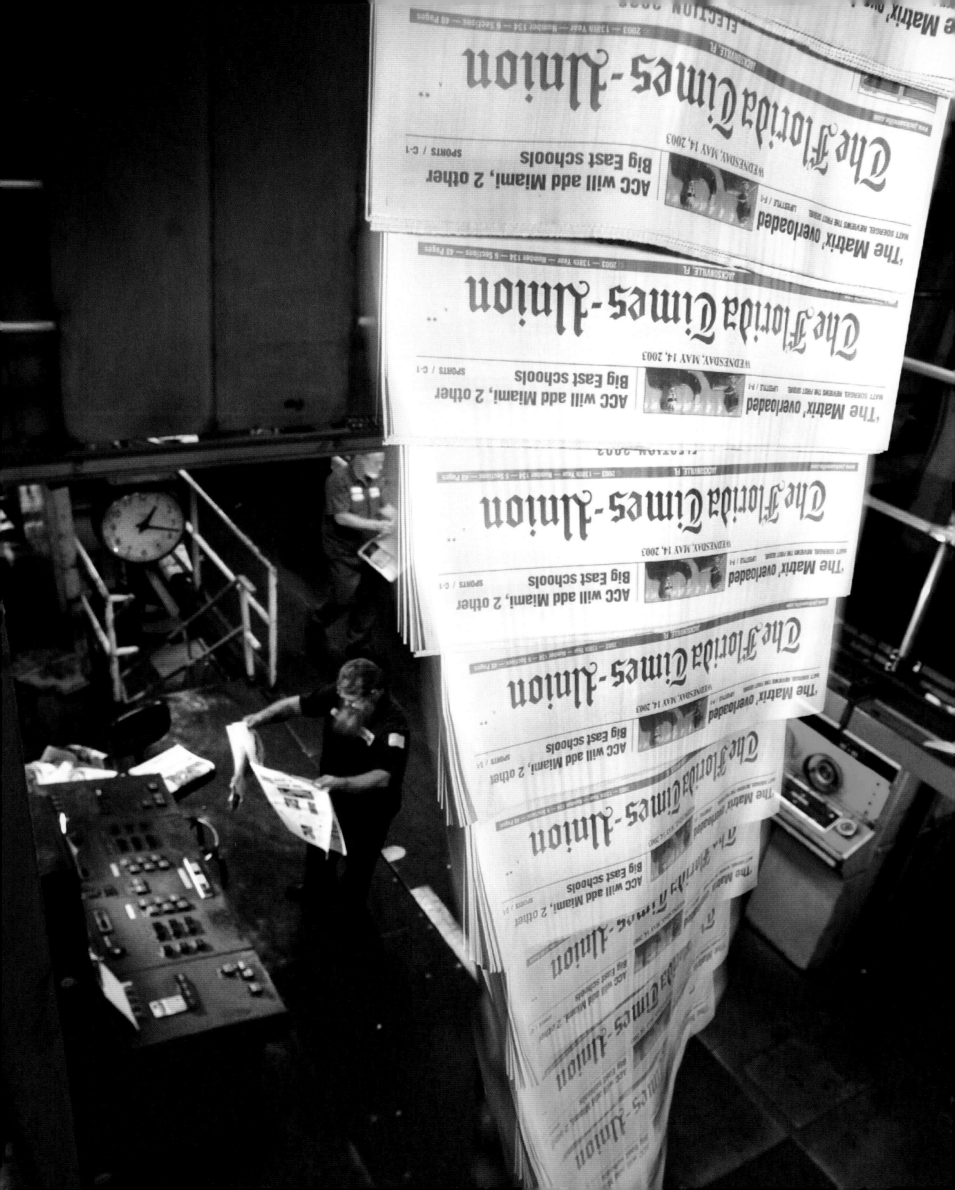

CORAL SPRINGS
Golf ball recycler Douglas Bounassi exits a water hazard at Broken Woods Country Club, one of several courses where he has contracts. Bounassi recovers, reconditions, and sells 1.5 to 2 million balls per year. They run the gamut from "gator droppings"—beat up balls people buy for 5 cents—to mint-condition Titleists that can fetch $2.00.
Photo by David Spencer, The Palm Beach Post

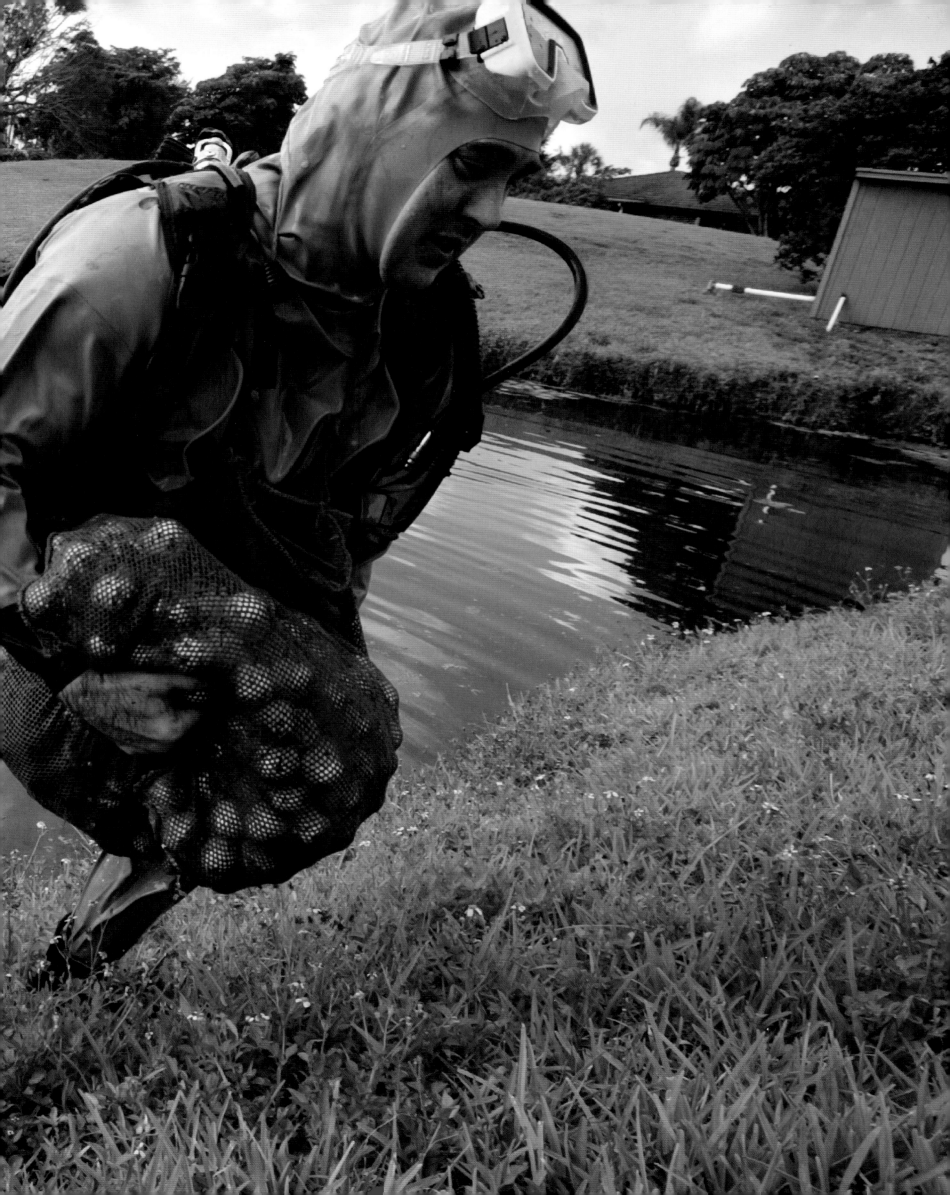

JACKSONVILLE

With one patient who'd been attacked with a golf club, another who'd fallen off a bridge, and a third who'd been hit by a car, doctors at Shands Hospital Trauma Center keep busy the evening of May 16. Third-year medical student Sharon Bassi and first-year resident Michael Moen suture lacerations on a woman thrown from her car, while custodian Modenna Jackson cleans up.

Photos by Jon M. Fletcher,
The Florida Times-Union

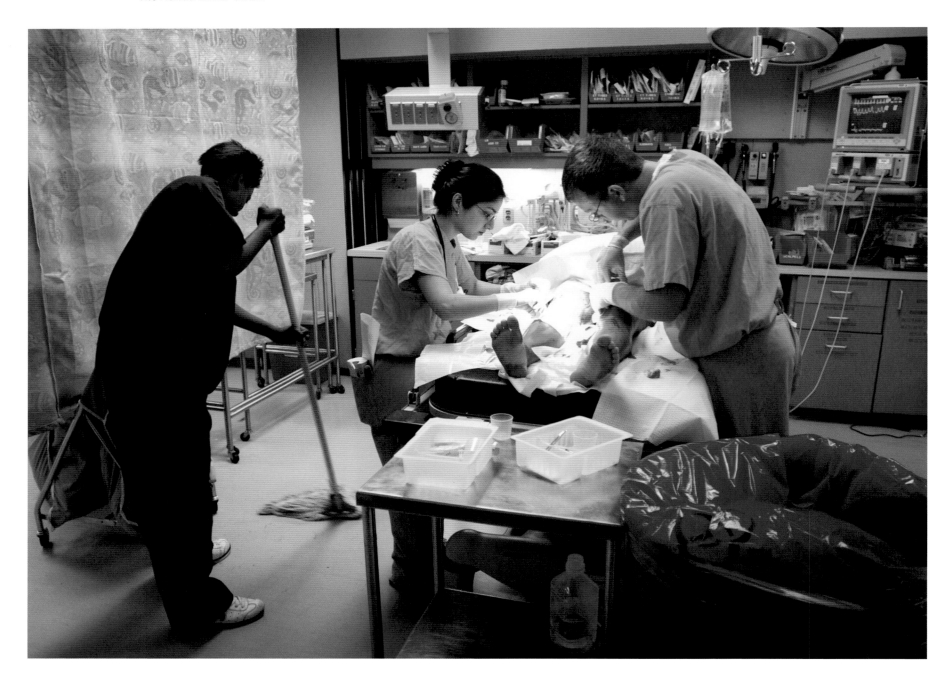

JACKSONVILLE

Third-year resident Christopher T. Johnson, 30, tries to hold himself together at the end of his 24-hour shift. Johnson, who had just witnessed the death of a gunshot victim, works on patients with head and neck traumas. He is preparing for a career in maxillofacial surgery and works up to 110 hours each week as a resident doctor.

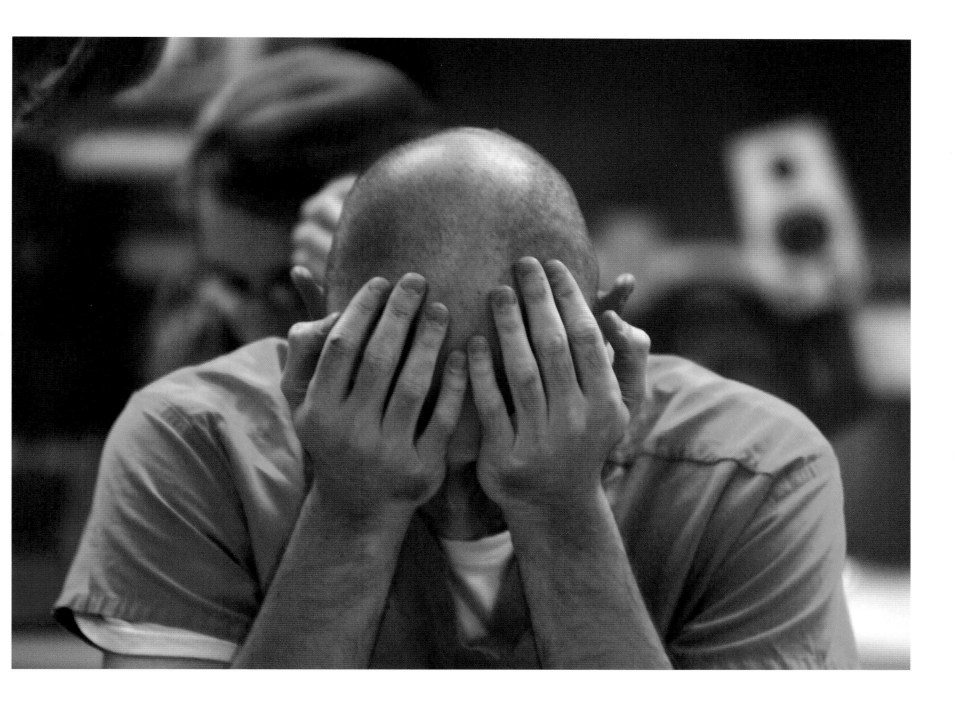

MONTICELLO
Archie Huggins, 84, is not sure exactly when his family acquired their farm, but he knows he was born there and his parents were, too. He raises chickens and a few hogs. Of his three mules, two are too stubborn to plow when it's time to plant the okra and butter beans.
Photo by Craig Litten, Tallahassee Democrat

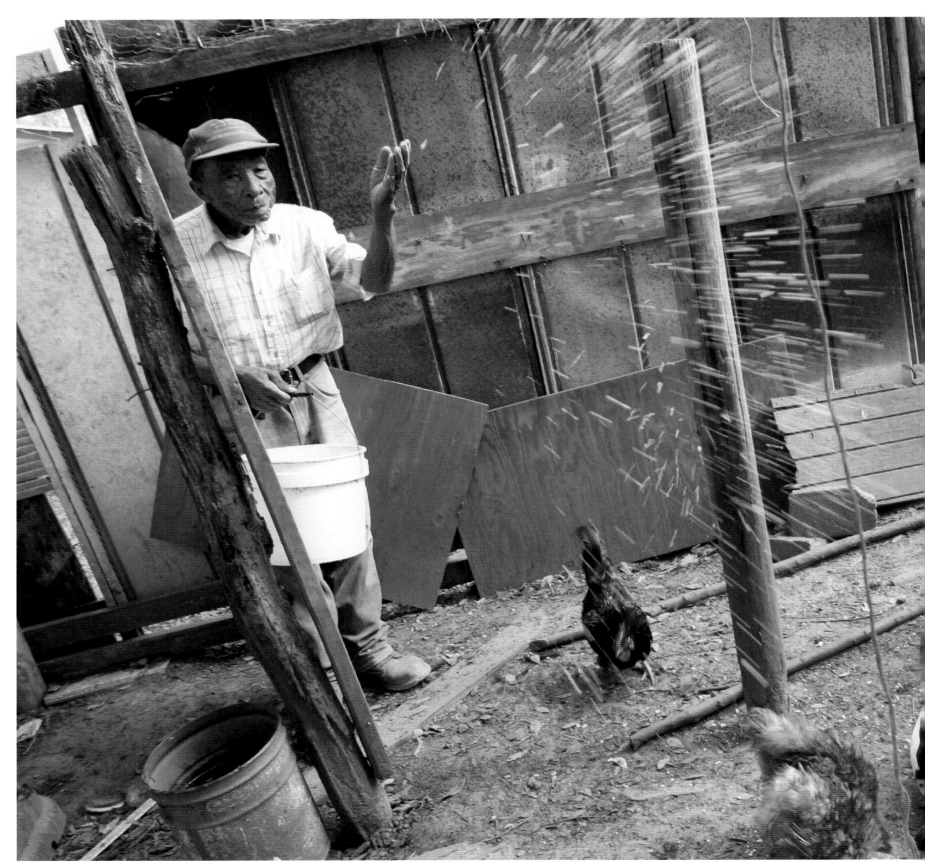

HAINES CITY

In 2002, 230 million 90-pound boxes of oranges were produced in Florida. A tiny fraction of the 2003 crop weighs down a parked truck on Highway 27. The main North-South route through central Florida, this highway is home to a myriad of mom-and-pop stands that sell juice, marmalade, and other citrusy products.

Photo by Ben Van Hook

CAPE CORAL

Lisa Mottla, her son Tyler, and boyfriend Dale Mathewson stake out a spot along Pine Island Road to sell melons off the back of a Ford truck. Their seedless variety was grown in Arcadia, along the Caloosahatchee River. With two growing seasons, Florida produces more watermelons than anyplace else in the nation.

Photo by Lexey Swall, Naples Daily News

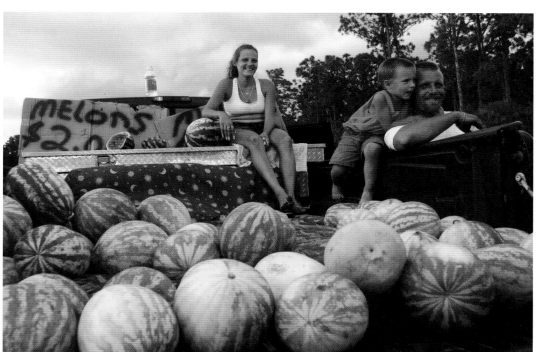

ALACHUA

Gordon Cates kisses snakes, lots of them. Kissing 10 Monocle cobras and a 15-foot king cobra consecutively on September 25, 1999, earned him a place in that year's *Guinness Book of World Records*. Cates says his goal is to "change people's fear of snakes. They're the most humane animals around. They only kill for two reasons—food or defense."
Photo by Jon M. Fletcher, The Florida Times-Union

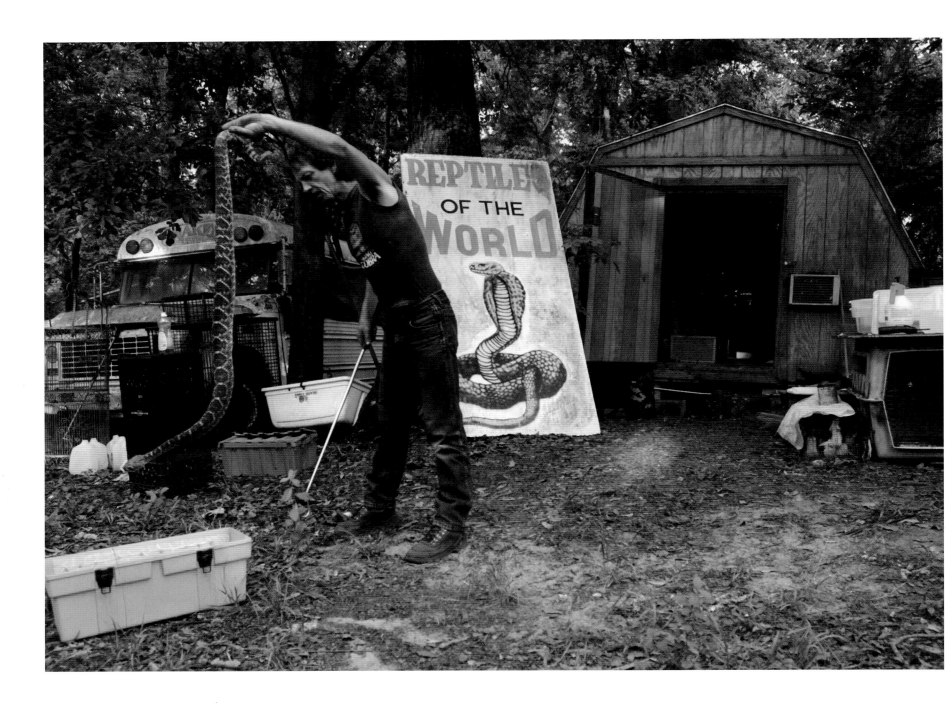

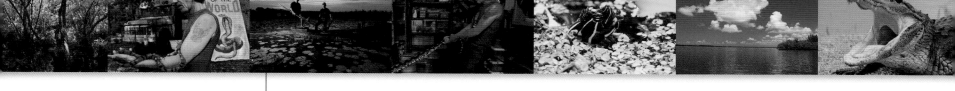

TALLAHASSEE

State-licensed alligator hunter Tony Hunter (left) controls "nuisance gators" that show up in yards, garages, or swimming pools. His son Michael sometimes helps dart and coax the reptiles to the boat. If no zoo needs one, Hunter kills it and sells the meat and hides. In the business for 26 years, Hunter says, "I still have all my pieces and no scars."

Photo by Craig Litten, Tallahassee Democrat

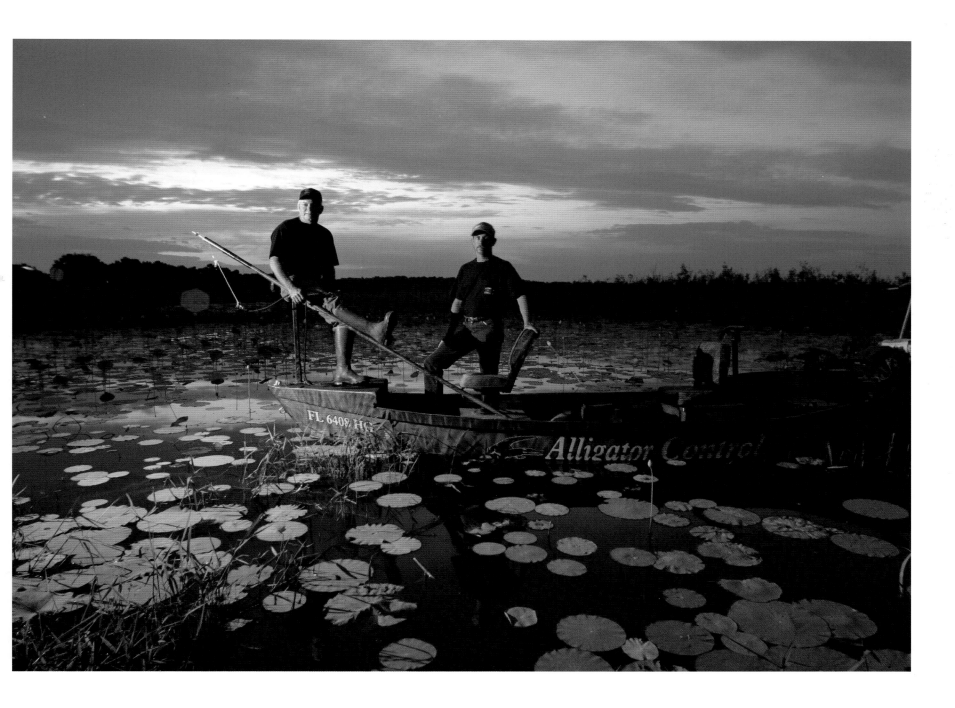

BIG PINE KEY

When a pod of 28 pilot whales beached themselves on Big Pine Key in April, the Marine Mammal Conservancy managed to move seven of the animals into a canal for rehab. This 13-year-old, 745-pound female was one of five who survived the ordeal. In spite of severe sunburn, pneumonia, and scoliosis, she was released to the open ocean some months after recovery.
Photo by Carol Ellis, Little Salt

HOMOSASSAS SPRINGS

Most Floridians love manatees, but some speed boaters resent the idle-speed zones that protect the slow-moving animals from collisions. These "sea cows," distantly related to elephants, ventured into the sea 45 million years ago and contributed to mermaid lore. Upon viewing a manatee, Christopher Columbus wrote, "These mermaids were not quite so handsome as they had been painted."
Photo by John Moran

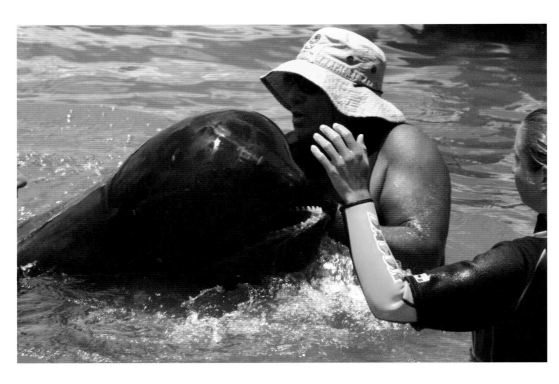

FORT PIERCE

At Tigers for Tomorrow, a last-stop animal shelter specializing in exotic cats, founder and president Sue Steffens feeds Blake, the 4-month-old off-spring of two of the shelter's tigers. In Florida, where there are 4,390 registered exotic pets, one of Steffens's goals is to educate people about the dangers and difficulties in domesticating wild animals.
Photo by Bruce R. Bennett

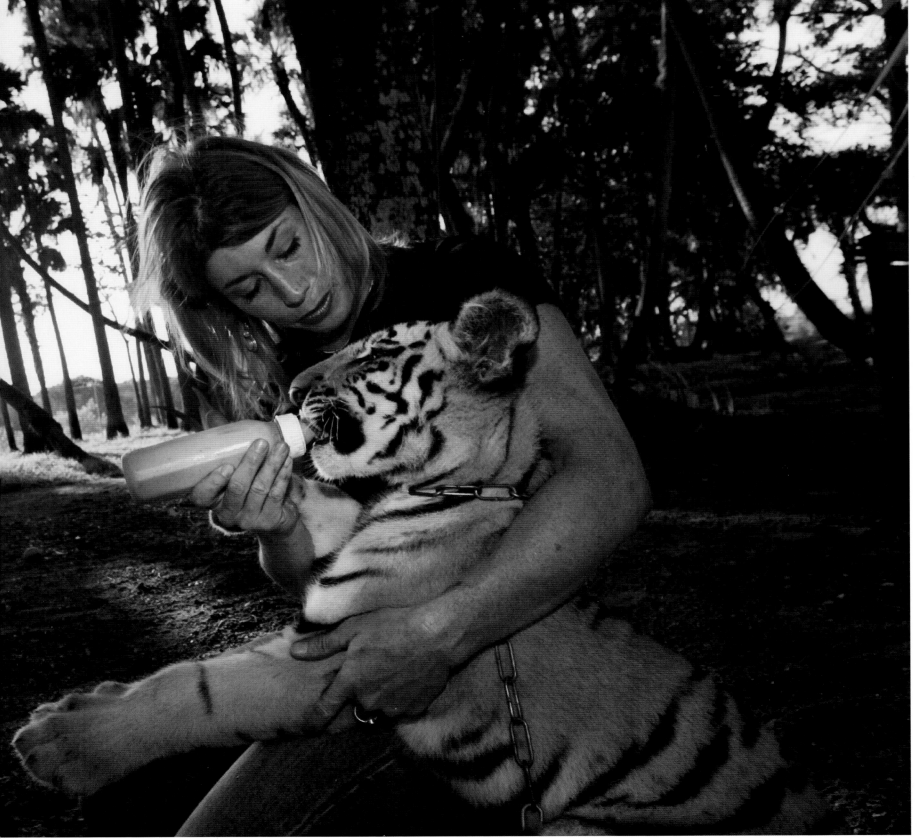

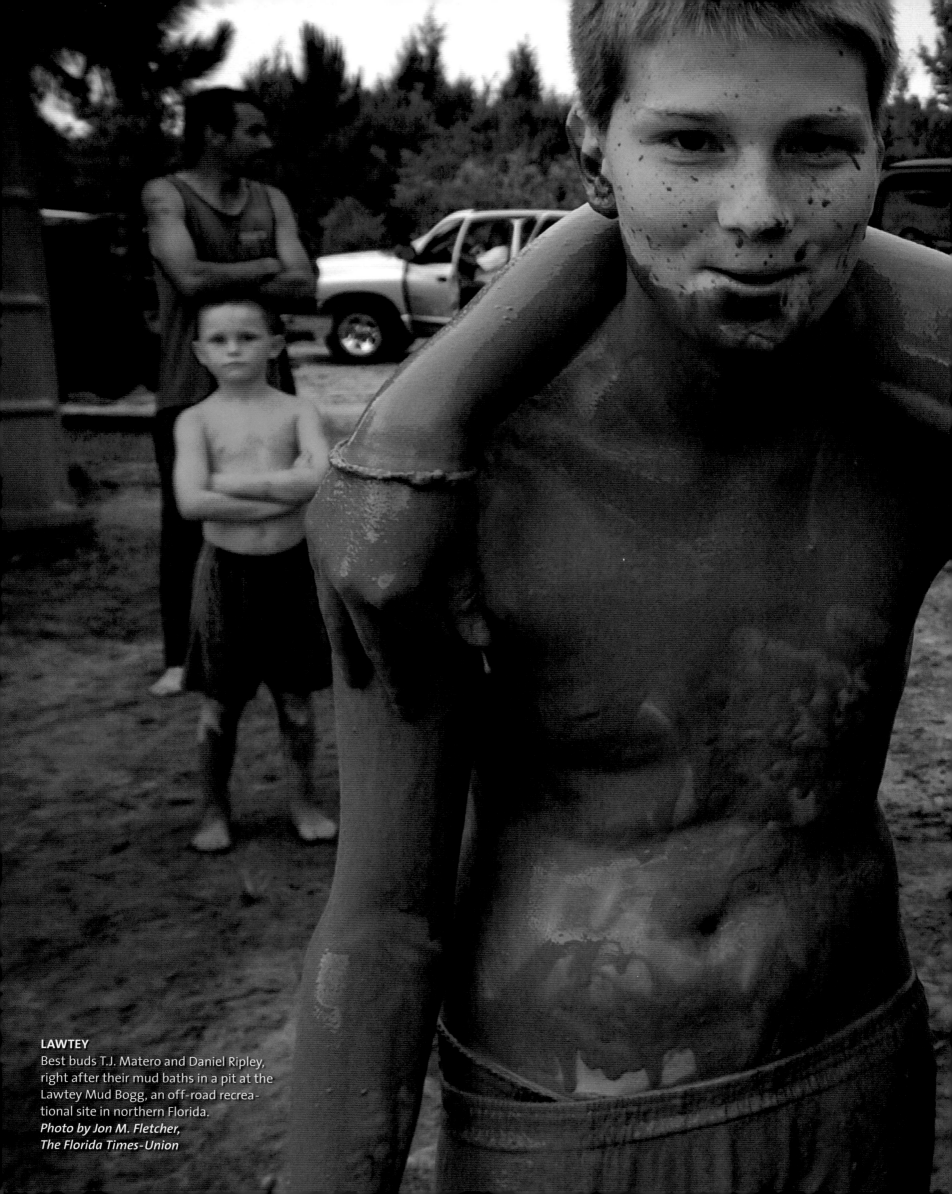

LAWTEY
Best buds T.J. Matero and Daniel Ripley, right after their mud baths in a pit at the Lawtey Mud Bogg, an off-road recreational site in northern Florida.
Photo by Jon M. Fletcher,
The Florida Times-Union

Florida At Play

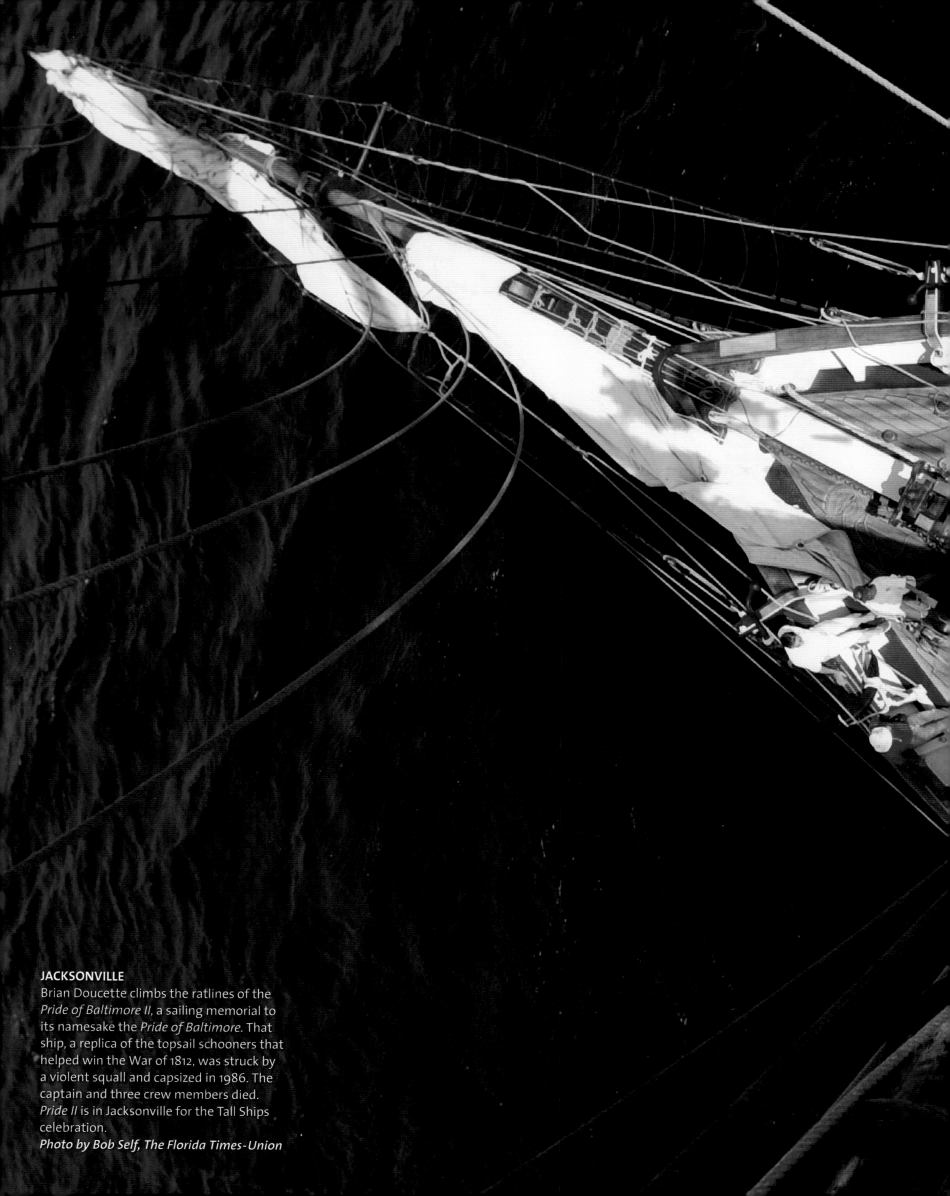

JACKSONVILLE
Brian Doucette climbs the ratlines of the
Pride of Baltimore II, a sailing memorial to
its namesake the *Pride of Baltimore*. That
ship, a replica of the topsail schooners that
helped win the War of 1812, was struck by
a violent squall and capsized in 1986. The
captain and three crew members died.
Pride II is in Jacksonville for the Tall Ships
celebration.
Photo by Bob Self, The Florida Times-Union

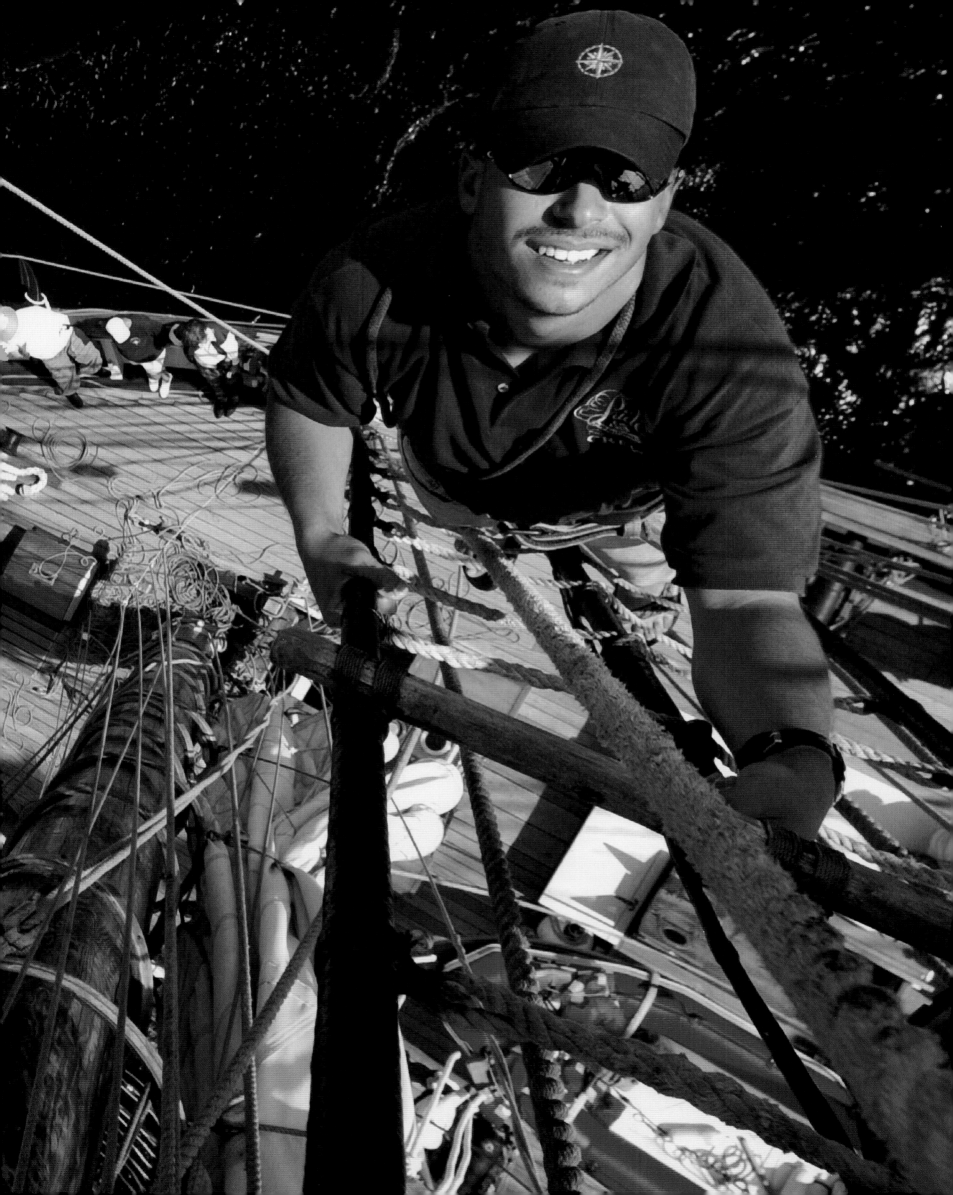

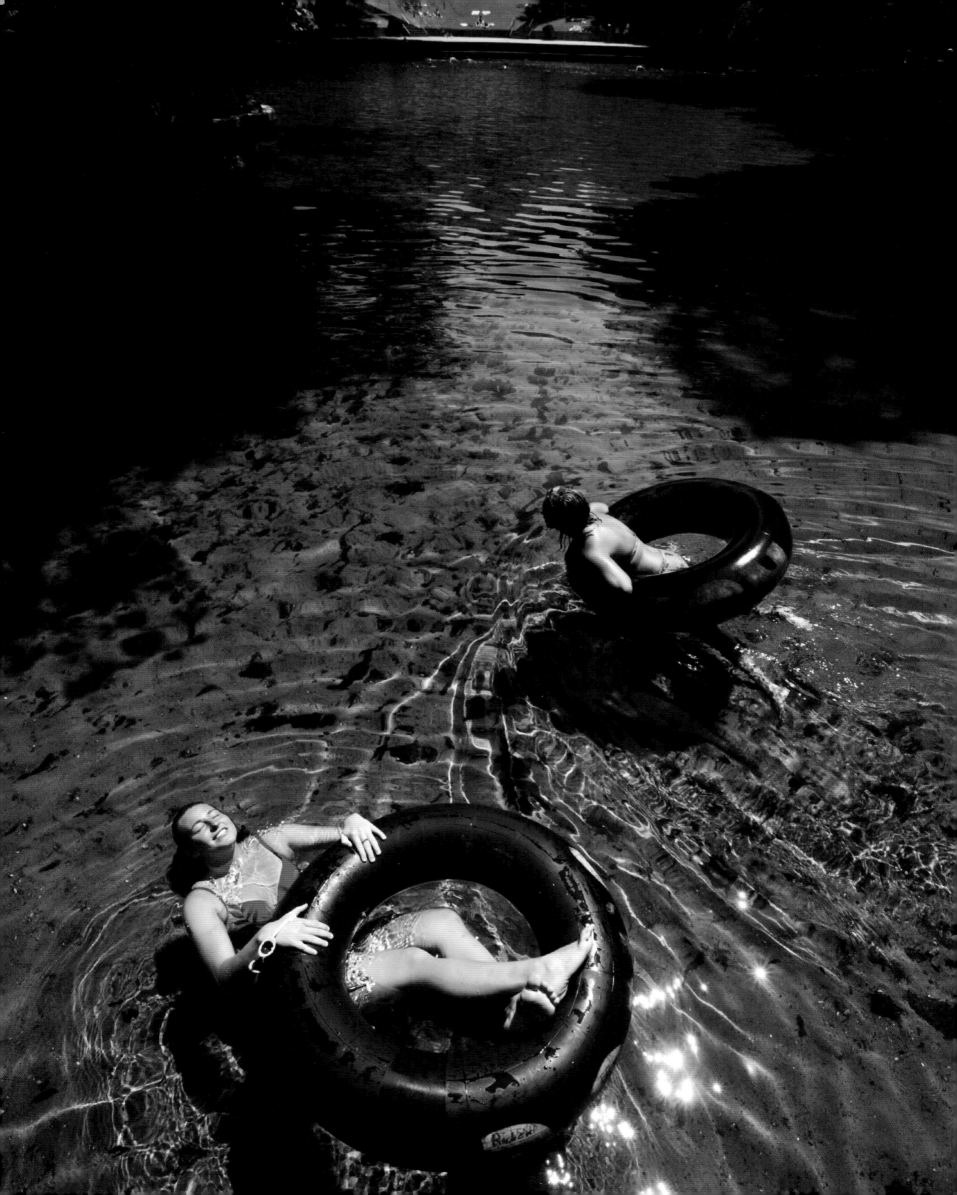

LONGWOOD
The heat is off: Brandy Misorek, left, and friend Janine Thompson seek refuge from the 95-degree heat in the 72-degree water of Wekiwa Springs. Wekiwa is a Creek Indian word meaning "spring of water" or "bubbling water."
Photo by Ben Van Hook

GAINESVILLE
At sunrise, two eights from Gainesville Area Rowing barely agitate the mirrored surface of Newnan's Lake. A few days earlier, the women's varsity crew, foreground, captured third place in the Florida Scholastic Rowing Association's State Championship Regatta.
Photo by John Moran

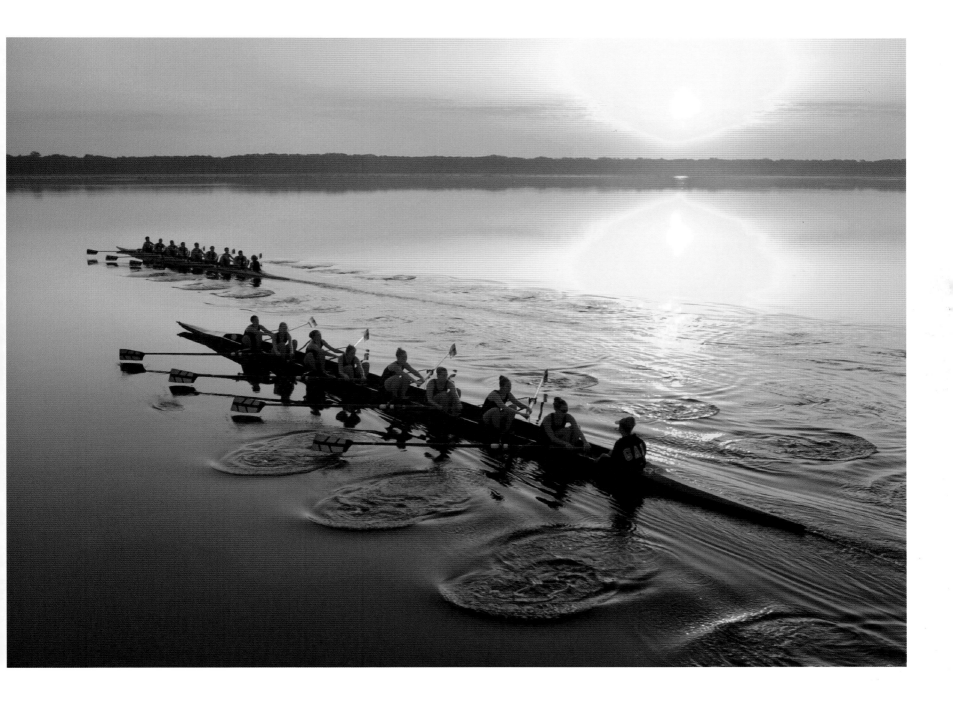

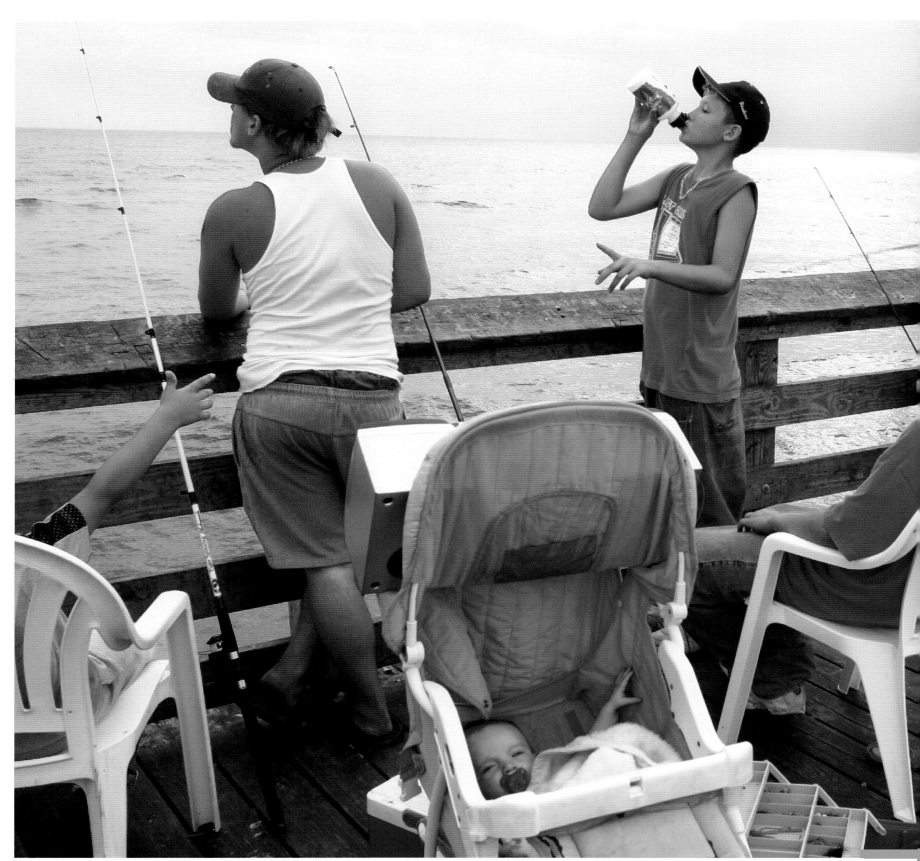

ISLAMORADA

Captain Ron Wagner lands a 125-pound tarpon for Pip Hall, a British angler. Hall fought the fish for two hours right through the old arches of the Channel 2 bridge. After the sporting match of woman versus fish, the contender with gills is released to find its way home.
Photo by Carol Ellis, Little Salt

BARRACUDA KEYS

Oooh, barracudaahhh: Prior to throwing it back into the shallows of the Gulf's backcountry, a sport fisherman holds up his fair-sized barracuda for a trophy photo. The island in the background is one of the Barracuda Keys.
Photo by Rob O'Neal

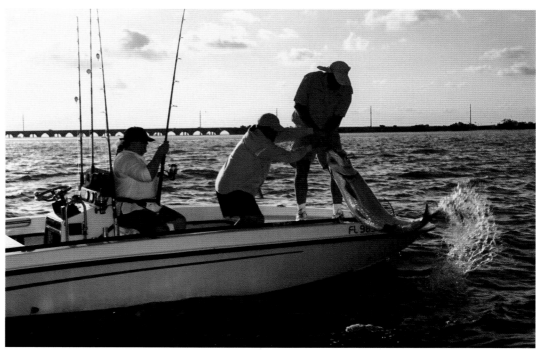

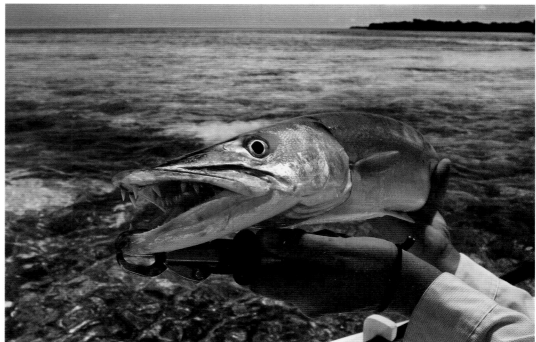

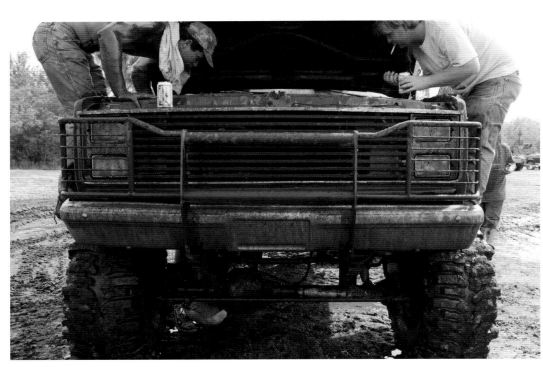

LAWTEY

Along with 200 other off-road enthusiasts, Eric Eddy and Randy Smith maneuver their trucks through the sludgy terrain at Lawtey Mud Bogg every Sunday. With regular mud jams and no official races, mud boggers come for its advertised "clean, dirty fun," not to compete. "It's a part of life, just like hunting," says Eddy. "It's all fun."

Photos by Jon M. Fletcher,
The Florida Times-Union

LAWTEY

Even with their doors removed to increase speed, Ellen and Eddy Cashmore's truck rarely manages to move through the mud at more than 10 miles per hour. For the past two years, the Cashmores have been riding to the bog to play in the muck and marvel at the other modified trucks.

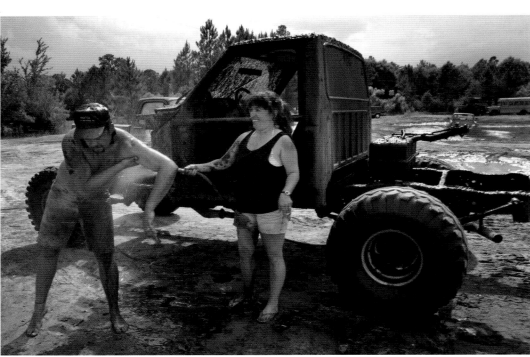

LAWTEY

Kayla Riley, peers out the cab of her dad's truck. "Coming out here is a blast," says Scott Riley, a regular at the bog. "It's full of horsepower and mud slinging. It really gets your heart going."

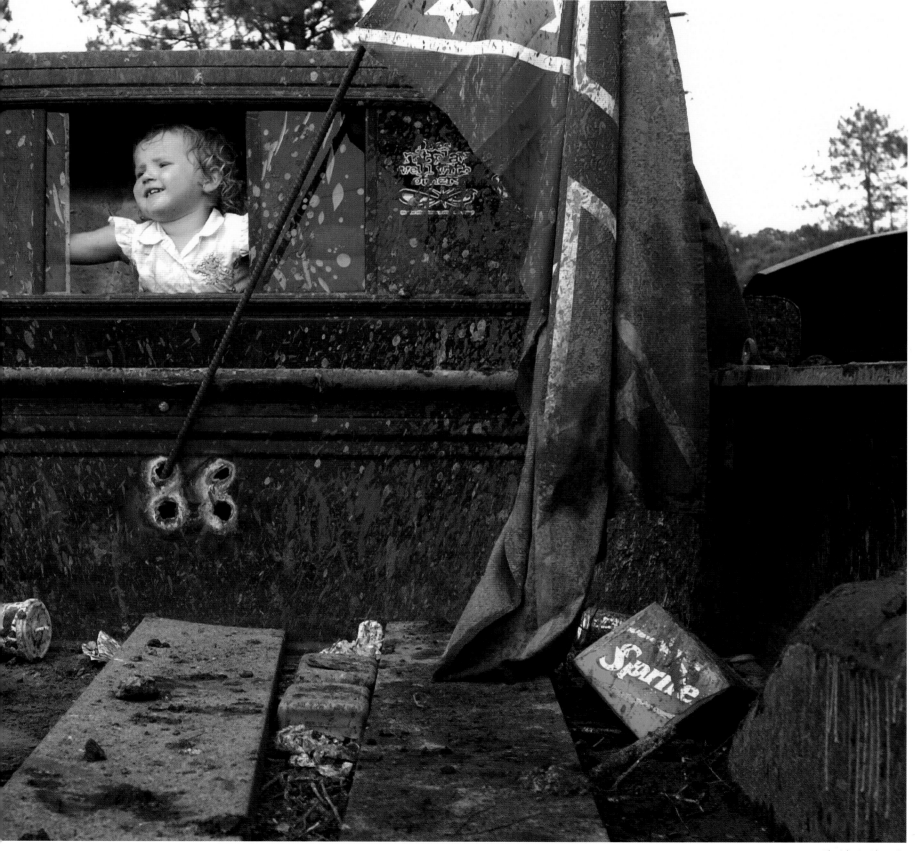

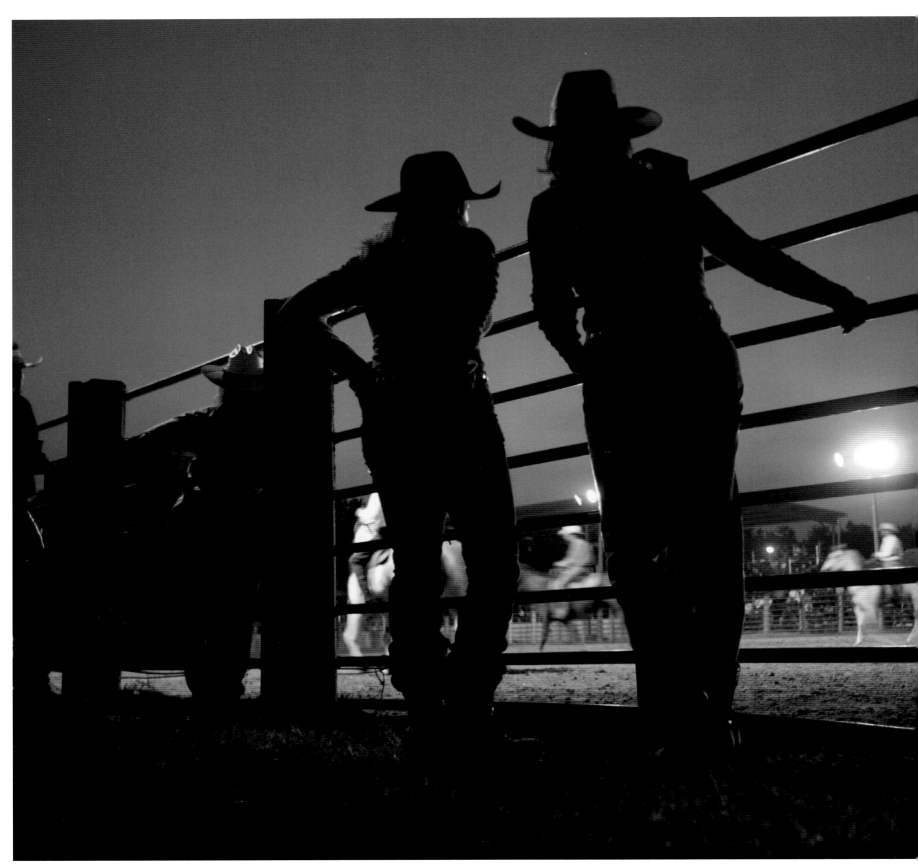

KISSIMMEE
The Friday night rodeo at the Kissimmee Sports Center has its roots in the local cattle industry, which began in the late 1800s. Cowboys needed to be skilled ropers because of the area's paletto-studded swampy terrain. The rodeo started as a friendly competition between local ranch hands.
Photo by Ben Van Hook

BRADENTON

It wasn't her footwork that got line dancer Jennifer Johnson noticed at the Joyland IV Country Music Night Club. It was her hat. Purchased that night for $4, the pink head-gear caught the eye of a woman who offered Johnson $20 for it. No deal. "I love glitter," says the University of South Florida student.
Photo by Chip Litherland, Sarasota Herald-Tribune

MIKESVILLE

Retired U.S. Marine Del Thayer plays blue-grass fiddle at a Saturday night jam he hosts in his barn turned music hall.
Photo by Jon M. Fletcher,
The Florida Times-Union

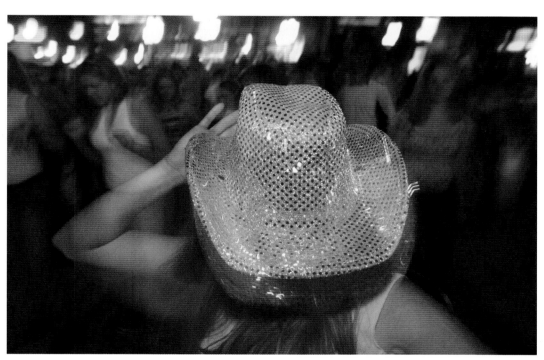

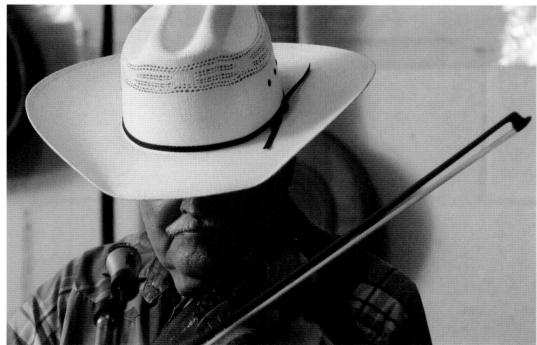

EAST FORT MYERS

Three times a week, Timothy Spiller practices roping steer for state rodeo competitions. Currently ranked number one in team roping in Florida, Timothy, 14, plans to make a living on the professional rodeo circuit.
Photo by Dan Wagner

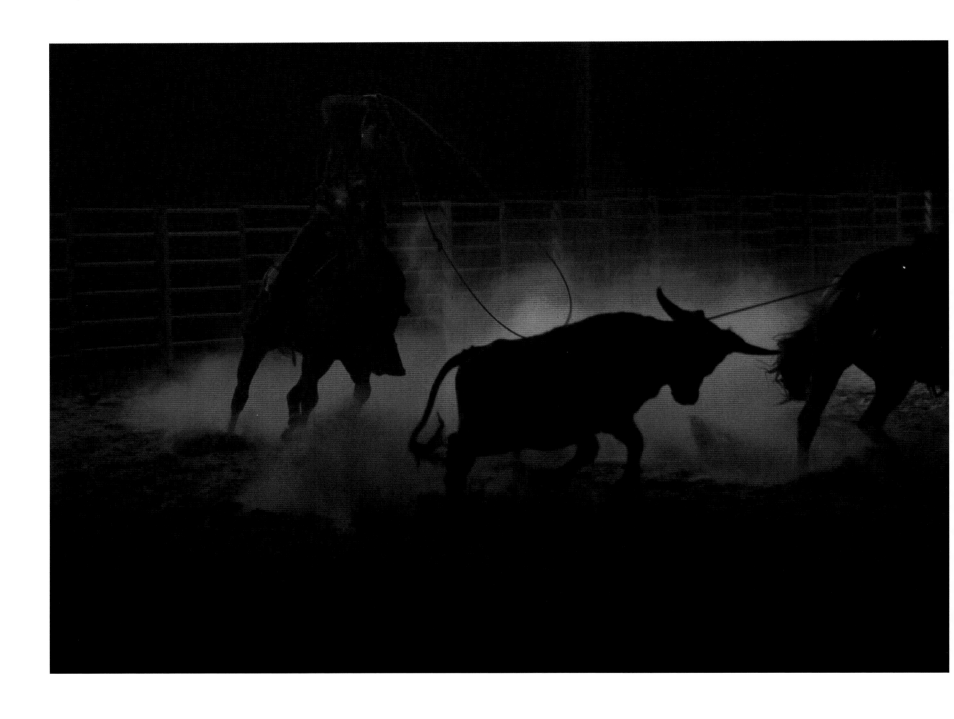

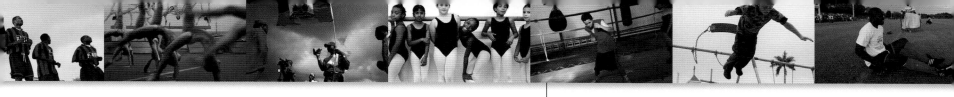

The Leprechaun Gym in Miami's Wynwood
neighborhood has been a lucky charm for Luis
Almendares. The 13-year-old pugilist is a Golden
and Silver Gloves boxing champion.
***Photo by Angel Valentin,
South Florida Sun-Sentinel***

CARRABELLE

Known as Florida's forgotten coast, this stretch of beach grass and gravel along St. George Sound sees fewer tourists than the white sand strips of other parts of the Gulf Coast. It's reminiscent of the outer keys in the 1960s: sand-dusted roads and room to set up a solitary tent.

Photo by Craig Litten, Tallahassee Democrat

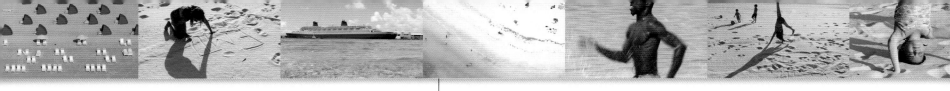

KEY WEST
Fort Zachary Taylor Historic State Park sits on
87 acres at Key West's westernmost reach. In ad-
dition to sporting the best beaches on the island,
old Fort Taylor saw action during both the Civil
War and the Spanish-American War.
Photo by Rob O'Neal

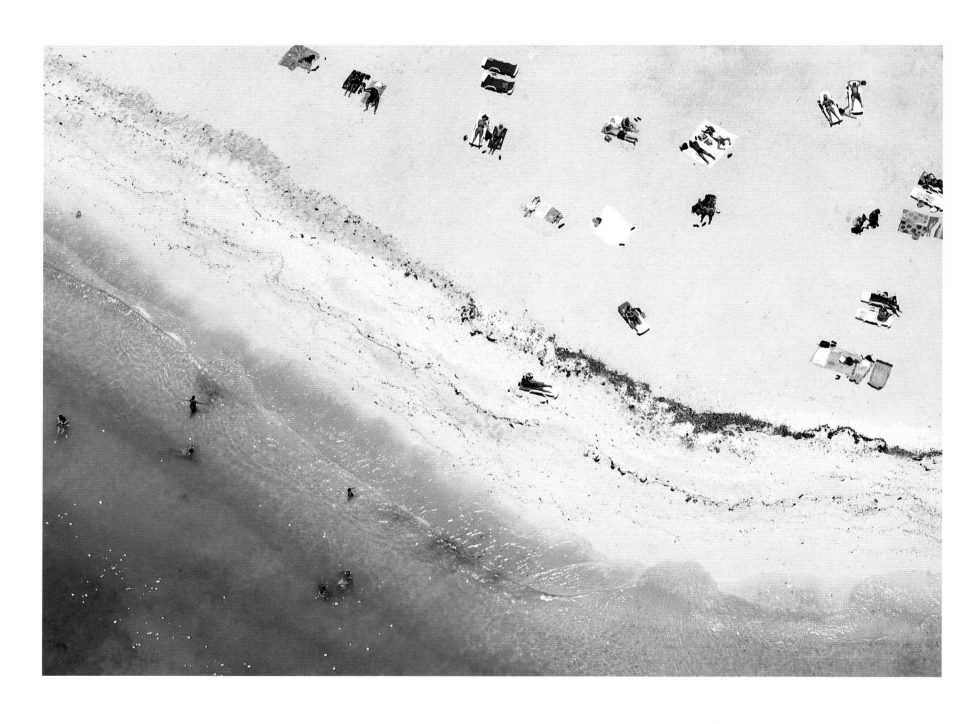

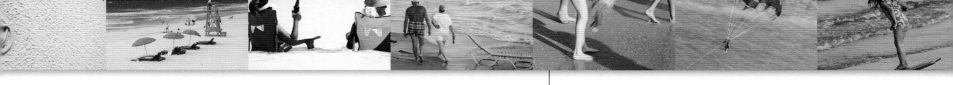

ST. PETE BEACH

Hula boola. The perfect beach attire for low-tide wading: a neon-green grass skirt.

Photo by Beth Reynolds,
The Photo-Documentary Press, Inc.

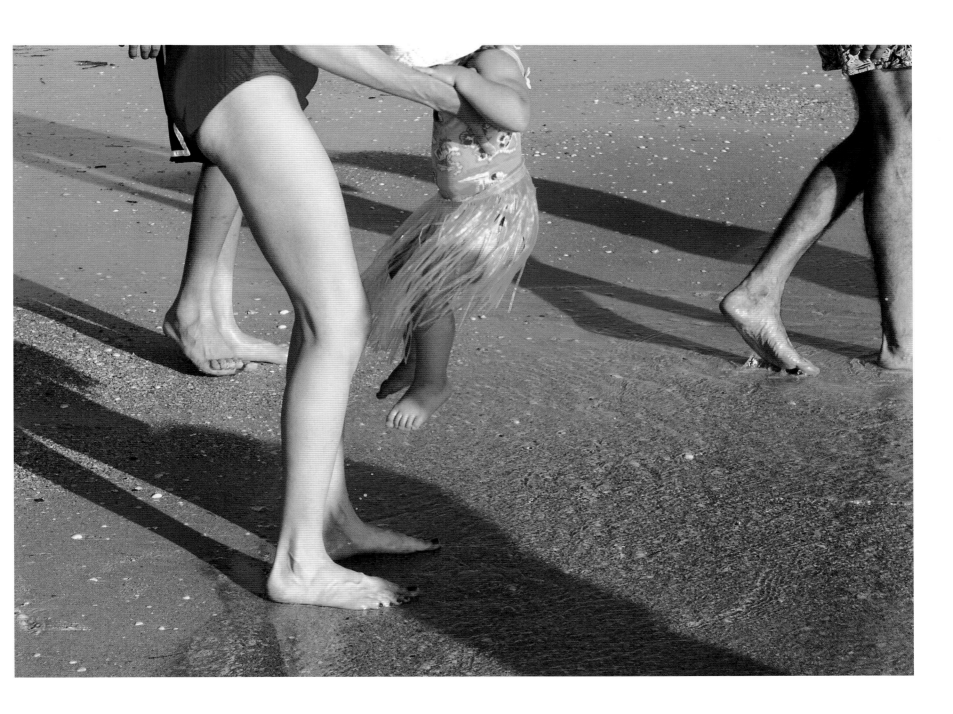

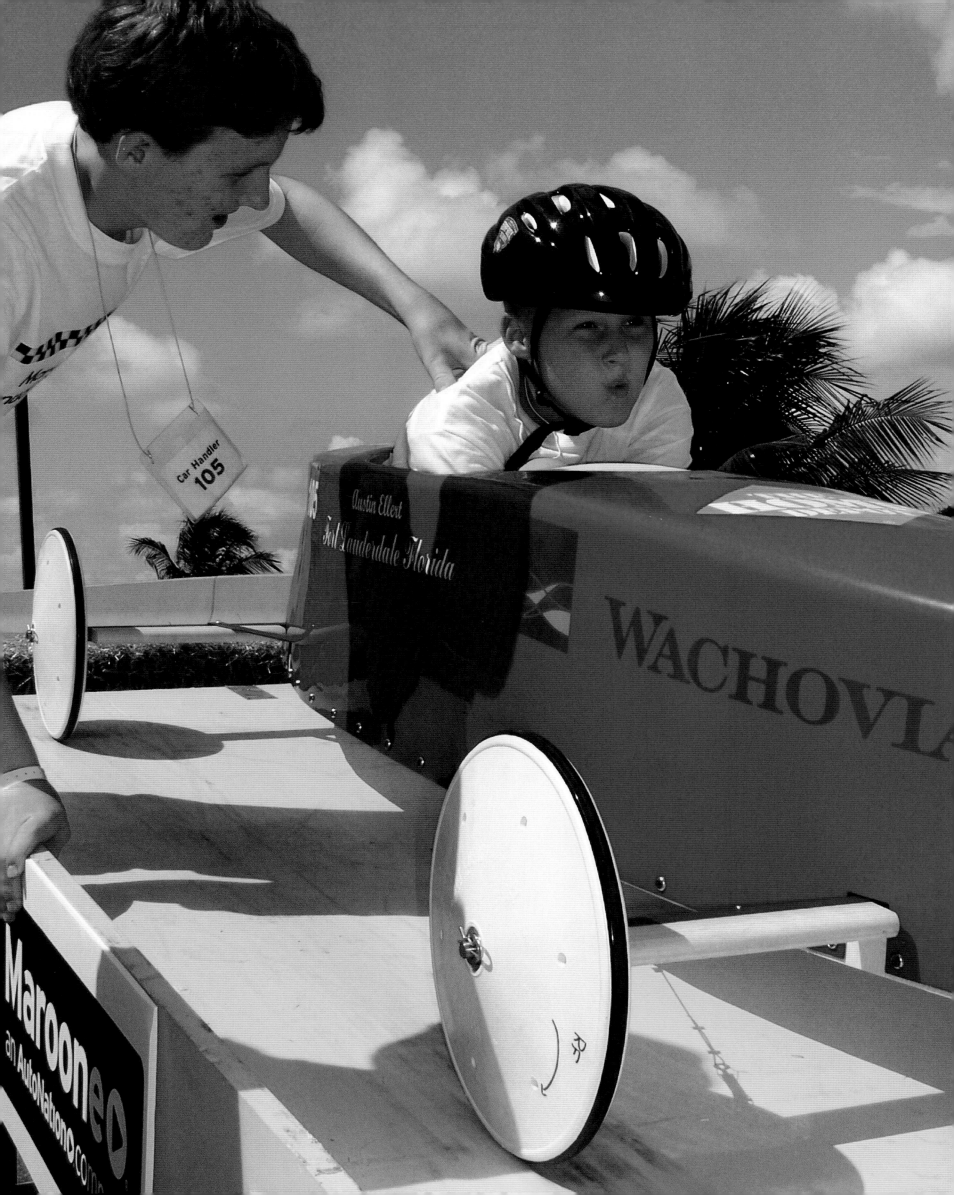

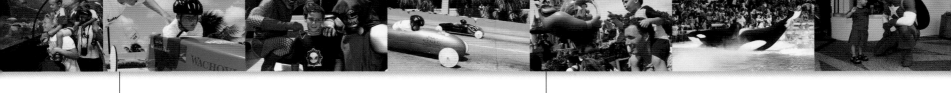

FORT LAUDERDALE
Austin powered: Austin Ellert gets last-minute advice from brother Will before competing in a Soap Box Derby qualifying race. The YMCA-sponsored event took place on the Andrews Avenue Bridge. First-timer Austin finished eighth out of 28.
Photo by Lori Bale

LAKE BUENA VISTA
Mark Koeller and son Sean of Alameda, California, catch the Share a Dream Come True Parade at Walt Disney World as it wends its way through the heat and humidity between Frontierland and Main Street USA.
Photo by Preston Mack

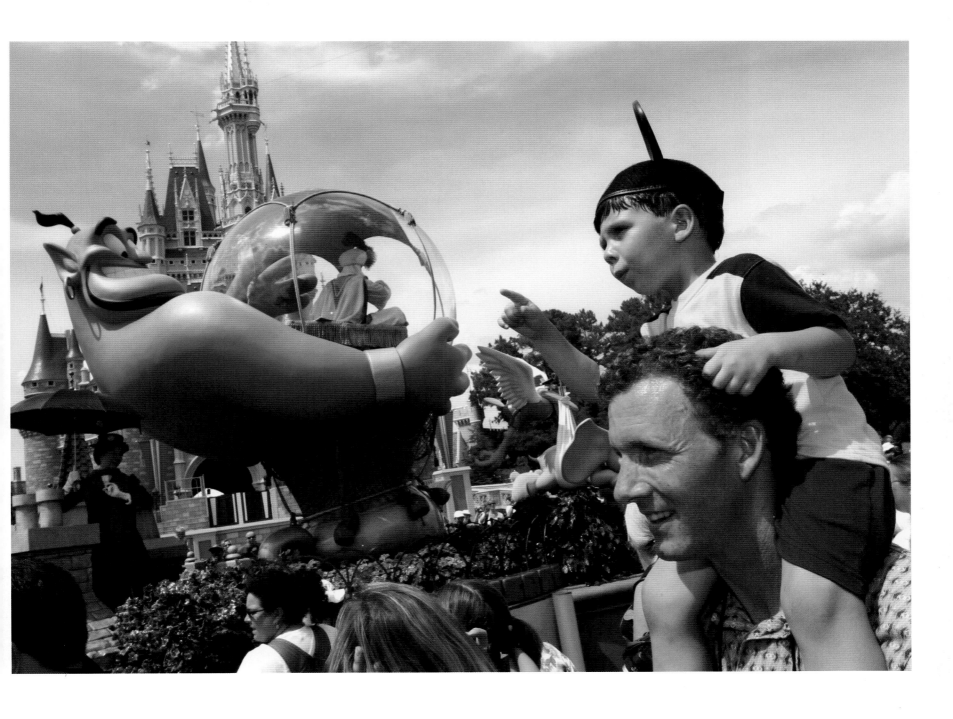

ST. PETERSBURG

Greyhounds started racing at Derby Lane in 1925.
Running at 40 mph, the dogs complete the 5/16
of a mile sand track in around 30 seconds. The
lead dog in each race chases a stuffed-rabbit
lure controlled by this operator above the course.
The first Florida dog track was built in 1922; the
state's annual take from greyhound racing at 17
tracks now totals $17 million.

Photos by Beth Reynolds,
The Photo-Documentary Press, Inc.

ST. PETERSBURG

Each racer has a "leadout," or handler, who puts them through their paces. Carlos Arias takes care of greyhound 6. The leadouts cannot speak to the betting public, an old tradition that keeps their attention focused on the dogs and prevents the release of inside information.

ST. PETERSBURG

Greyhounds must be within 1.5 pounds of their recorded weight to qualify for races. These hounds, headed for weigh-in, were trained since puppyhood for racing. The breed's special heritage began in ancient Egypt, and continued in England where, after 1066, the aristocracy so favored the dog that commoners were forbidden to own them.

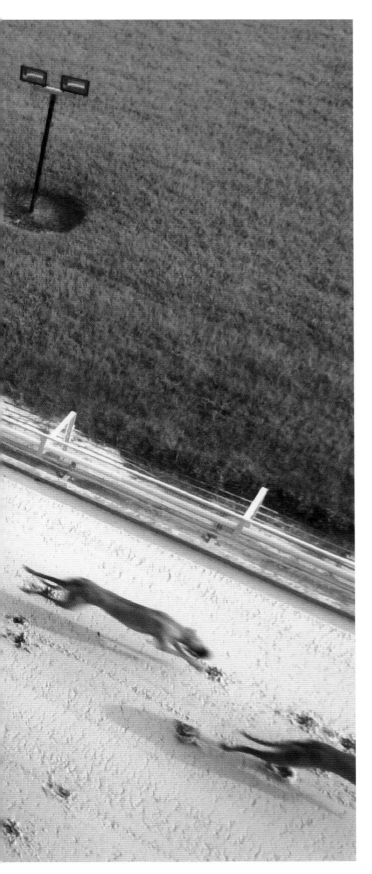

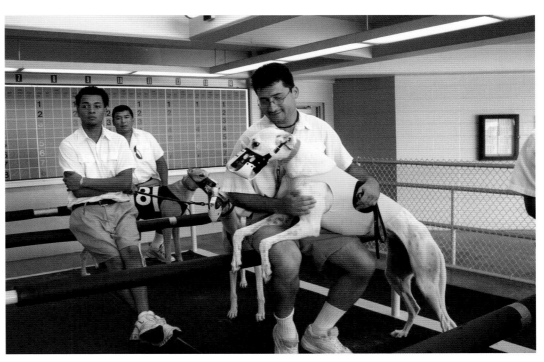

PINELLAS PARK
Widow Betty Flynn bowls for the Pirates.
She reports that the guys on her team are
"crazy, but nice."
Photo by Cheryl Anne Day-Swallow

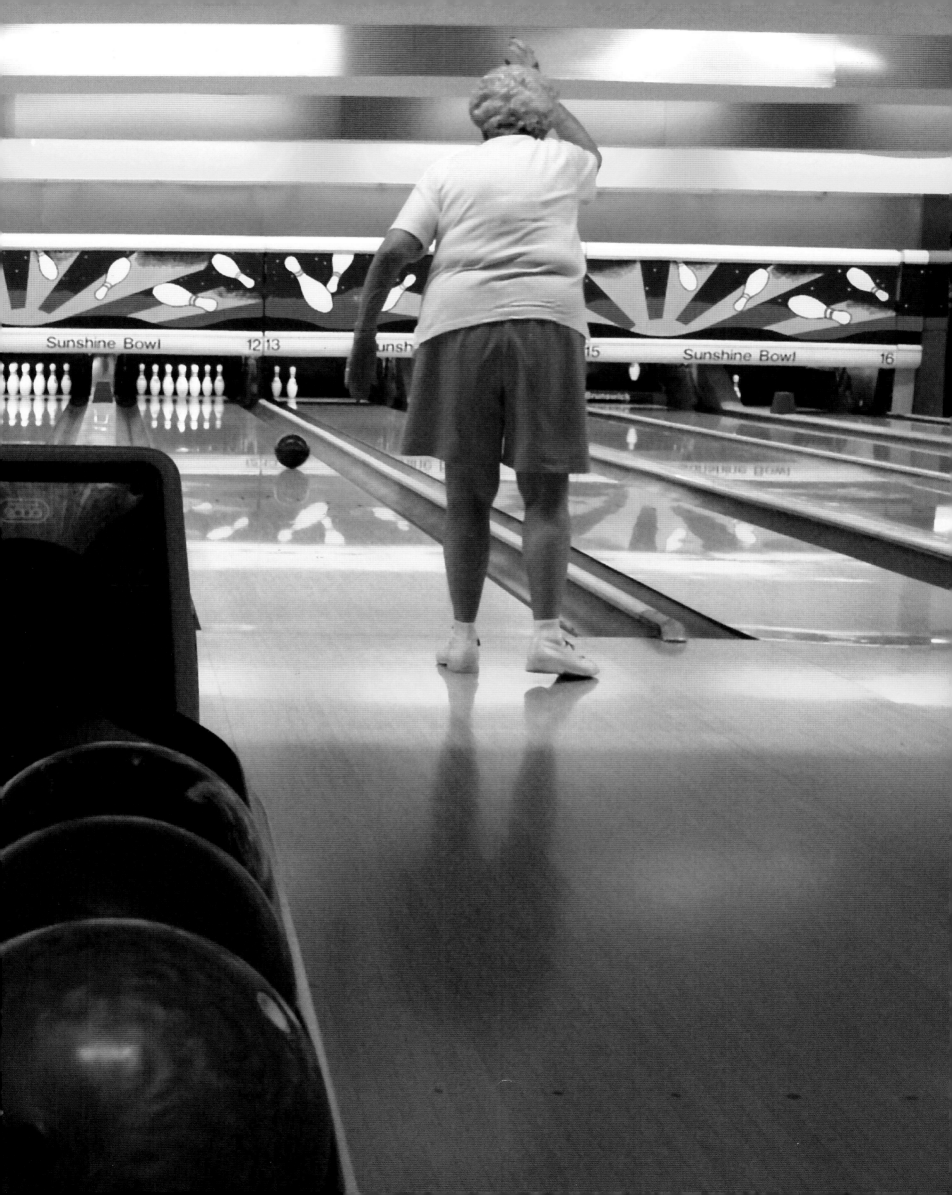

LANTANA

Wearing his trademark cap, visiting performer Tony Sanso, 73, finishes his set at Donnelly Place, an assisted living facility. He's been playing piano since he was 9, when his father put a piano in the pool hall he owned in Vineland, N.J. Sanso lost most of his voice box to throat cancer but always gestures to the crowd to sing along.
Photos by David Spencer, The Palm Beach Post

LANTANA

Wearing his trademark cap, visiting performer Tony Sanso, 73, finishes his set at Donnelly Place, an assisted living facility. He's been playing piano since he was 9, when his father put a piano in the pool hall he owned in Vineland, N.J. Sanso lost most of his voice box to throat cancer but always gestures to the crowd to sing along.
Photos by David Spencer, The Palm Beach Post

LANTANA

Director of Activities Phyllis Spann keeps to Sanso's beat with resident Fay Penn, 84. An year veteran of assisted living facilities, Spar has been with Donnelly Place since 1997. A b part of her job is organizing shopping, theat and restaurant outings for residents.

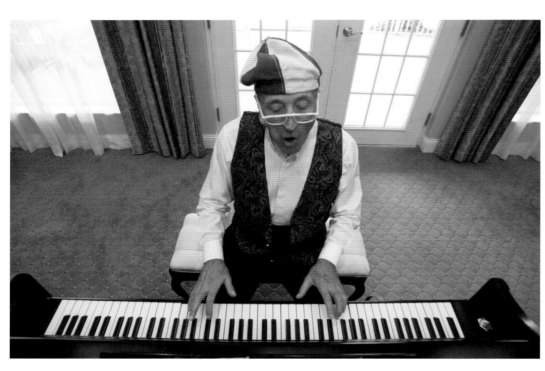

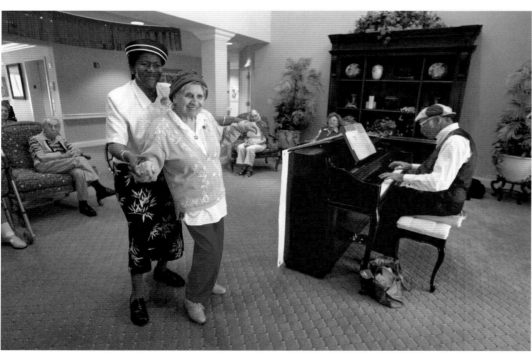

LANTANA

Donnelly Place serves 120 seniors ages 80 and over. Sixty of the residents are wheel-chair bound, and 30 have Alzheimer's, requiring constant attention. In the spotlight, 86-year-old Betsy Huggins (in the peach-colored shirt) dances with Donnelly Place activities assistant Kirill Kuchenkov. The facility is one of 19 Classic Residence Care Centers operated by the Hyatt Corporation.

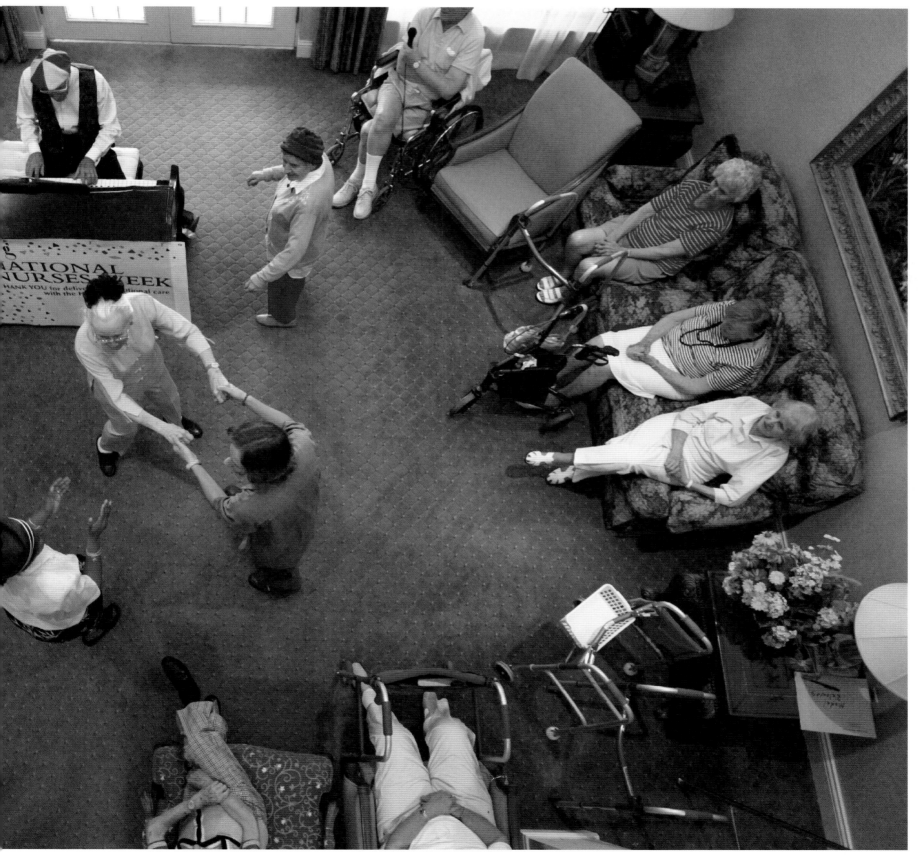

CASSELBERRY

Every Sunday 84-year-old Louise Simunek can be found square dancing for three hours at the Casselberry Senior Center. Her husband got her started more than 60 years ago, but he died young in 1949. Ever since, she's carried on the tradition. "It keeps me young," she says.

Photo by Kelly Jordan,
Daytona Beach News-Journal

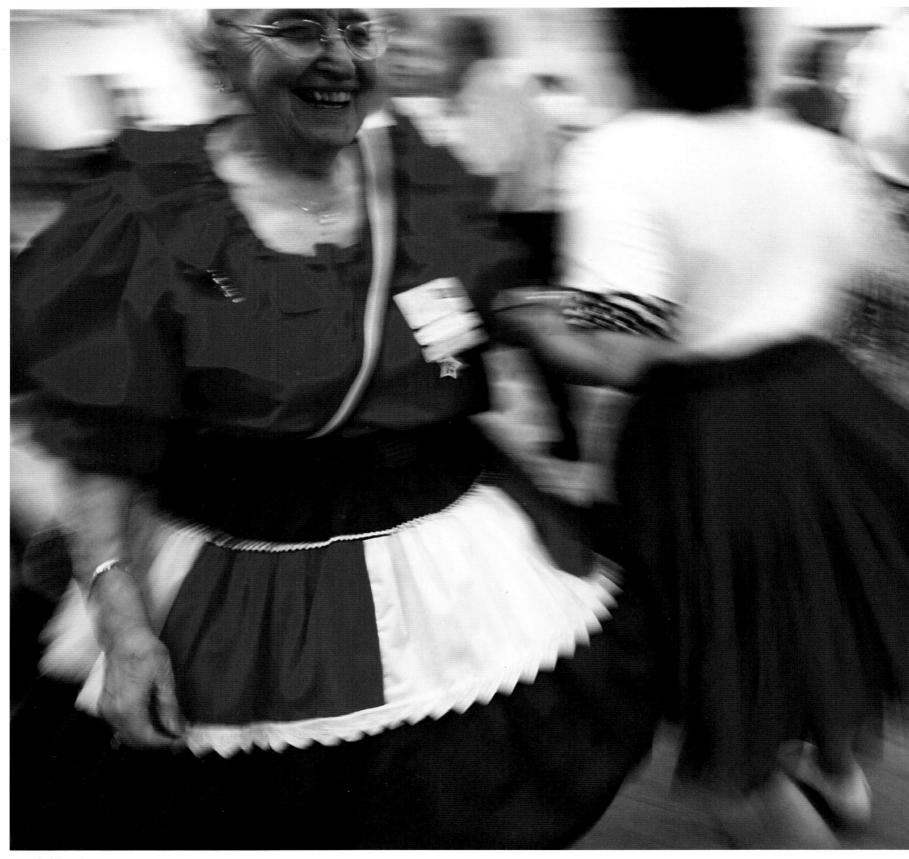

WEST PALM BEACH

Something wicket this way comes: The National Croquet Center is home to the United States Croquet Association, the Croquet Foundation of America, and the National Croquet Club. Most Americans are familiar with backyard croquet, essentially a toy version of the British sport. The more sophisticated six-wicket croquet, requiring heavier equipment and well-manicured lawns, did not arrive in America until the late 1970s.
Photo by David Spencer, The Palm Beach Post

WEST PALM BEACH

Edith Bronstein, 87, curls a weighted dowel to strengthen her arms at the Joseph L. Morse Geriatic Center. The Boston native entered the long-term care facility in 2000.
Photo by Bruce R. Bennett

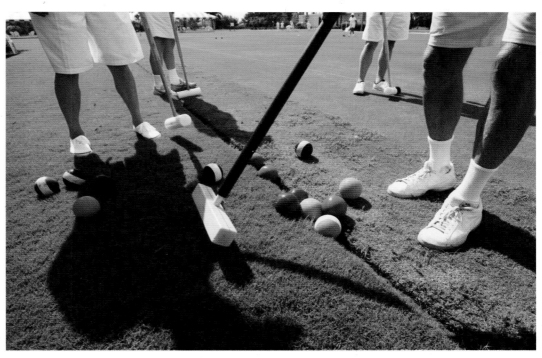

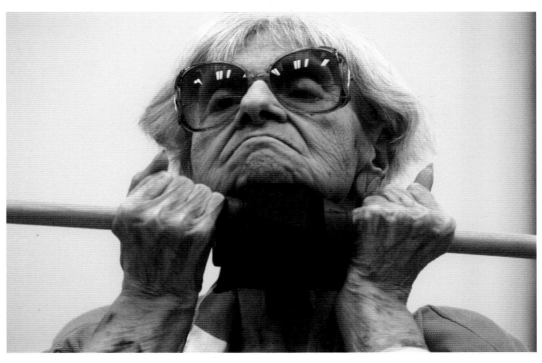

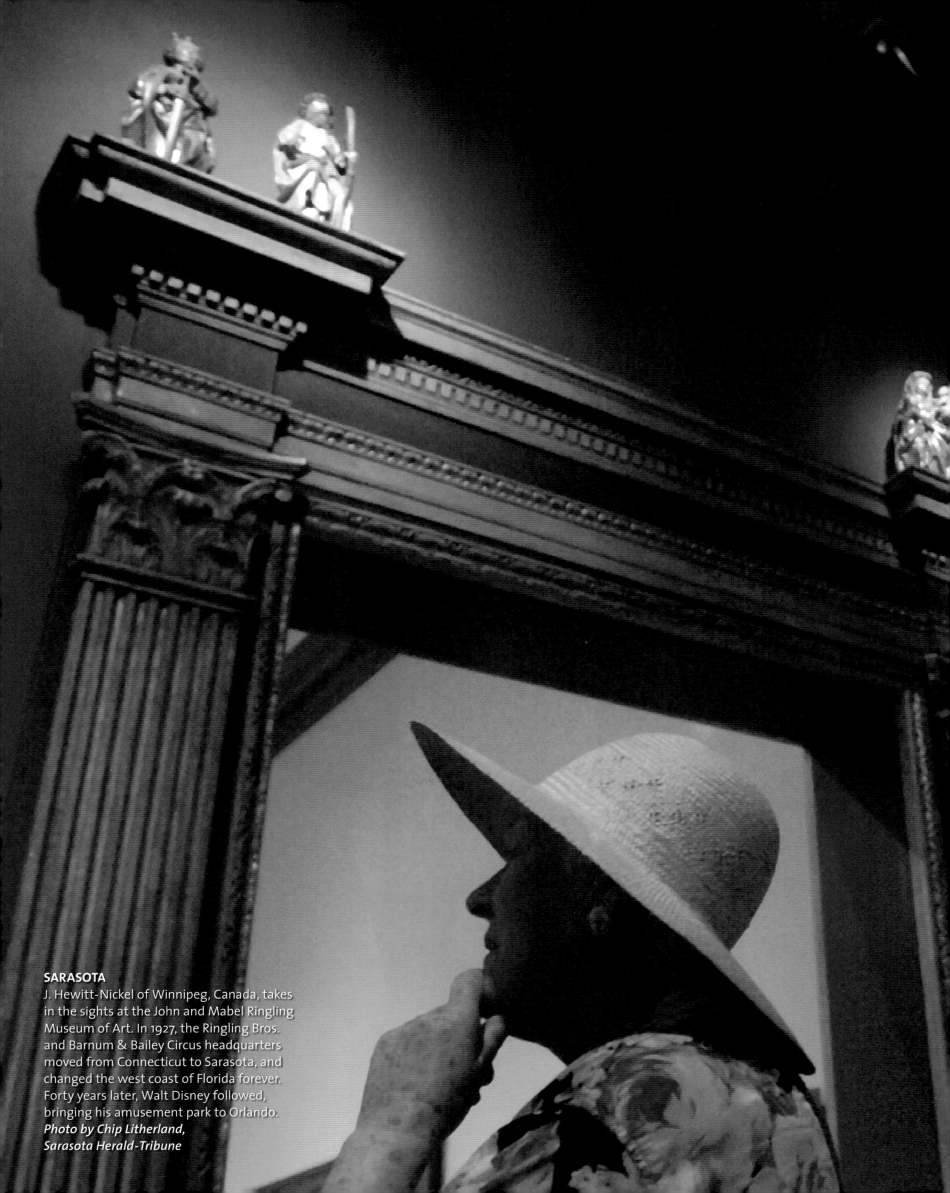

SARASOTA
J. Hewitt-Nickel of Winnipeg, Canada, takes
in the sights at the John and Mabel Ringling
Museum of Art. In 1927, the Ringling Bros.
and Barnum & Bailey Circus headquarters
moved from Connecticut to Sarasota, and
changed the west coast of Florida forever.
Forty years later, Walt Disney followed,
bringing his amusement park to Orlando.
Photo by Chip Litherland,
Sarasota Herald-Tribune

PALM BEACH
The Circle Dining Room at The Breakers, a 560-room resort hotel on 140 oceanfront acres in the heart of Palm Beach. In 1896, Standard Oil magnate Henry Flagler built The Palm Beach Inn. Soon guests began requesting rooms "by the breakers" and he changed the name.
Photo by David Spencer, The Palm Beach Post

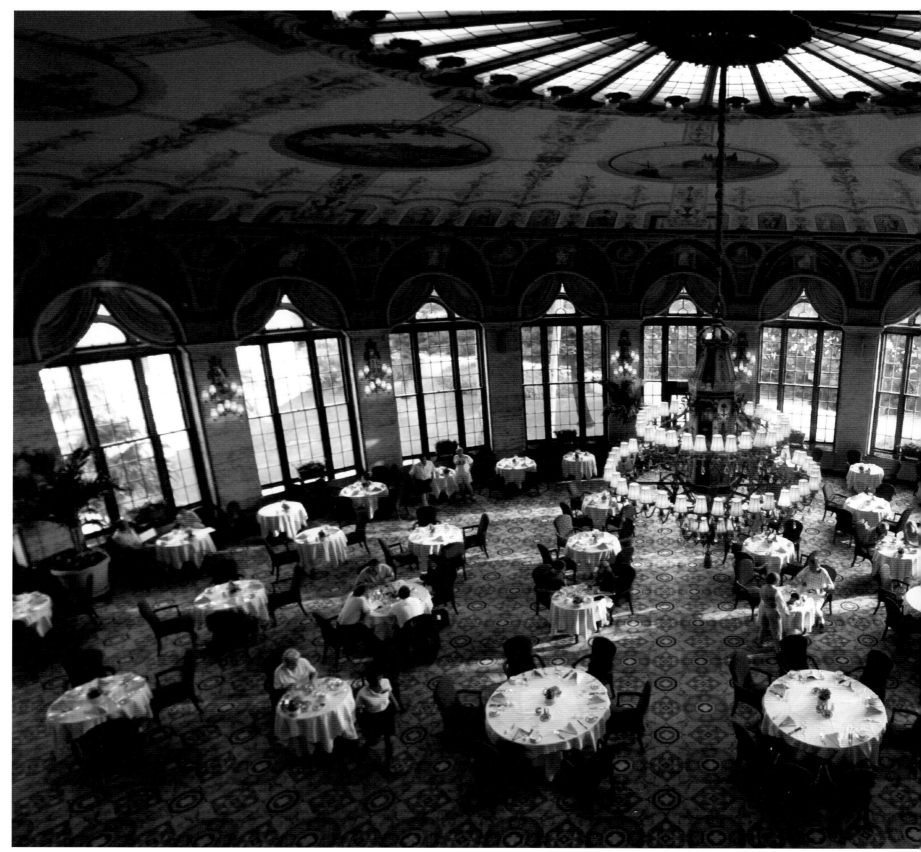

MIAMI

On the corner of Calle Ocho and Fifteenth Avenue in Little Havana, Cuban exiles congregate to commiserate about politics in their homeland, drink shot-sized cups of Cuban coffee, and play dominoes. Founded in 1976, Domino Park is a testament to Cubans' fascination with the complex Chinese game, introduced in Cuba during the 1850s when 125,000 Chinese were shipped to the island as indentured servants.

Photo by Nuri Vallbona, The Miami Herald

MIAMI

Coca-Cola on the soles of her shoes: To keep her flamenco shoes from slipping out from under her, Nuria Cid coats them with Coca-Cola before her triweekly shows at the Spanish tavern, Casa Panza in Little Havana. Cid, who studied dance in her native Cuba, has been performing flamenco for 15 years.

Photo by Nuri Vallbona, The Miami Herald

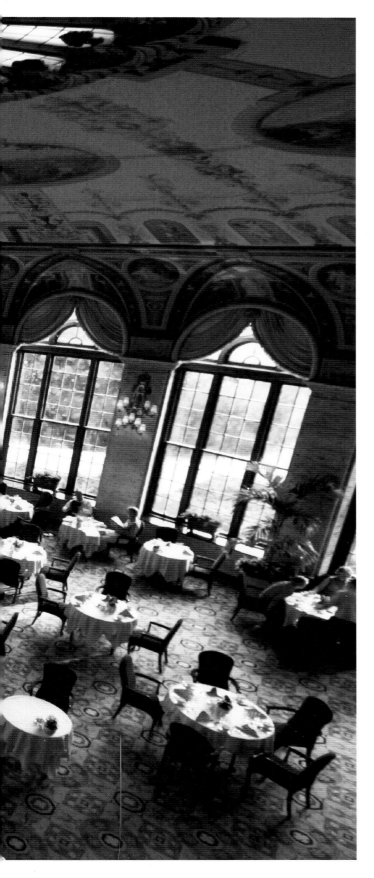

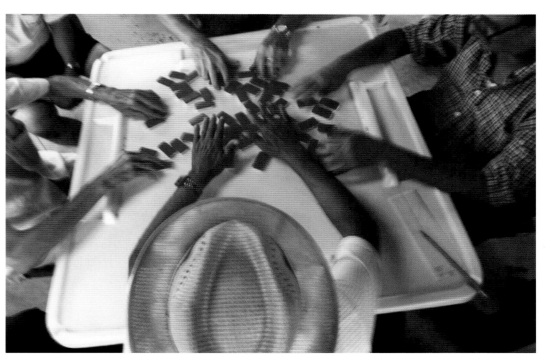

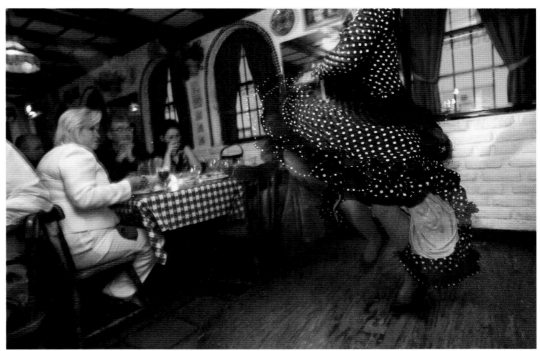

ST. PETERSBURG
"I like the process, I enjoy the camaraderie, and I like the results—sometimes," says Pat Davis, who sketches a model doing one-minute poses during a life-drawing class at The Arts Center. Davis first tackled watercolor painting nine years ago and now takes three classes a week at the 30-year-old center, preferring figure work to anything else.
Photo by Beth Reynolds,
The Photo-Documentary Press, Inc.

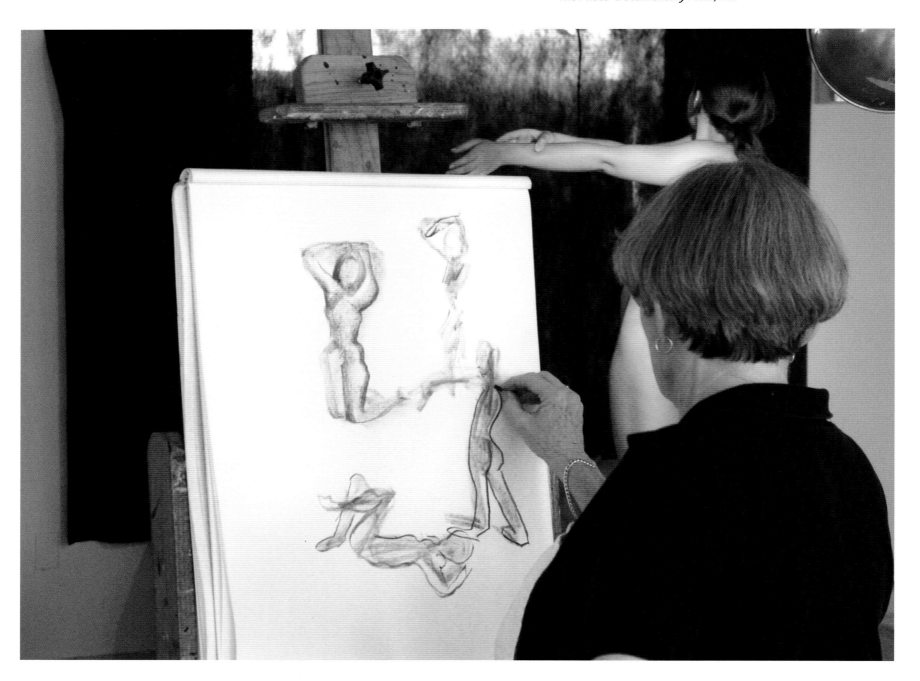

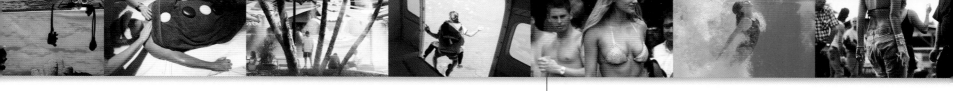

FORT LAUDERDALE
Hey, what's everybody lookin' at? Shooters, a bar on Florida's Intracoastal Waterway, reaches maximum capacity during Sunday's hot body contest, which gives contestants a shot at cash, prizes, and applause.
Photo by Melissa Lyttle

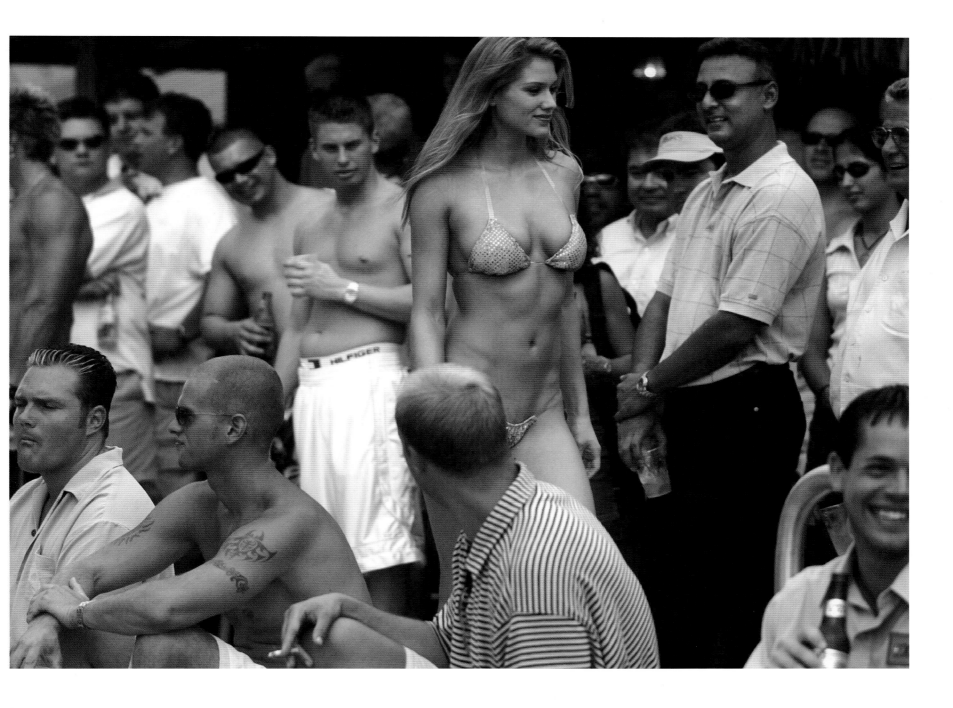

NAPLES
"This is my ministry, doing for others," says Gloria Allen, Assistant Shepherd Mother at Triumph and Kingdom of God in Christ Church. As an officer of the church, she organizes speakers, bakes for church events, and generally tries to help anyone in need.
Photo by Lisa Krantz, Naples Daily News

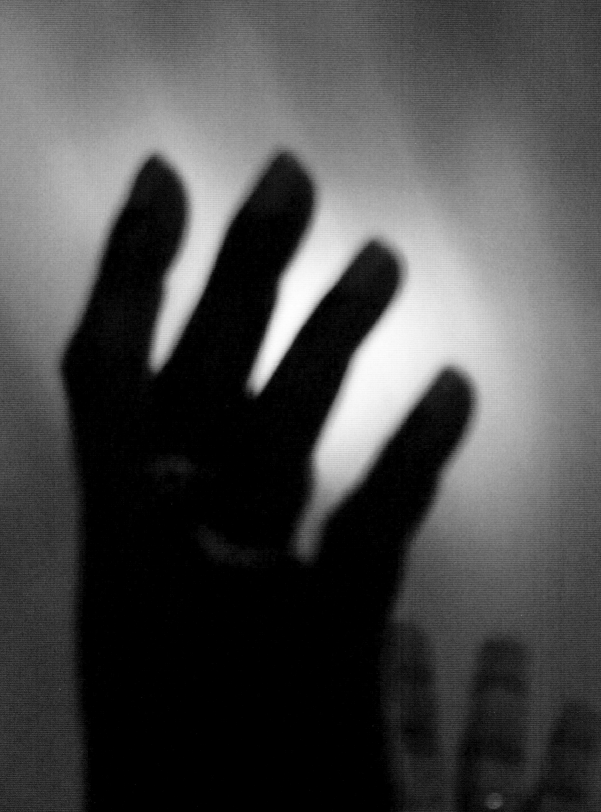

Reason To Believe

ST. PETERSBURG

"Sometimes people call us Holy Rollers," says Pastor Annie L. Robinson (right). "But it's the same God as them fancy churches." Here she leads noonday prayers in her tiny Crusader for God storefront church on 6th Avenue in midtown St. Petersburg. Ten years ago, the congregation got too big to continue meeting in Robinson's house.

Photo by Jamie Francis, St. Petersburg Times

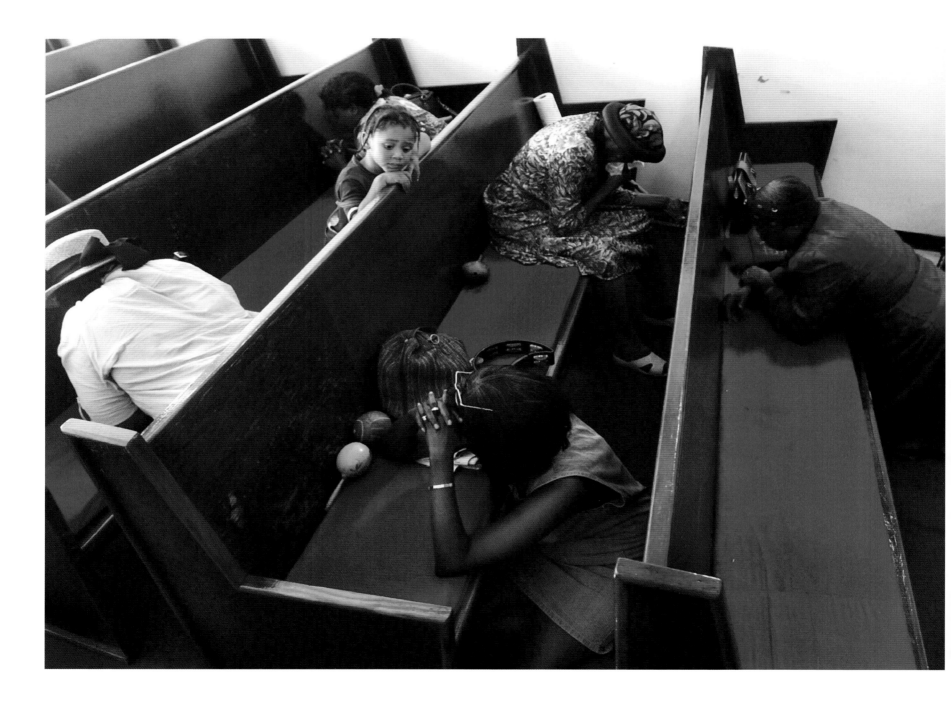

Gloria Allen and Geneva Shoemaker
greet each other after Sunday services
at Triumph Church. Socializing in the
fellowship hall and sampling Allen's
homemade pies and cakes are next.
Photo by Lisa Krantz, Naples Daily News

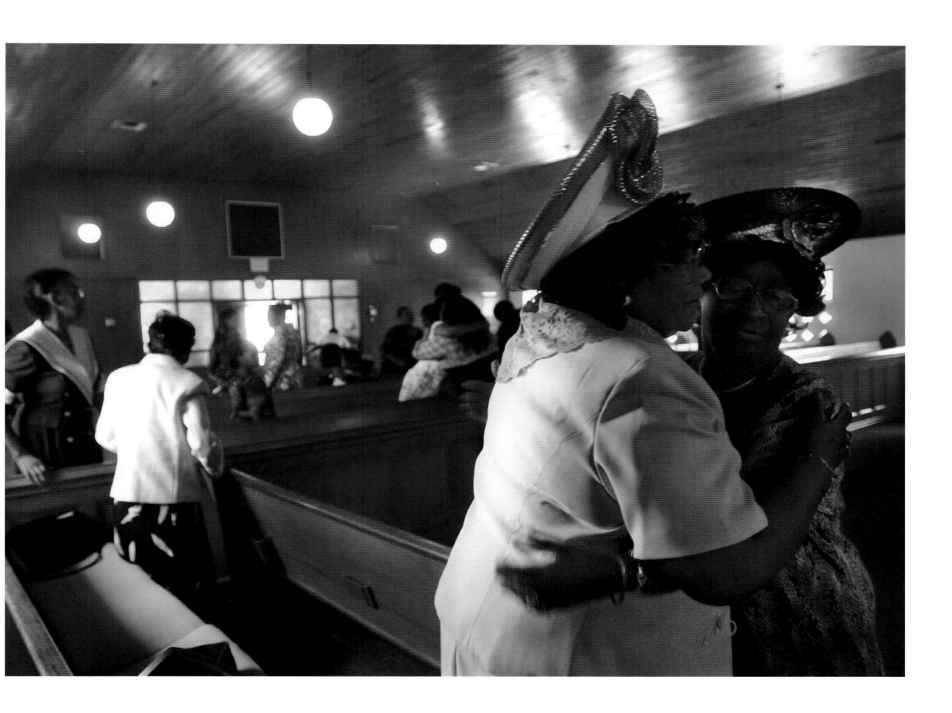

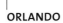

ORLANDO

Pham H. Su, 75, and Pho Q. Uy, 68, pray at the Long Van Temple, a religious and cultural magnet for Vietnamese Americans. Many of the congregants are former refugees who fled Vietnam after the fall of Saigon in 1975.

Photo by Preston Mack

CLEARWATER

Some believe the rainbow likeness of the Virgin Mary that appeared in 1996 in the mirrored glass of a bank building is a holy manifestation. Others attribute it to the effects of mineral-rich tap water on the glass's tinted surface. Whatever the cause, the Shepherds of Christ Ministries bought the building on Highway 19 and erected the crucifix in 2000.

Photo by Cheryl Anne Day-Swallow

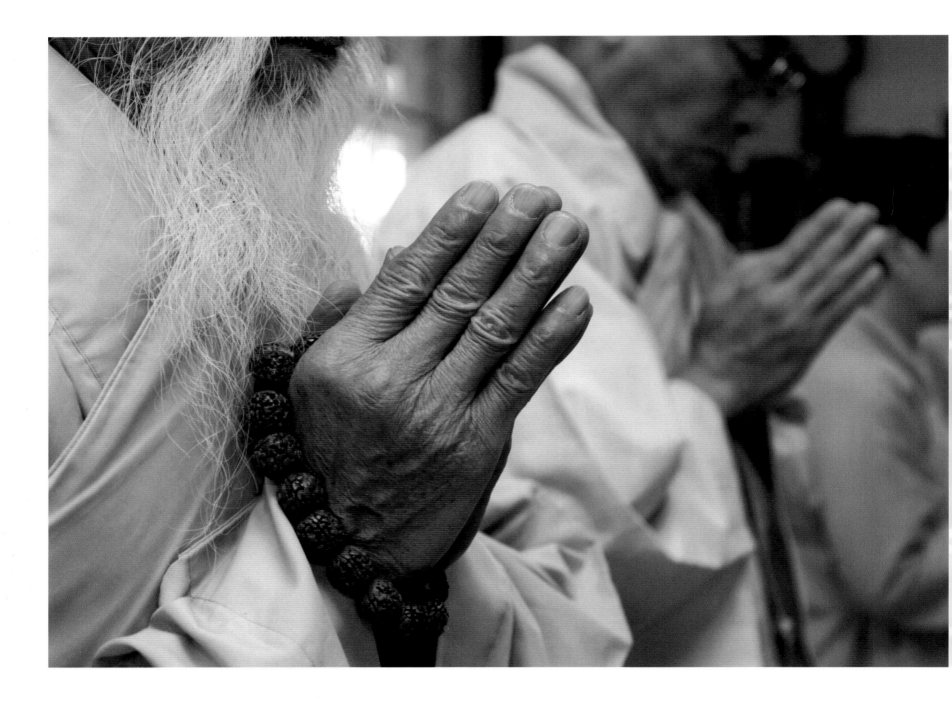

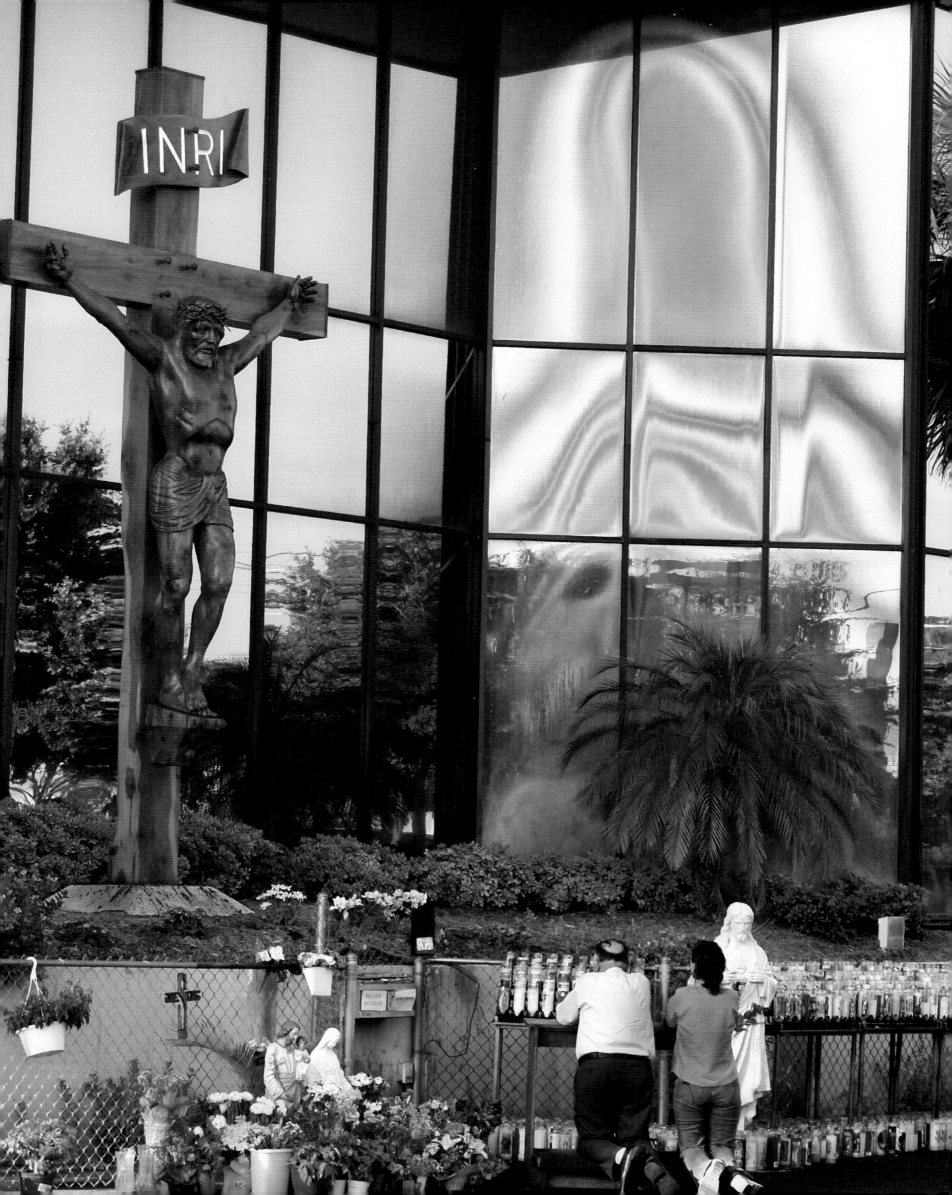

NAPLES
The Kollegger family created a "sacraments wall" to emphasize to their children that events such as Holy Communions and baptisms call for family portraits. Home-schoolers Zoe and brother Zachary made depictions of the Stations of the Cross, lined up below the portraits, as a decoupage project.
Photo by Lisa Krantz, Naples Daily News

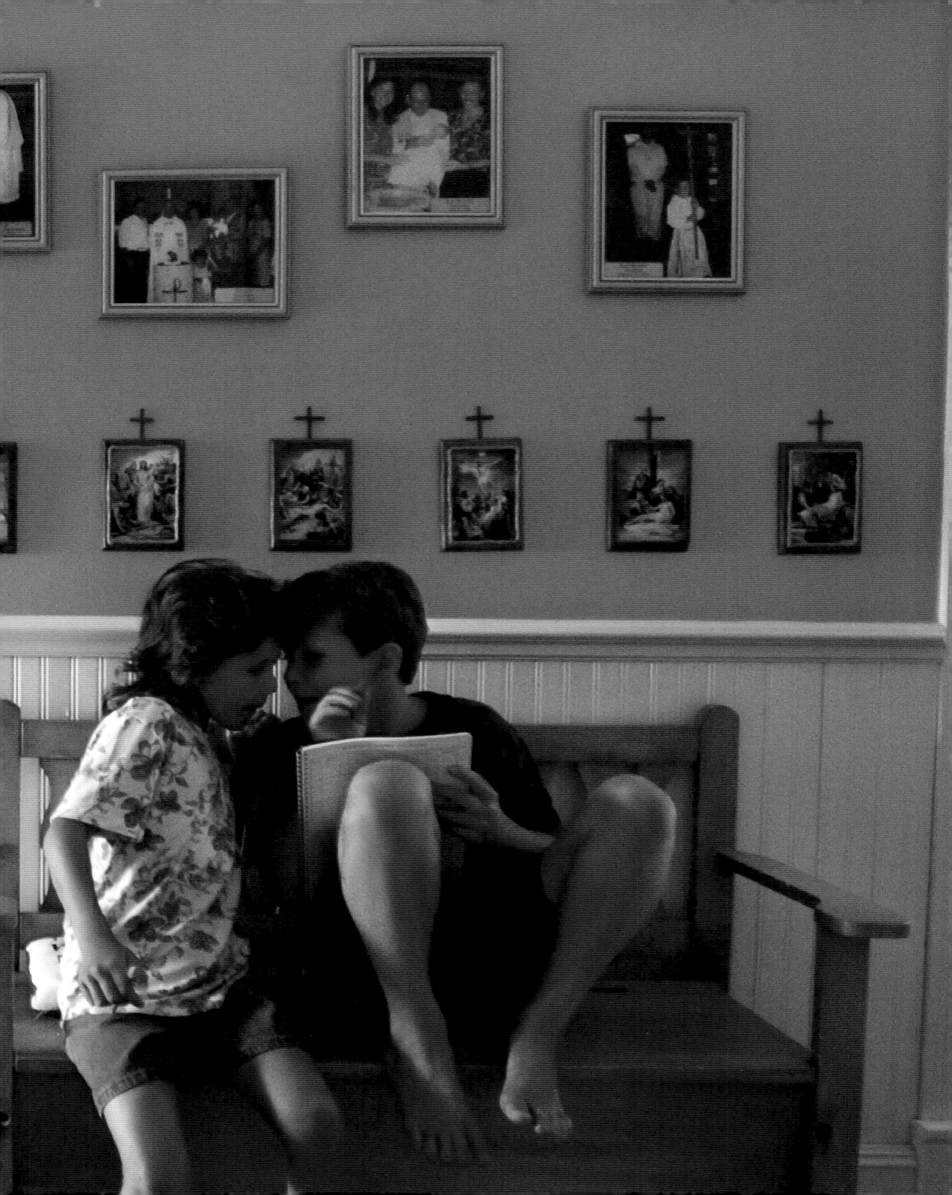

TEQUESTA

First-generation Pakistani Americans Asma and Sarah Azimi celebrate their college graduation. Asma, 22, received her degree in education from the University of Michigan, and Sarah, 26, graduated from Eastern Michigan University with a B.A. in communications. The sisters say they will honor the Muslim tradition of arranged marriages but will be the first women in their family to pursue careers outside the home.

Photos by Jacek Gancarz, Palm Beach Daily News

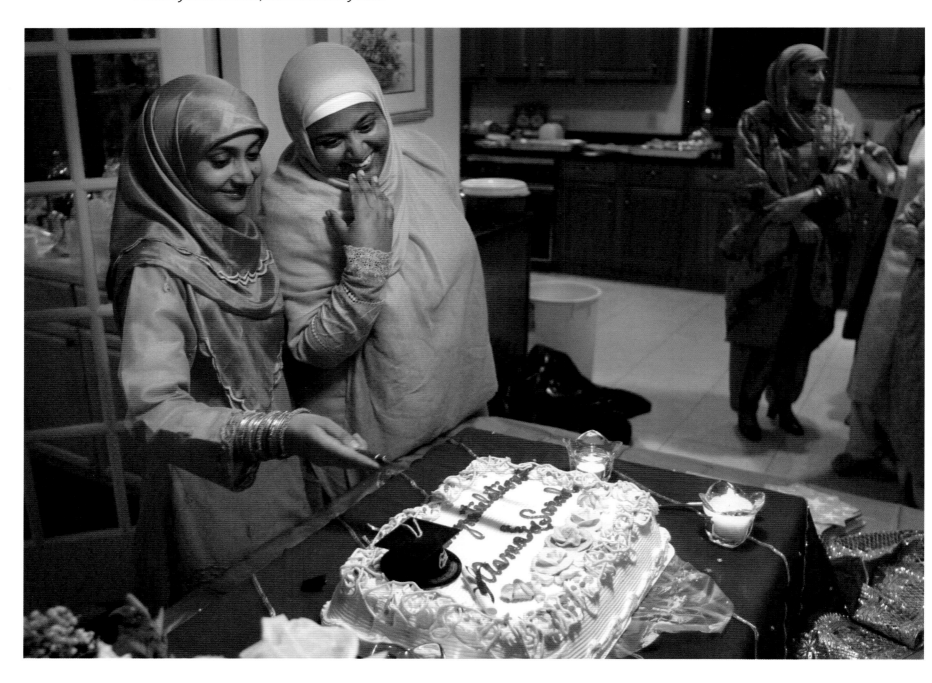

TEQUESTA

Some of the 40 family and friends who came to celebrate Asma and Sarah's college graduations congregate in the living room of Asma's in-laws. Men were allowed to join the gabfest; they were just more interested in the food.

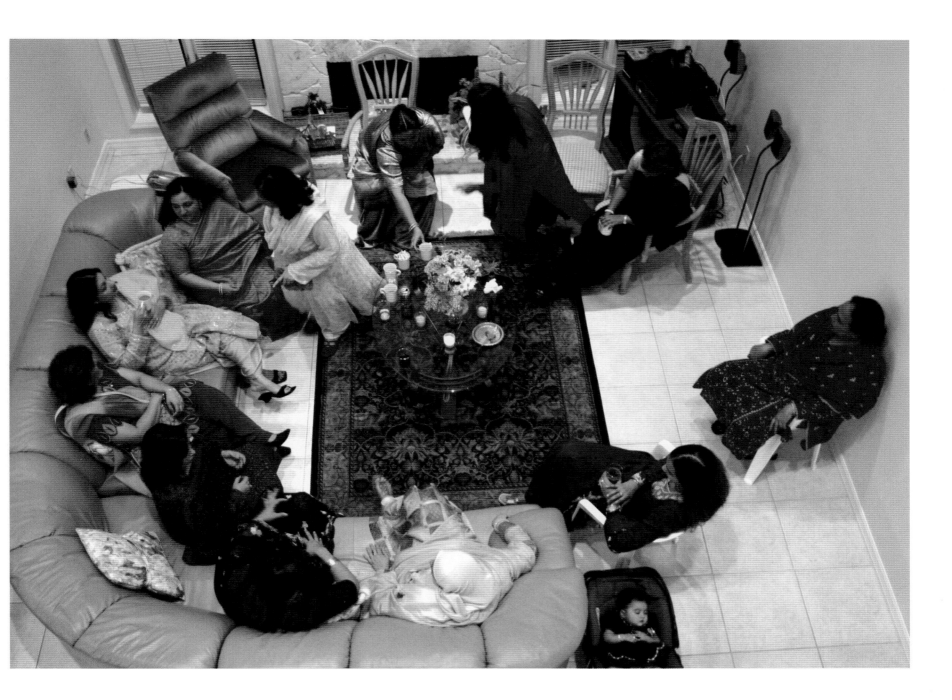

MIAMI

At Haloumba Botanica in Little Haiti, owner and Vodou priest Papa Paul sells religious dolls, candles, clothing, and statues. He also performs ceremonies, readings, and herbal cures, drawing on the mystical origins of his native Haiti, which he left in 1975.

Photo by Andrew Kaufman, Contact Press Images

WEST PALM BEACH

Local residents call Alexander Holmes "the man who walks everywhere." The 83-year-old retiree walks up to 15 miles a day around town. When he's not walking he's volunteering at the Tabernacle Missionary Baptist Church or visiting the sick.

Photo by Jacek Gancarz,
Palm Beach Daily News

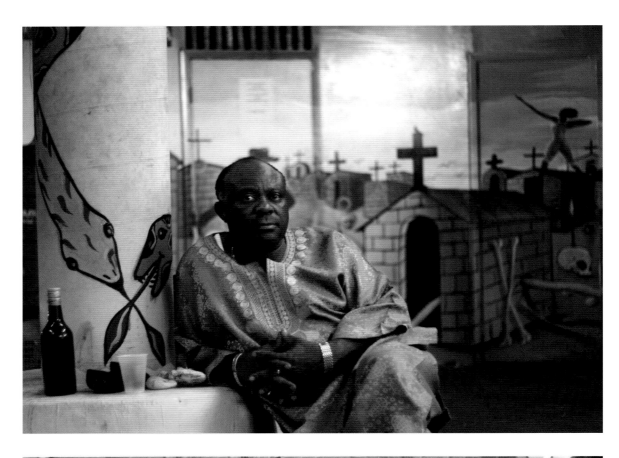

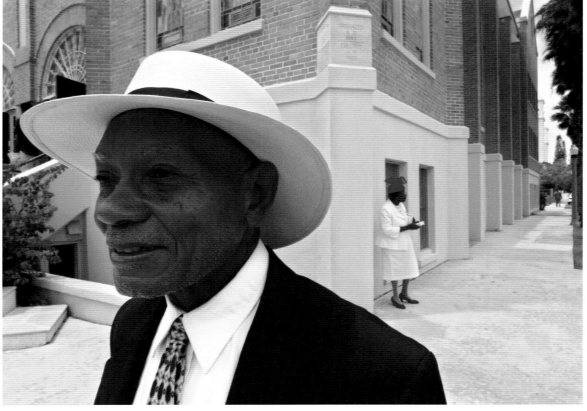

WEST PALM BEACH

"We should strive to live in harmony like good neighbors. We must be tolerant of others," says Ed Lefkowitz, president of the Holocaust Survivors of the Palm Beaches. Lefkowitz speaks from experience—he escaped from Poland after the Germans invaded in 1939, only to spend five years in a Soviet labor camp.

Photo by Jacek Gancarz,
Palm Beach Daily News

WEST PALM BEACH

Thirteen years ago, kindergarten teacher Genethel Harris of New York City came to Florida for a vacation and on a lark gave her name to the school board. Within a few days, she had mulitple teaching offers. The warm weather and friendly people convinced her to leave New York where she'd lived for 30 years. "I love it here," says Harris. "It's paradise."

Photo by Jacek Gancarz,
Palm Beach Daily News

WEST PALM BEACH

In 1961, in his native India, Abdul Gaffar saved a Hindu man from being beaten to death by Muslims. When the man asked why Gaffar had risked his life, Gaffar, a Muslim who now prays at the county mosque, replied, "It does not matter your religion. It is my duty to help humanity."

Photo by Jacek Gancarz,
Palm Beach Daily News

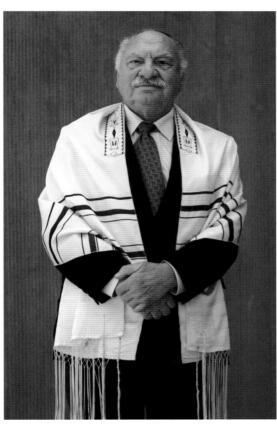

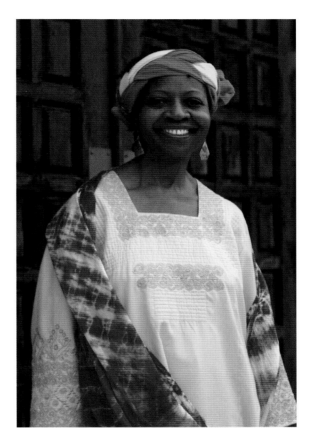

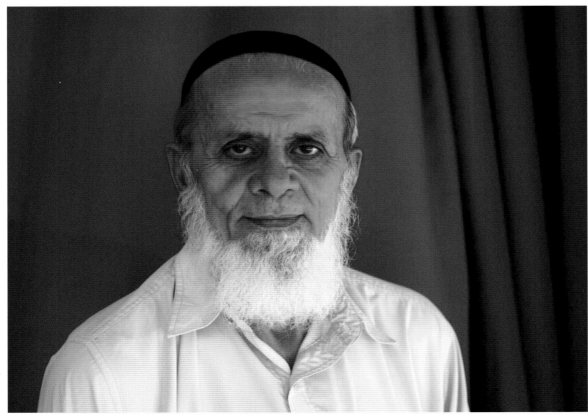

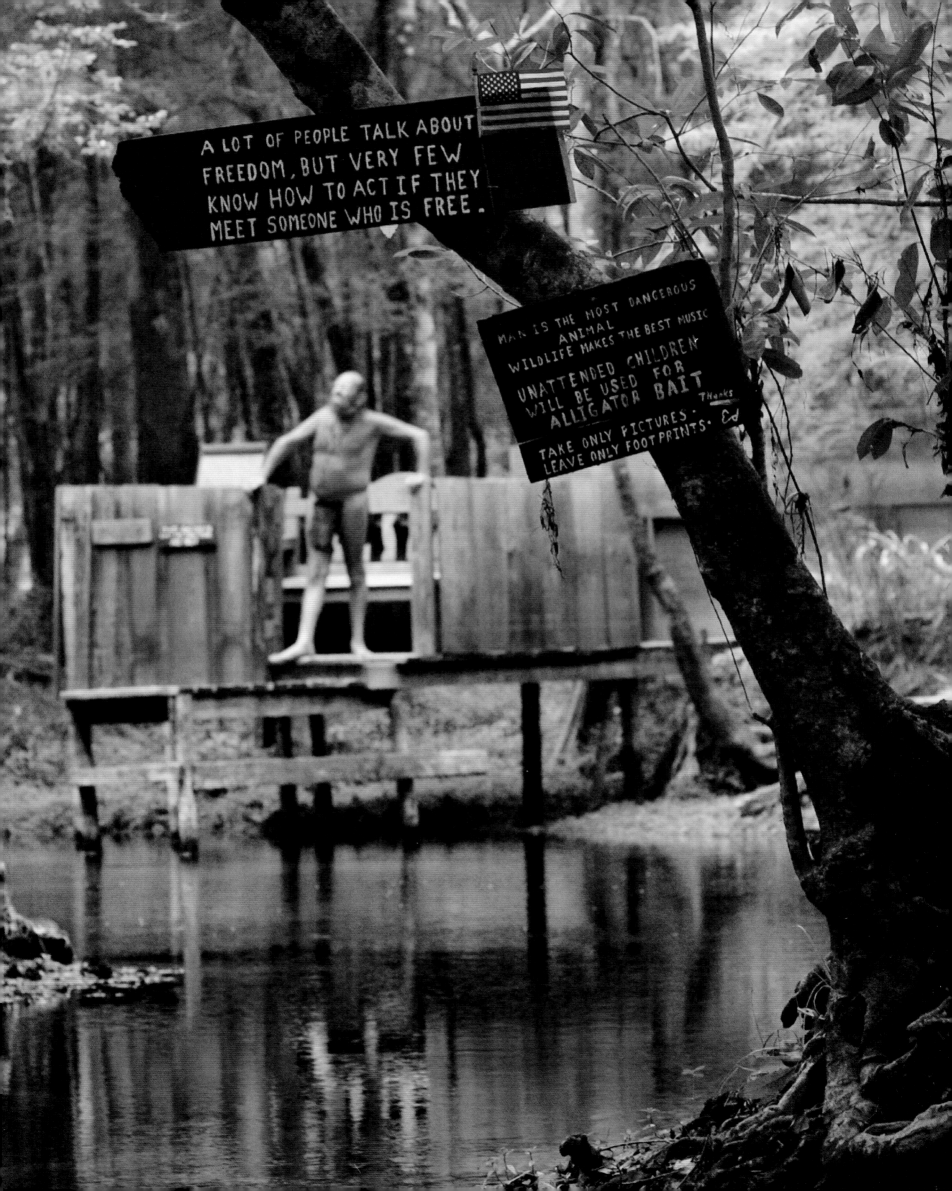

HIGH SPRINGS

The most-photographed feature of the High Springs canoeing camps is not the wildlife but the springs' self-appointed caretaker Ed Watts, aka Naked Ed. He was recently visited by a canoeing father and daughter who caught him with his clothes on. "Daddy," the distraught girl cried, "you promised a naked man!"

Photo by Jon M. Fletcher,
The Florida Times-Union

GULF BREEZE

John Rotalsky reads the Bible inside his parked car on the Gulf Breeze fishing pier. He's been coming to the pier for four years to practice and display his religious beliefs. "The reason I'm out here is for Jesus, because he's worthy," says Rotalsky. "It's not about me."

Photo by Gary McCracken,
Pensacola News Journal

GULF BREEZE

Motorists on the busy Pensacola Three Mile Bridge are hard-pressed to miss John Rotalsky's lurid, religio-patriotic assemblage. He used to stand on his car and read scripture, but a spell of bad weather forced him to billboard his message and seek shelter inside the station wagon.

Photo by Gary McCracken,
Pensacola News Journal

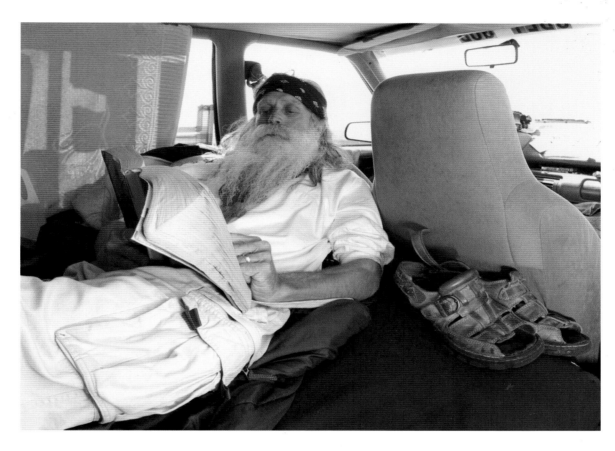

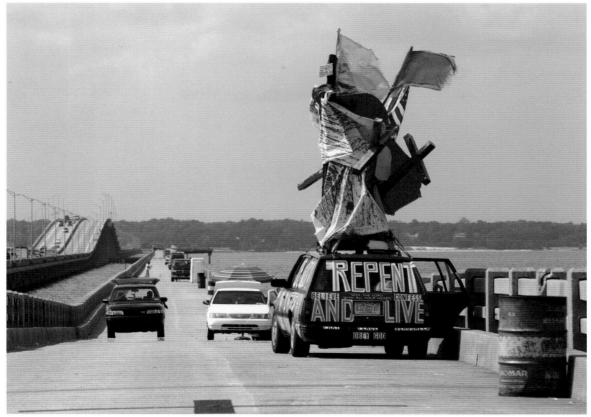

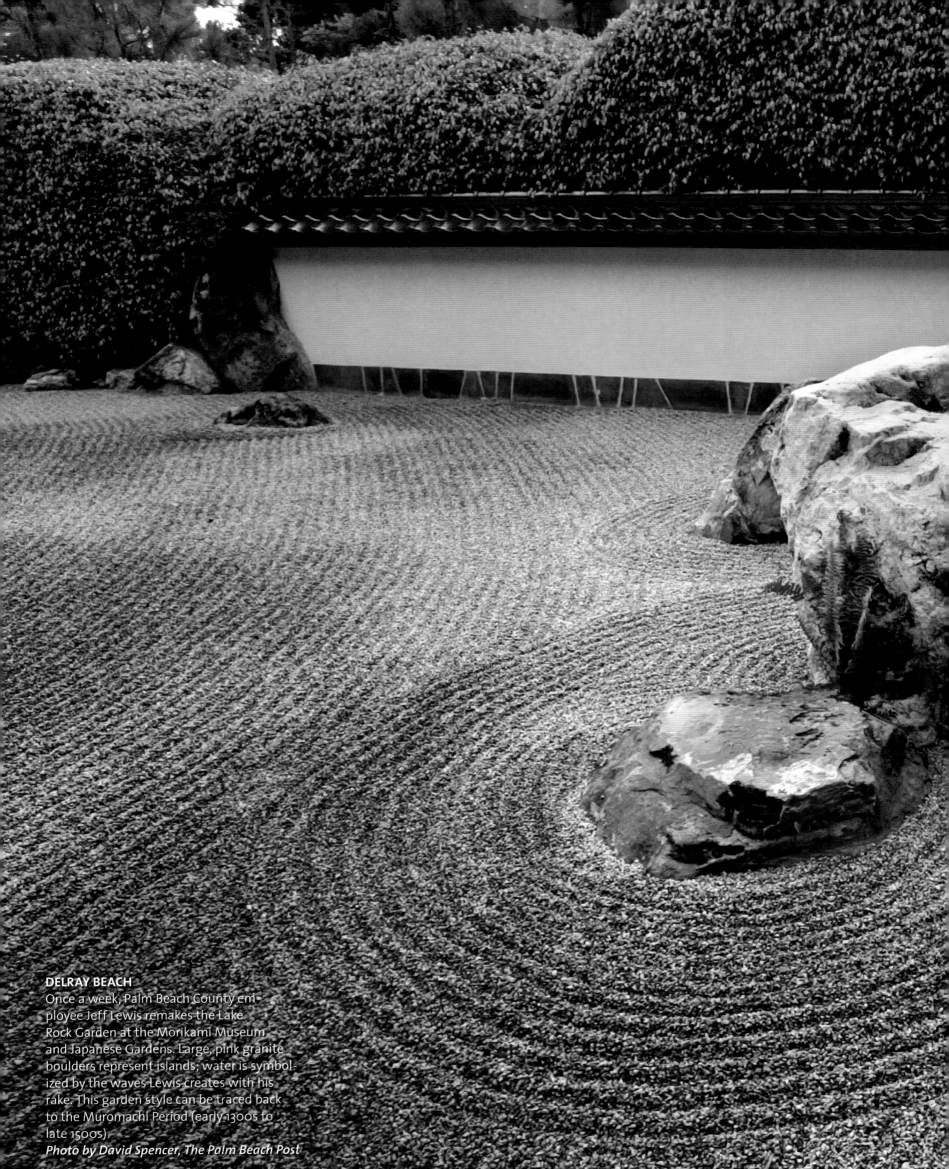

DELRAY BEACH
Once a week, Palm Beach County employee Jeff Lewis remakes the Lake Rock Garden at the Morikami Museum and Japanese Gardens. Large, pink granite boulders represent islands; water is symbolized by the waves Lewis creates with his rake. This garden style can be traced back to the Muromachi Period (early 1300s to late 1500s).
Photo by David Spencer, The Palm Beach Post

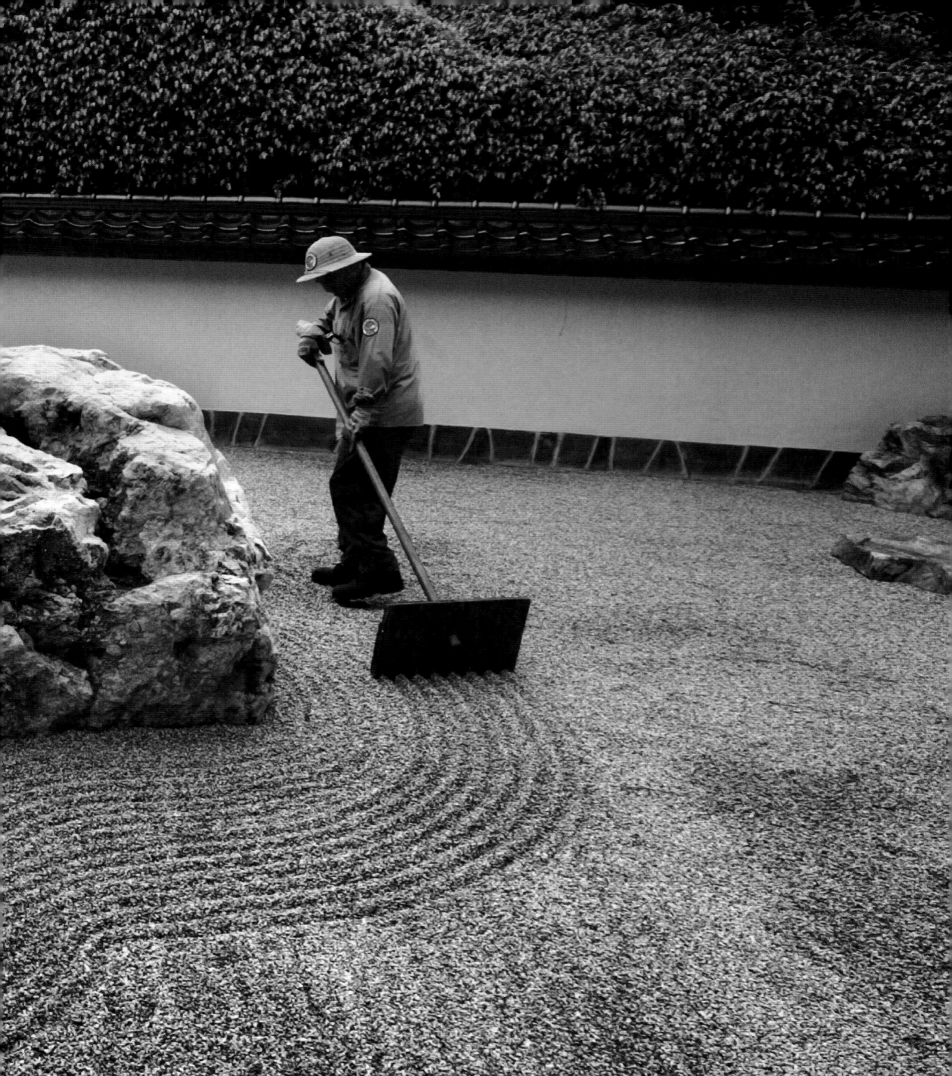

WARM MINERAL SPRINGS
Susan Davis, a wellness director and acupuncturist at Warm Mineral Springs, treats Bruce Ward for chronic neck pain. The homeopathic spa claims to be the Fountain of Youth site Ponce de Leon searched for in the 1500s.
Photo by Jamie Francis, St. Petersburg Times

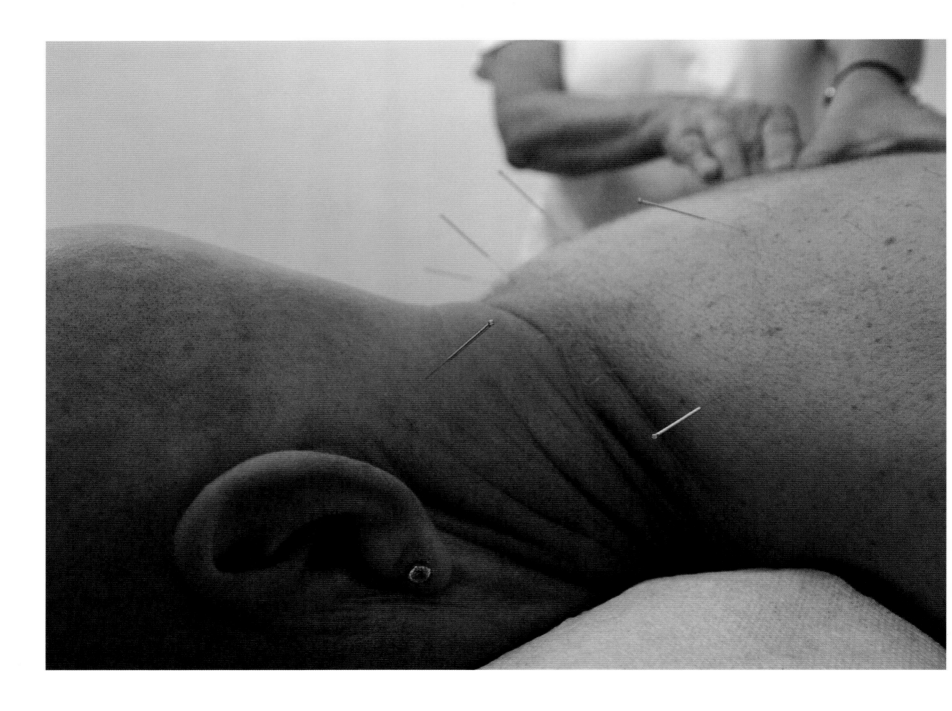

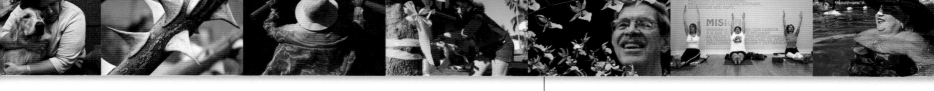

BELLE GLADE

After his wife gave birth to their youngest daughter more than 40 years ago, Milton Carpenter bought her an orchid. That orchid became two. When the orchids outgrew the windowsill, Carpenter started growing them in his yard. A small greenhouse followed. Now his business, Everglades Orchids, encompasses two 4,000-square-foot greenhouses containing 25,000 orchids and more than 1,000 varieties.

Photo by David Spencer, The Palm Beach Post

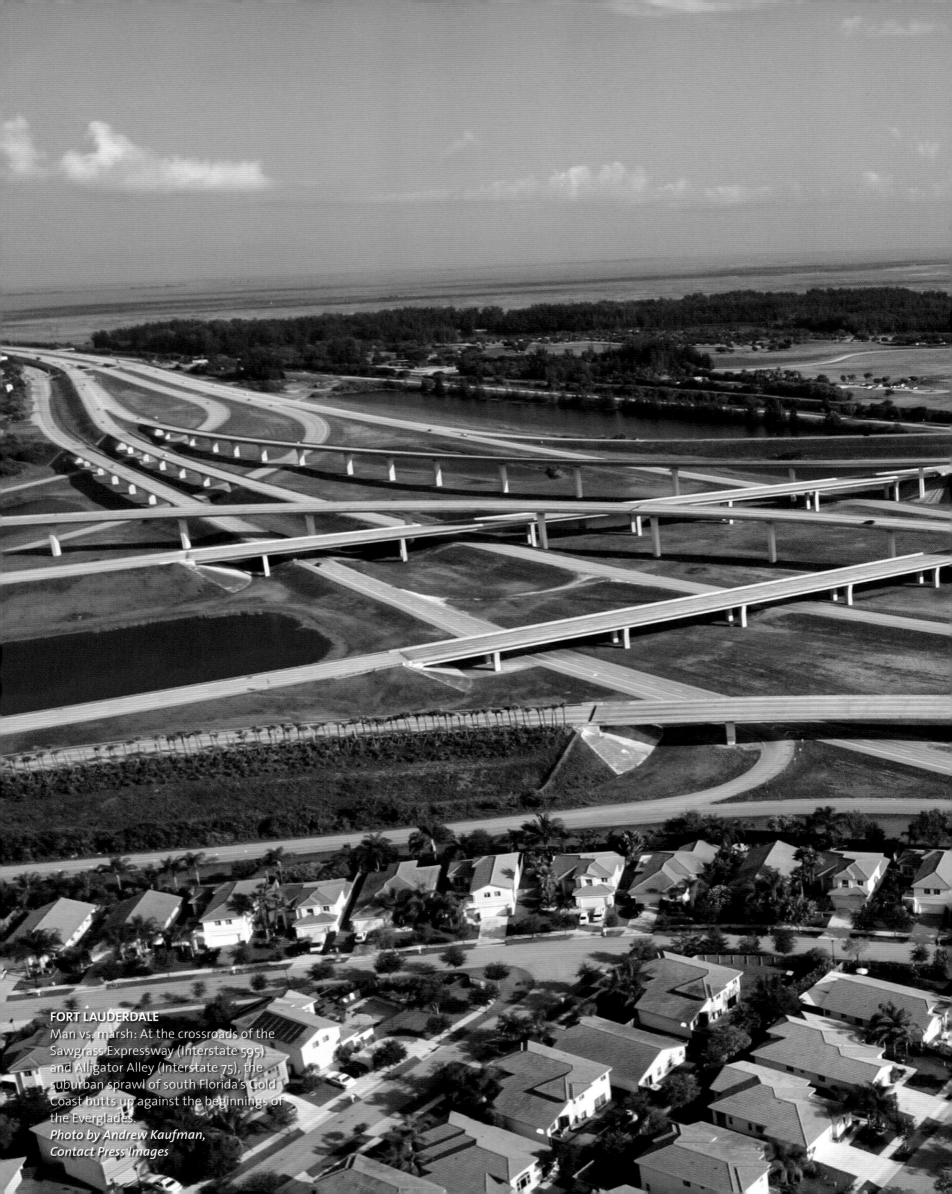

FORT LAUDERDALE
Man vs. marsh: At the crossroads of the
Sawgrass Expressway (Interstate 595)
and Alligator Alley (Interstate 75), the
suburban sprawl of south Florida's Gold
Coast butts up against the beginnings of
the Everglades.
Photo by Andrew Kaufman,
Contact Press Images

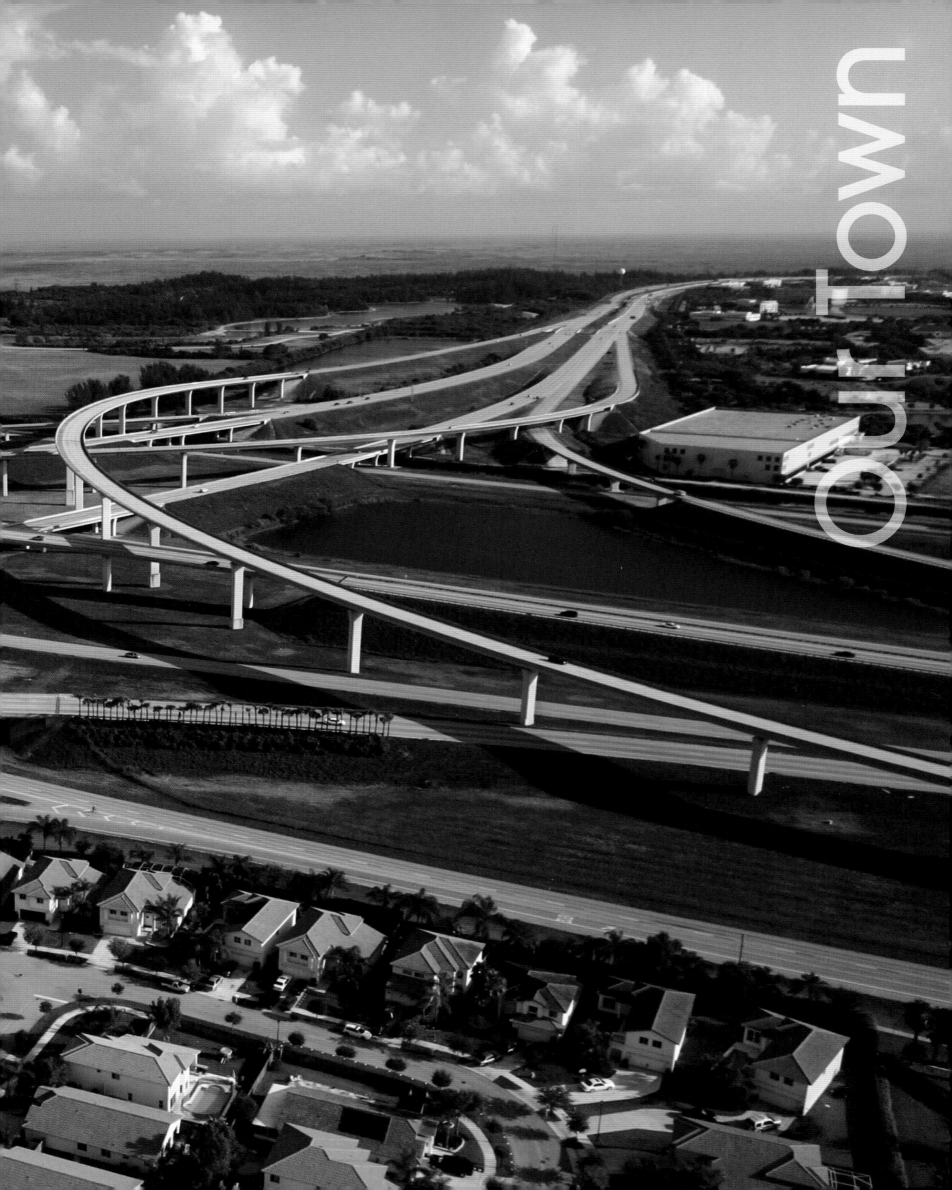

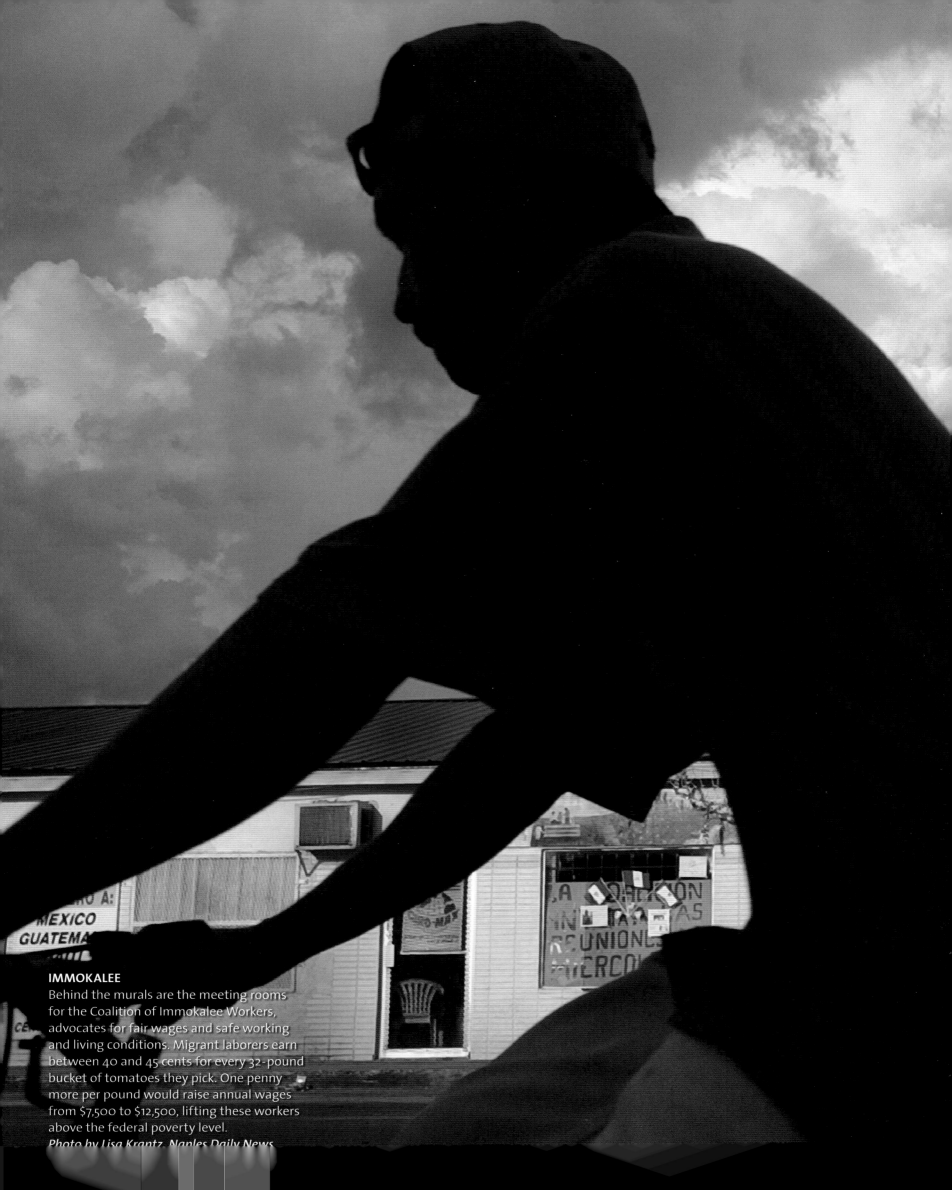

IMMOKALEE

Behind the murals are the meeting rooms for the Coalition of Immokalee Workers, advocates for fair wages and safe working and living conditions. Migrant laborers earn between 40 and 45 cents for every 32-pound bucket of tomatoes they pick. One penny more per pound would raise annual wages from $7,500 to $12,500, lifting these workers above the federal poverty level.

Photo by Lisa Krantz, Naples Daily News

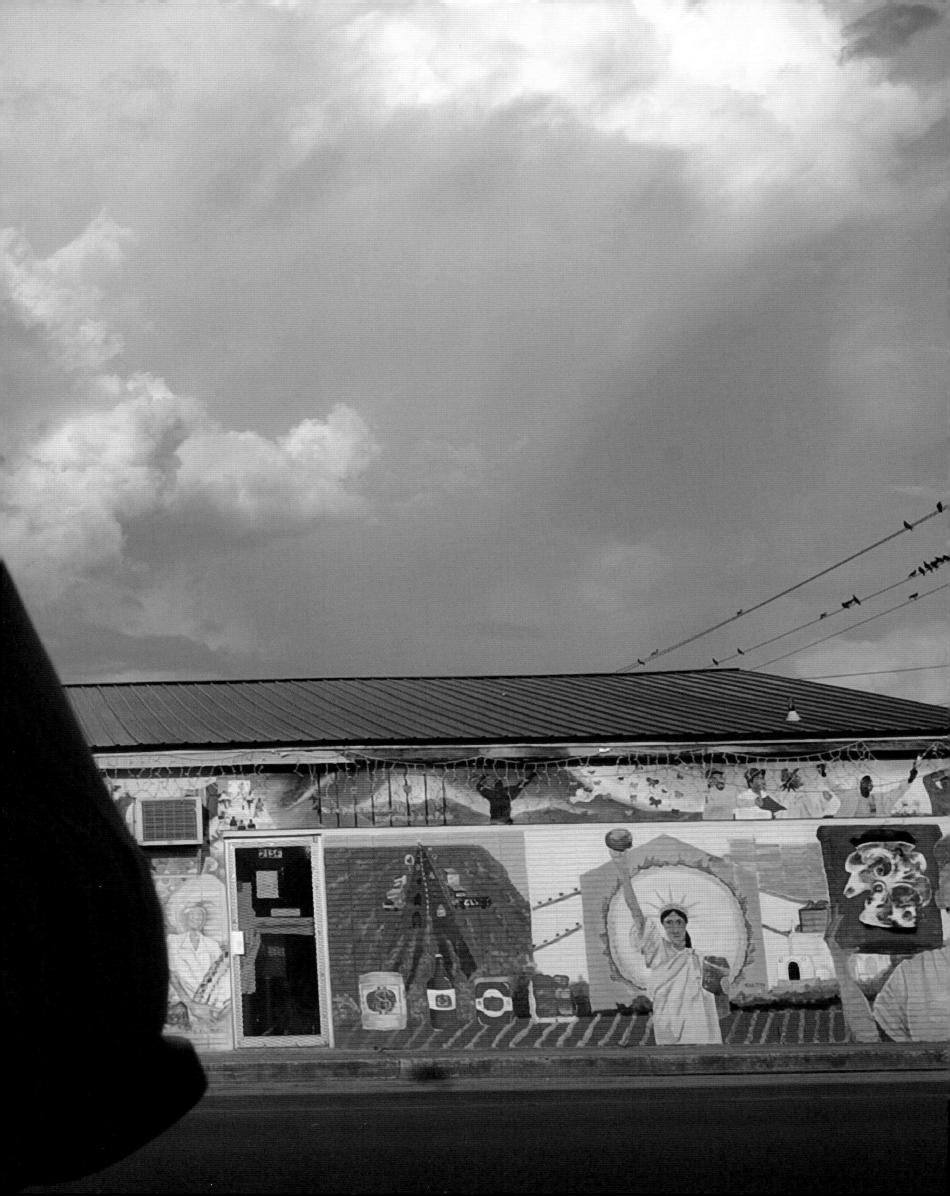

TALLAHASSEE
The Florida Vietnam Veterans Memorial
honors 1,942 military men and women from
the state who gave their lives and the 83 who re-
main missing in action. An American flag
spans the twin granite columns that stand
across Monroe Street from the old and new
state capitol buildings.
Photo by Greg R. Drzazgowski

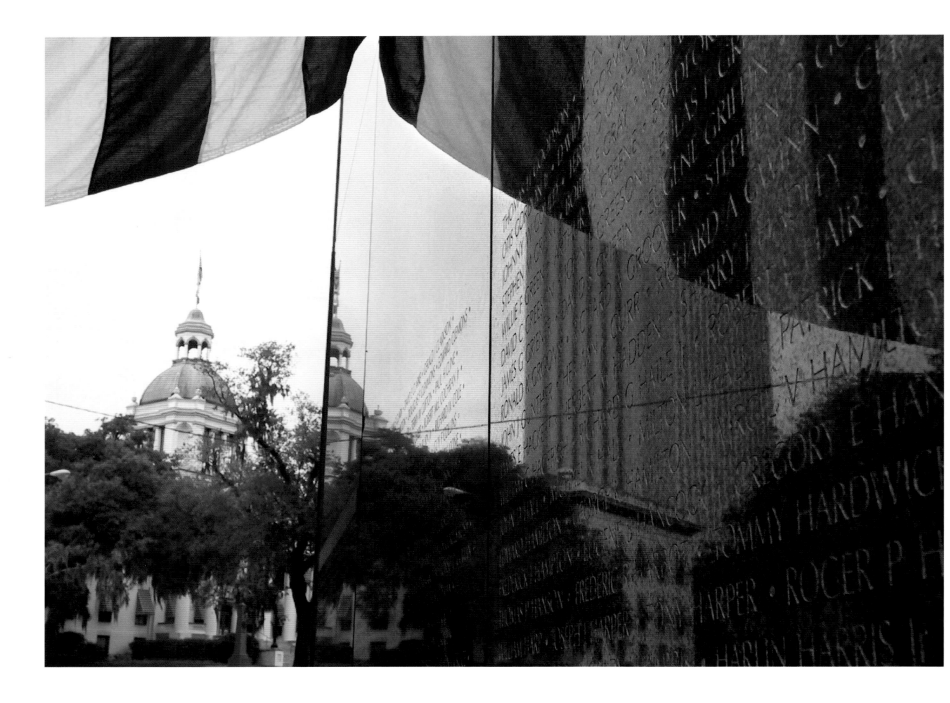

OCHOPEE

Michelle Smith is postmaster of the country's smallest post office, which measures 7 feet 3 inches by 8 feet 4 inches. The Ochopee mail route covers 130 miles round-trip along State Road 41 near the Everglades. The post office delivers mail to approximately 500 families including residents of the Miccosukee and Seminole Indian reservations.

Photo by Jacek Gancarz, Palm Beach Daily News

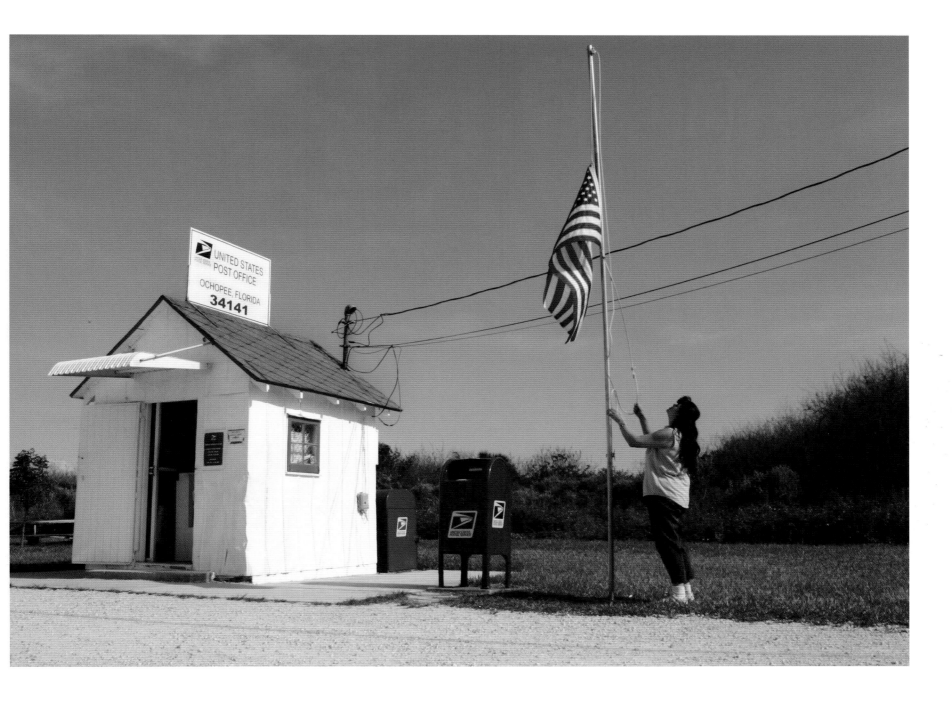

PALM BEACH COUNTY

In the underground lending library they run out of their home, these self-proclaimed anarchists mask their identities behind photographs of Governor Jeb Bush. Part of a 10-member collective, the couple grows their own food in a community garden and distributes leftovers to those in need. The library is known by word-of-mouth to a loose network of friends and colleagues.
Photo by Jacek Gancarz, Palm Beach Daily News

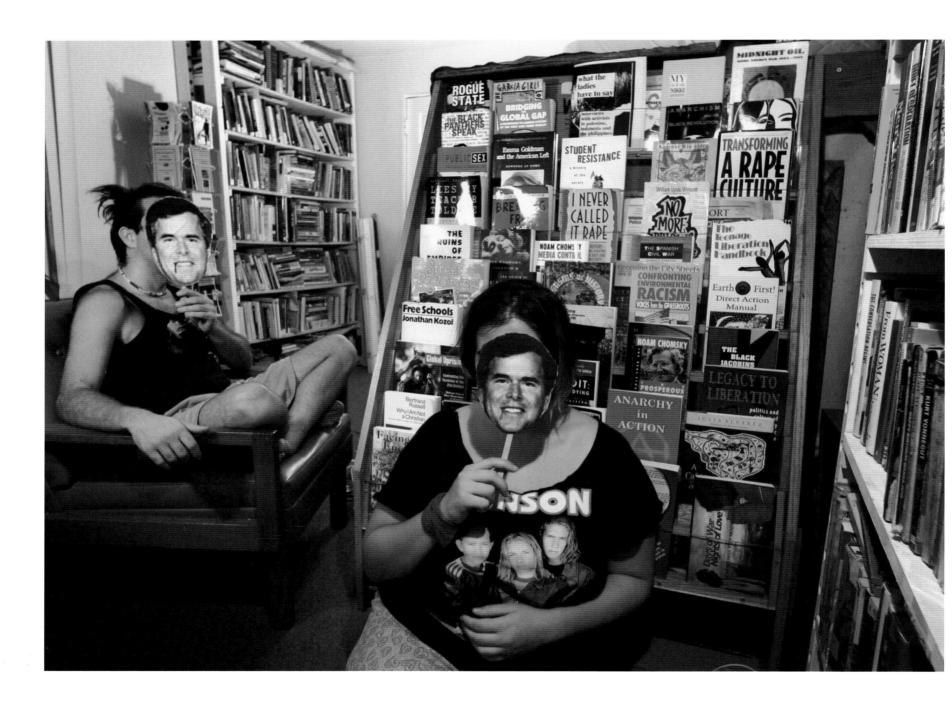

SWEETWATER

In his first bid for political office, businessman Emilio Dominguez gets campaign help from family and friends, including Gingsen Davalos, his niece, Anselmo Cosio, David Taylor, and Lauren Cosio. Dominguez's platform called for more police and city park improvements.

Photo by Nuri Vallbona, The Miami Herald

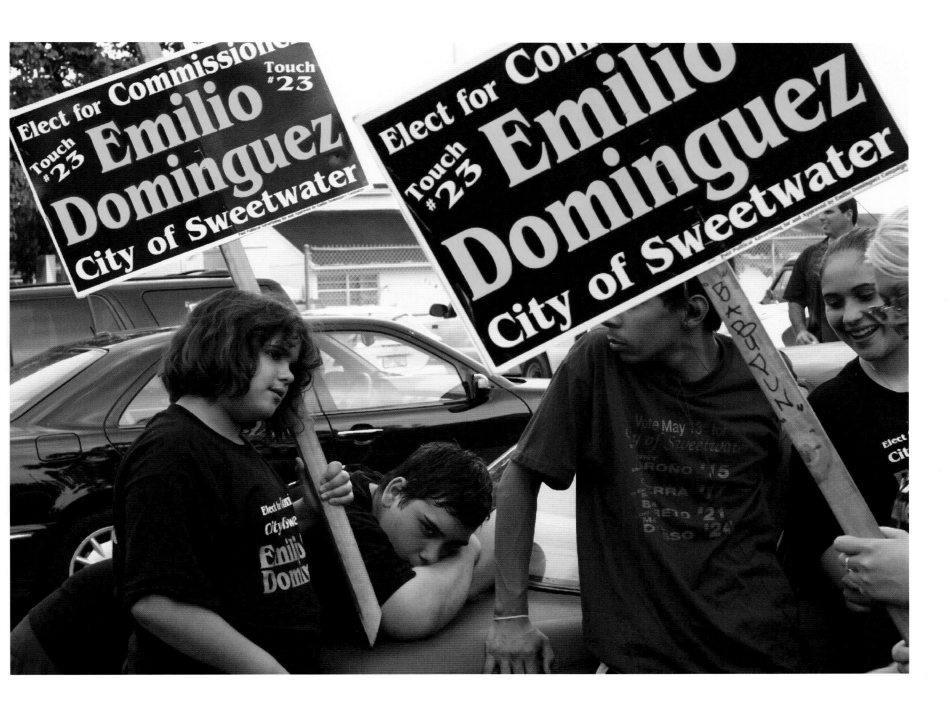

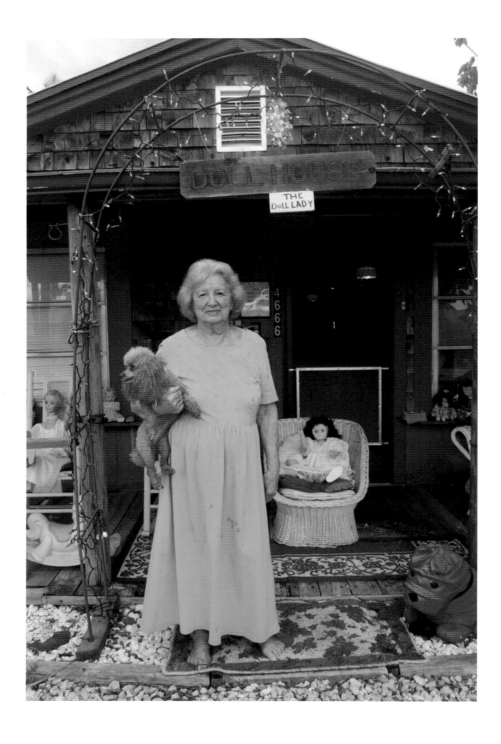

MATLACHA

Locals call her "Doll Lady," a sobriquet that gives no hint of Helen O'Rourke-McClary's powerhouse life: civilian public relations chief for the Pentagon in the 40s, a director for the SS *Hope* hospital ship, founder of the Better Business Bureau's charities' watchdog division, and 40-year fundraiser for the Salvation Army. "I didn't hit the glass ceiling," she says. "I came in above it."
Photo by Lexey Swall, Naples Daily News

KEY LARGO

Jim "Dirtman" Chisholm and William "Doc" Hamilton ride with the U.S. Military Vets Motorcycle Club. On a run south in the Keys from their base in Homestead, they made a pit stop at Alabama Jacks, an open-air bar with live country music favored by bikers and the sailing set. "You see a good mix of people in there, rich and poor," says Dirtman.
Photo by Carol Ellis, Little Salt

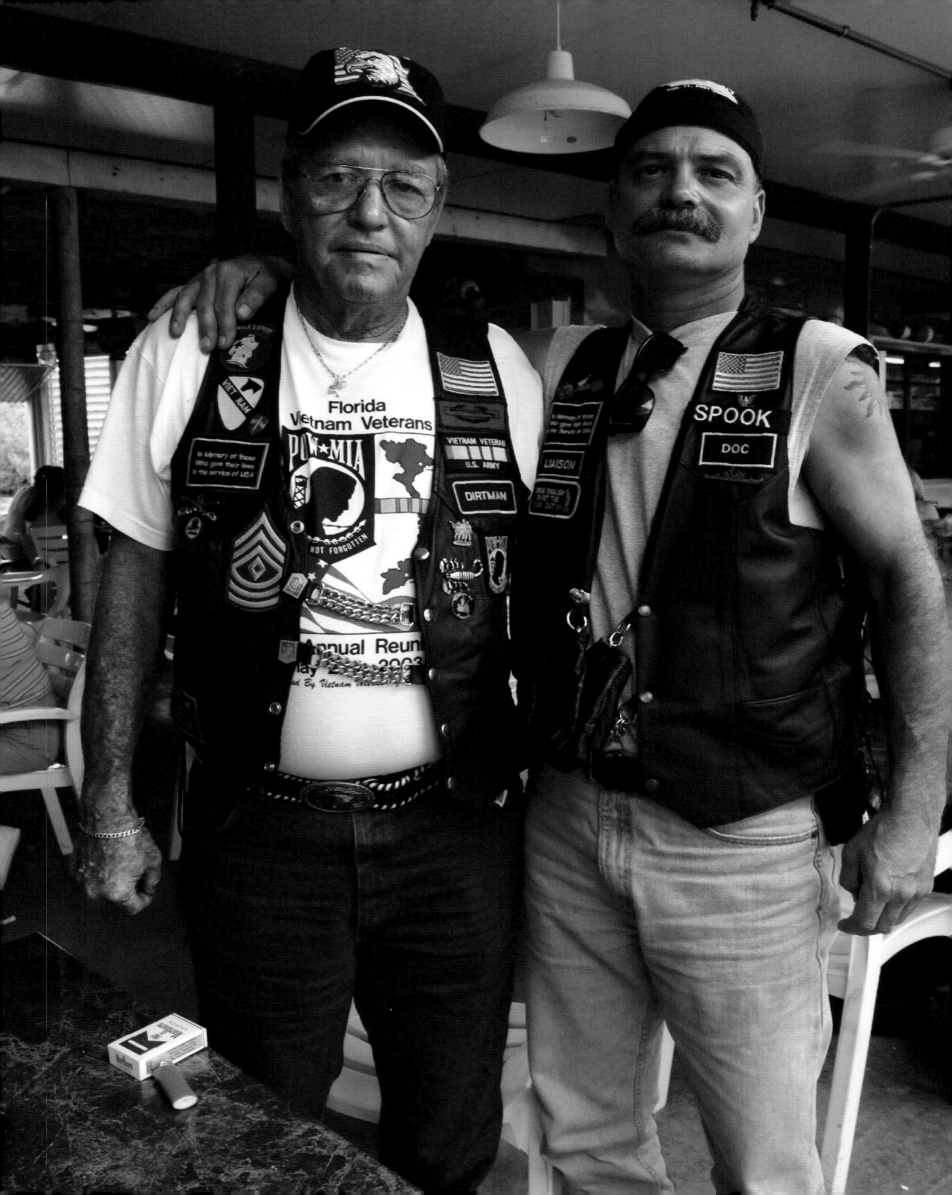

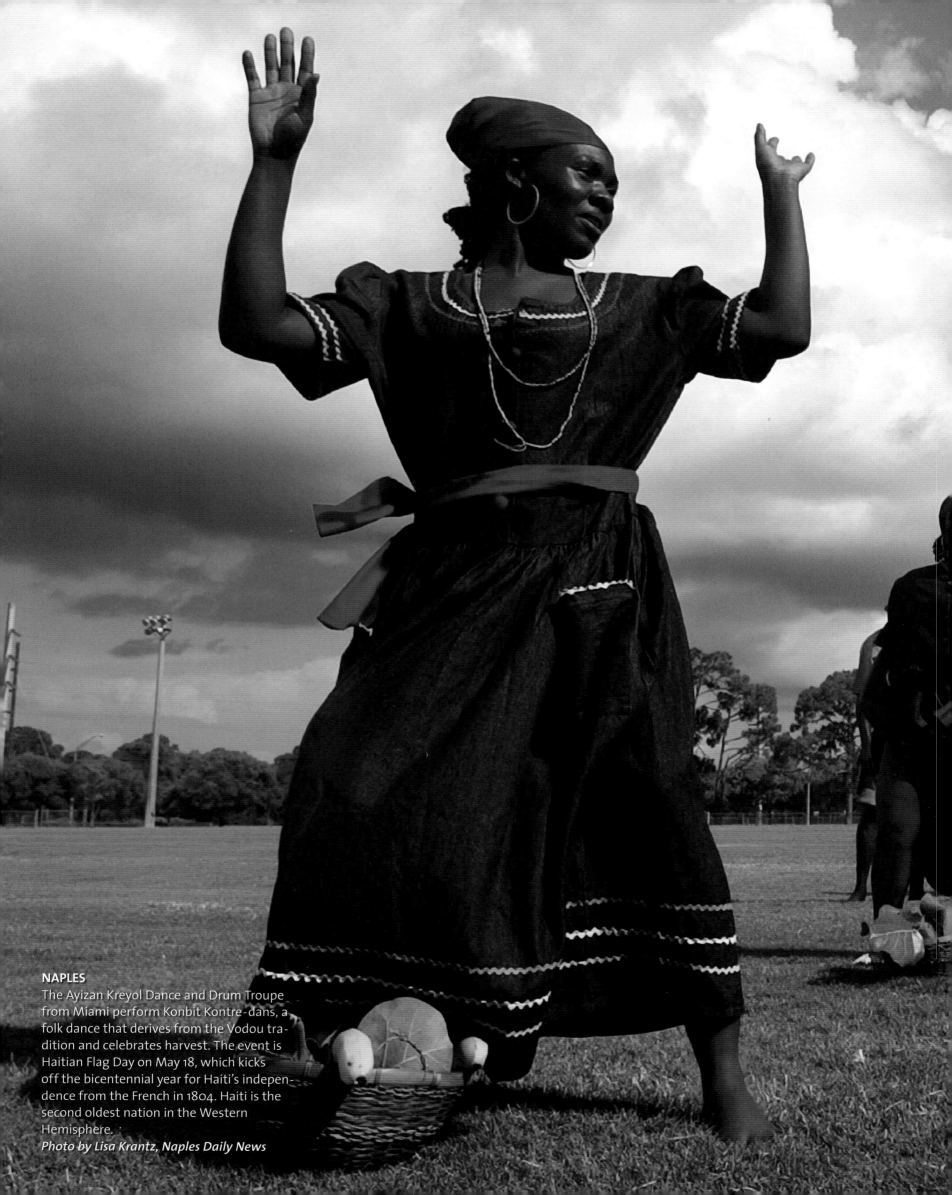

NAPLES

The Ayizan Kreyol Dance and Drum Troupe from Miami perform Konbit Kontre-dans, a folk dance that derives from the Vodou tradition and celebrates harvest. The event is Haitian Flag Day on May 18, which kicks off the bicentennial year for Haiti's independence from the French in 1804. Haiti is the second oldest nation in the Western Hemisphere.

Photo by Lisa Krantz, Naples Daily News

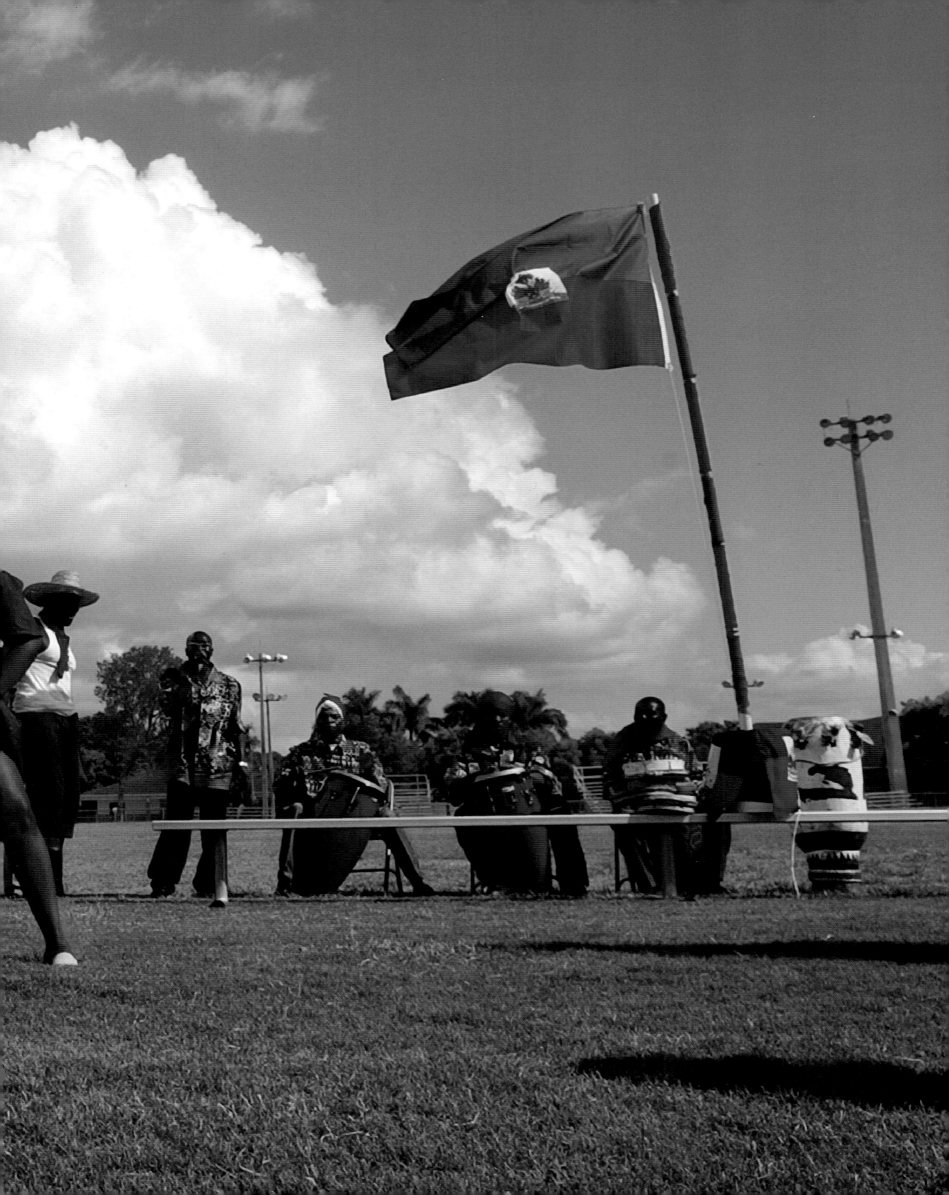

Juan Torres finds a bit of home at La Mexicana, a grocery that imports products from Mexico. An hour inland from Naples, Immokalee has a large population of Mexican, Guatemalan, and Haitian immigrants and seasonal workers. The farming season starts in southern Florida and moves north to other states as crops ripen.
Photo by Lisa Krantz, Naples Daily News

MIAMI

In front of a Flagler Street advertisement for household accessories, Fabiola Mendez shields herself from the stark sunlight. A political refugee of Colombia's civil war, Mendez moved to Miami in 2000 but misses her homeland. "Even exiles consider their home country to be the best place," she says.

Photo by Monica Ortiz

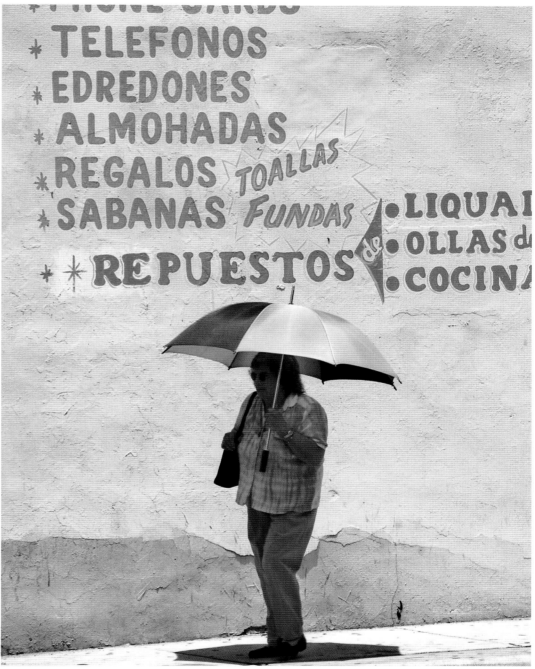

ST. GEORGE ISLAND
Little boxes on the seaside: Developers started building these shotgun row houses in 1993 on a tiny barrier island off the coast of the Florida panhandle. About a third of the land mass is state park, so vacationers can camp or pony up for one of the multitude of condos and beach cottages for rent or sale.
Photo by Greg R. Drzazgowski

ST. GEORGE ISLAND
The arched opening of a real estate sign frames a row house along the Gulf of Mexico. Beach dwellers pay a premium for a piece of this island paradise: $1.5 to $3 million for a gulf-front house or $600,000 for a condo.
Photo by Greg R. Drzazgowski

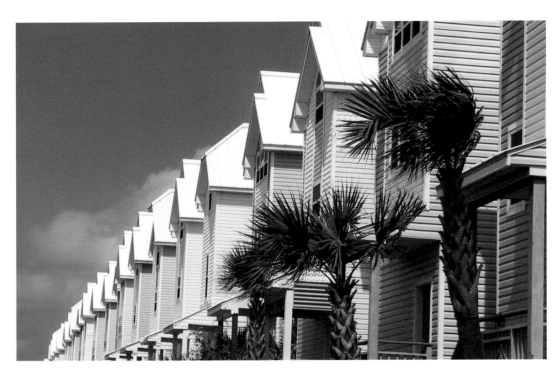

KEY WEST

The southernmost house in the continental United States is located at the end of Duval Street on the Atlantic Ocean side of Key West. A private residence since 1896, the historic home is now open to the public. Among its famous guests: President John F. Kennedy, Queen Isabella and King Ferdinand, and Tennessee Williams.
Photo by Rob O'Neal

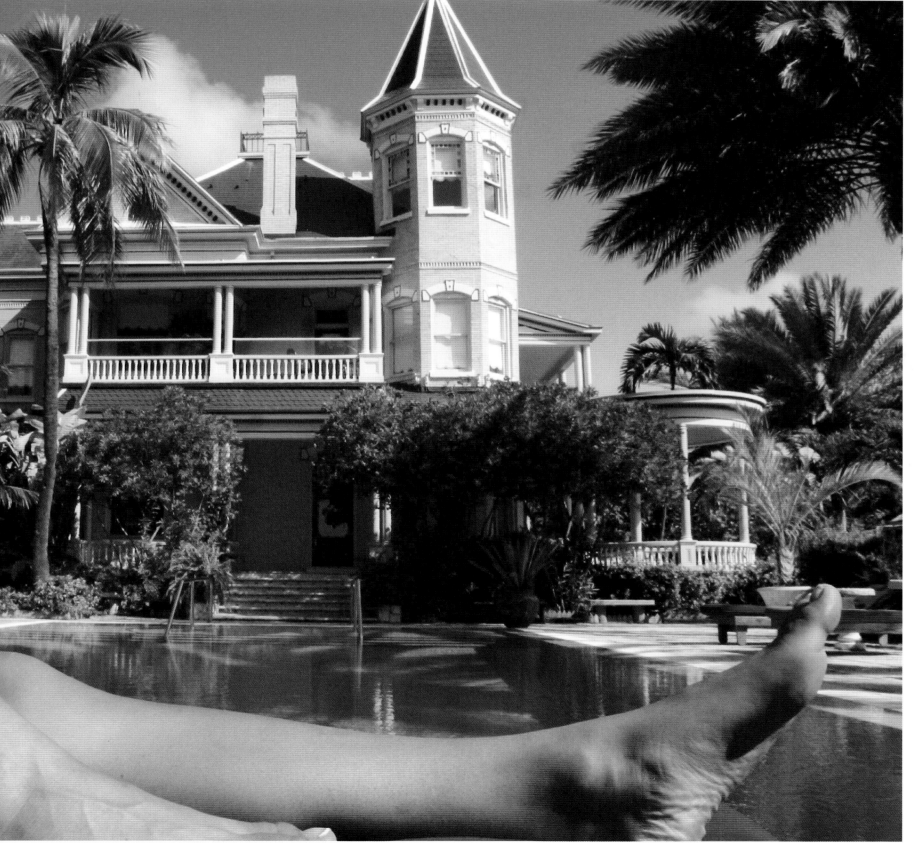

SARASOTA

John Rohs watches the sunset fade from inside Michael Davis's steel, fiberglass, and bronze installation, *The Big Frame*, one of 22 sculptures lining the Sarasota Bayfront. The nonprofit sponsor of the exhibit hoped to engage and provoke public perceptions of public art. Mission accomplished.

Photo by J. Arthur Jorgensen

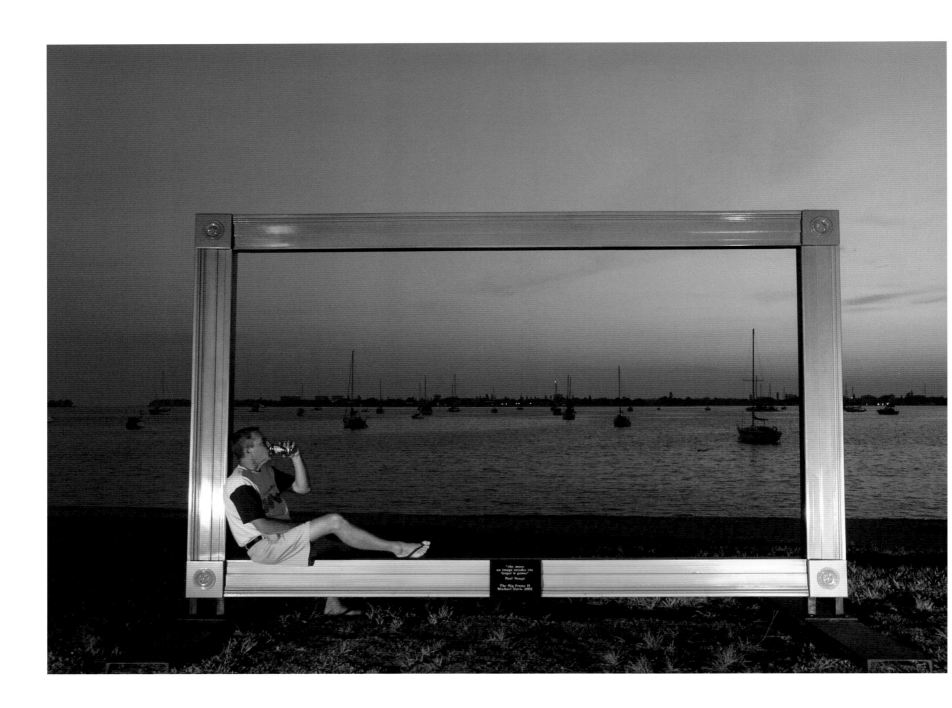

ST. AUGUSTINE

The Spanish built the Castillo de San Marcos fort from coquina stone in 1672. Two weeks of bombardment by the British Navy in 1702 barely disturbed the 4-foot-thick walls, which sheltered 1,500 people. Now the fort is a waystop for tourists seeking the legendary Fountain of Youth site, where conquistadors thought they had found "the waters that maketh old men young."
Photo by D.J. Johnson, www.rave4.com

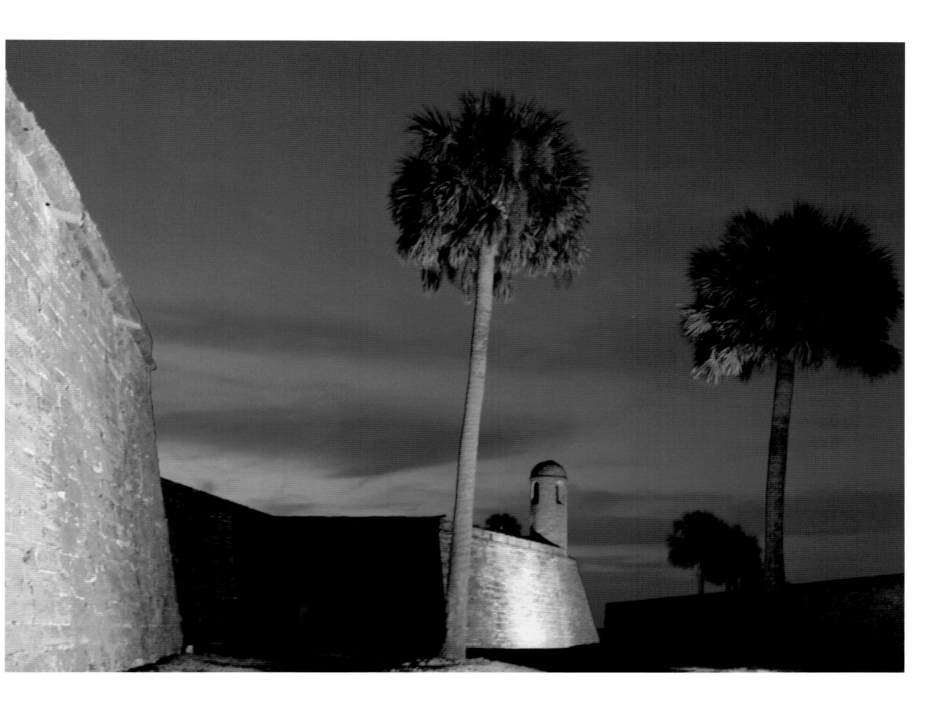

ORLANDO

From a gift shop rooftop, a Tyrannosaurus rex surveys the scene at Pleasure Island, the ostensibly adult face of Disney World with restaurants, evening street parties, and eight nightclubs. Pleasure Island is one of four Disney theme parks to open on the 35,000-acre property since the arrival of the Magic Kingdom in 1971.
Photo by Rafael Tongol

STARKE

While his parents shop for native crafts at the Silver Lining Trading Post, Joshua Fleschmann plays in a tepee where small weddings and prayer pipe ceremonies are held by the First American Culture and Education Preservation Association. The group's 300 members represent 16 of the nation's 550 Native American tribes.
Photo by Jon M. Fletcher, The Florida Times-Union

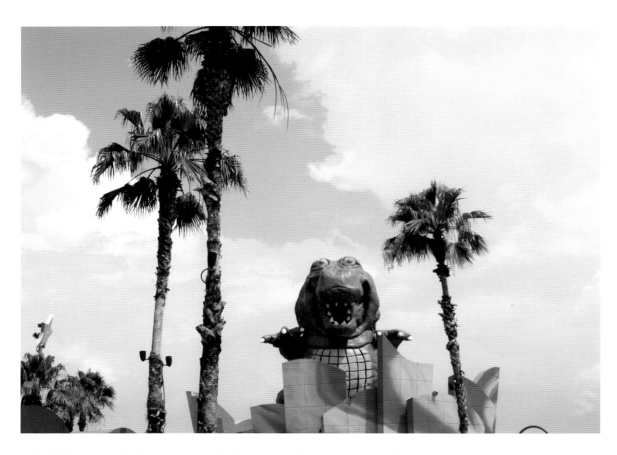

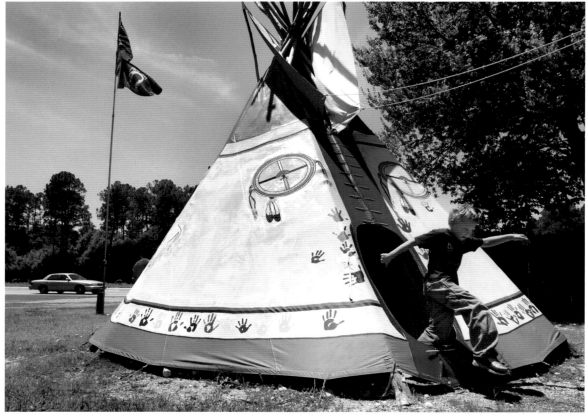

KISSIMMEE

Locals laughed at the idea that people would pay money to see alligators when Gatorland opened in 1949. Unlike its garish entrance on Highway 441, the 110-acre park is mostly a natural habitat for gators, crocs, snakes, and birds. Near Orlando, the attraction tries to compete with Walt Disney World, drawing visitors who like smaller crowds and a more relaxed, old Florida atmosphere.

Photo by John Moran

PANAMA CITY BEACH

Goofy Golf founder Lee Koplin thought the miniature golf courses that came into fashion in the 1920s were too small in scale, so he upped the ante in 1958, building oversized cartoonish obstacles—dinosaurs, apes, pyramids—all along the course. Joel Goos from Winston, Georgia, searches for his "goof ball" while his kids Kaley and Mark wait.

Photo by Craig Litten, Tallahassee Democrat

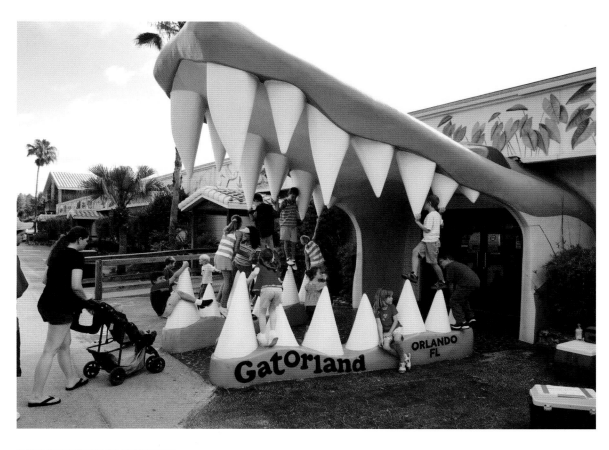

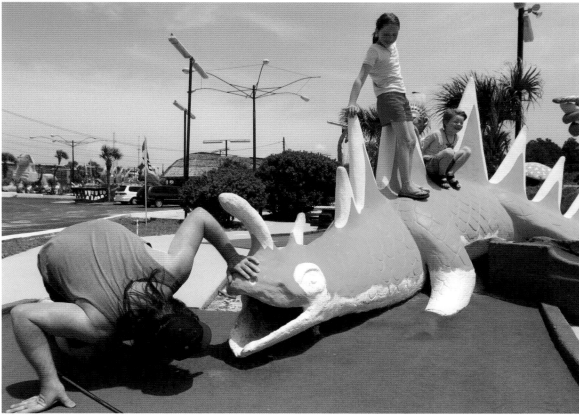

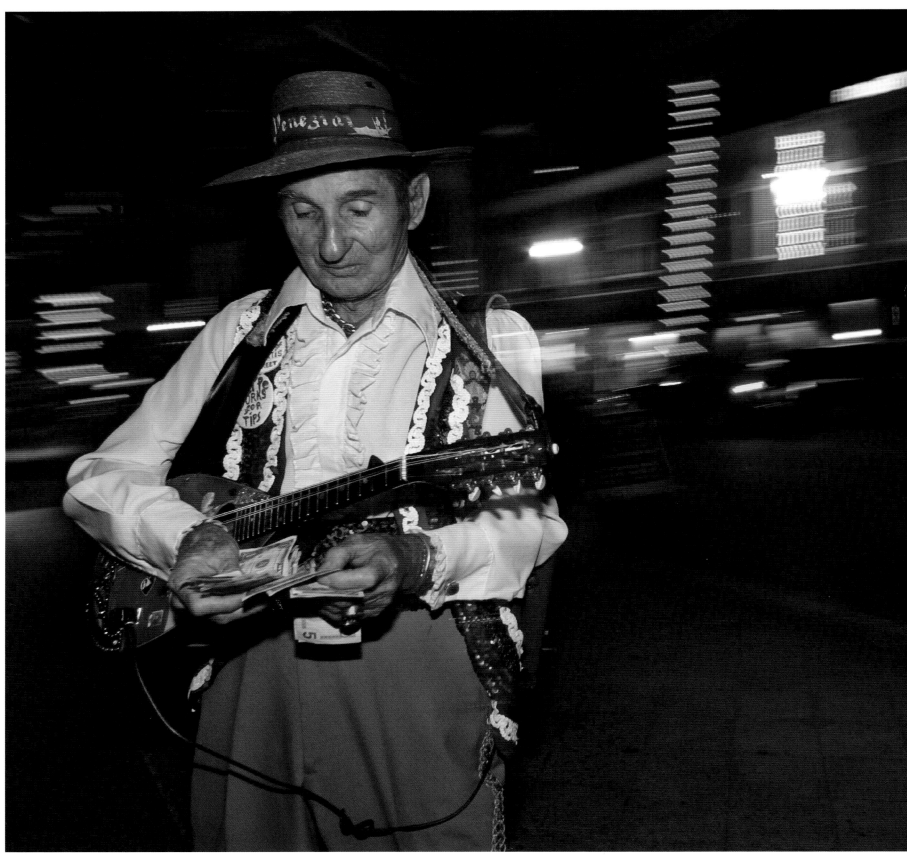

WEST PALM BEACH

Street musician Peppe Pepsidero has been play-
ing his electric mandolin for 60 years. For the
past five, he's been a regular fixture at Clematis
by Night, a weekly outdoor food and music festi-
val where he plays his favorite Italian classics
such as "Torno Sorrento" and "O Sole Mio."
Photo by Jacek Gancarz, Palm Beach Daily News

MARCO ISLAND
Junior Alvin Marte nuzzles into senior Yadira Viamonte on the dance floor during the Lely High School Junior/Senior Prom. The event, held at the Marco Island Marriott, was as cosmopolitan as the student body, with its Asian theme—dragons abounded everywhere—and music ranging from reggae to Latin and hip-hop.
Photo by Dan Wagner

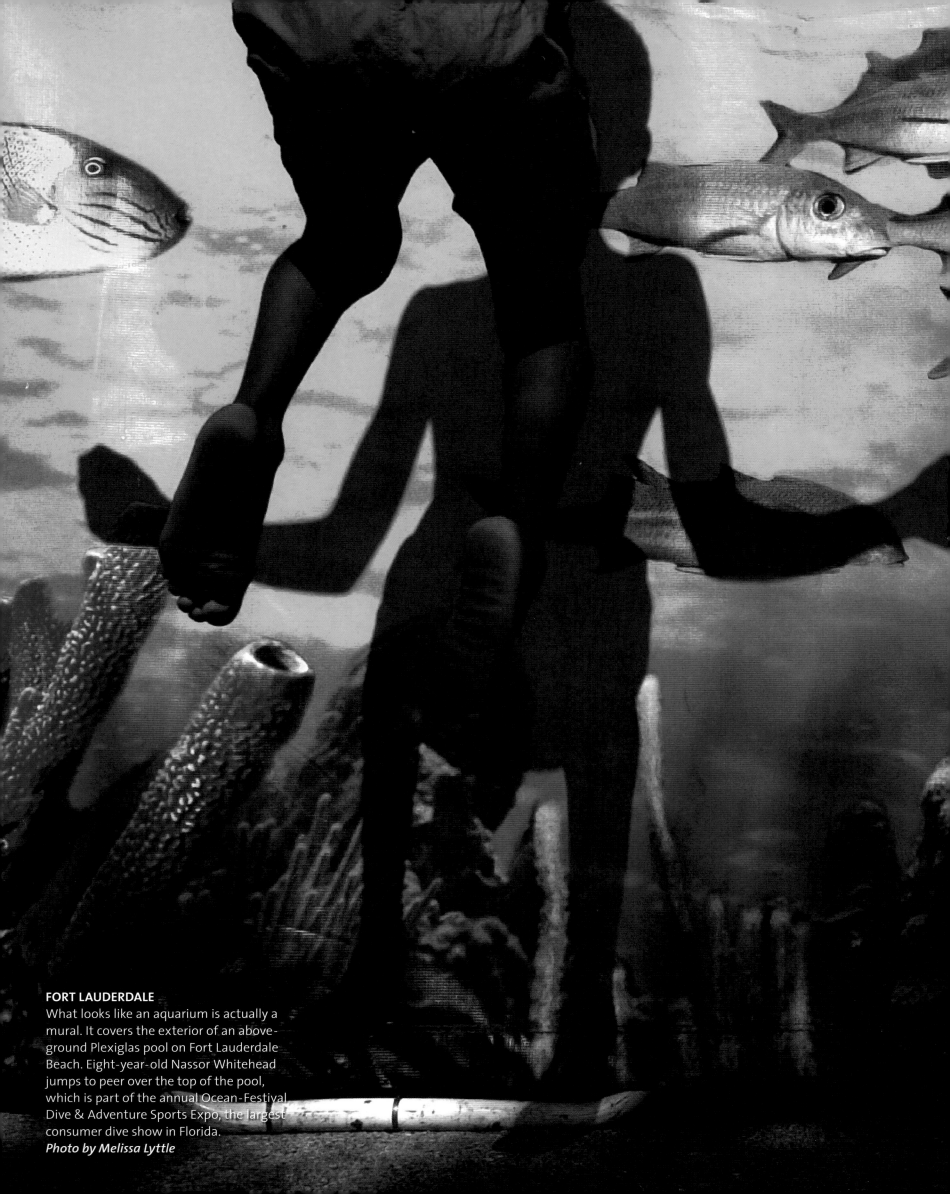

FORT LAUDERDALE
What looks like an aquarium is actually a mural. It covers the exterior of an above-ground Plexiglas pool on Fort Lauderdale Beach. Eight-year-old Nassor Whitehead jumps to peer over the top of the pool, which is part of the annual Ocean-Festival Dive & Adventure Sports Expo, the largest consumer dive show in Florida.
Photo by Melissa Lyttle

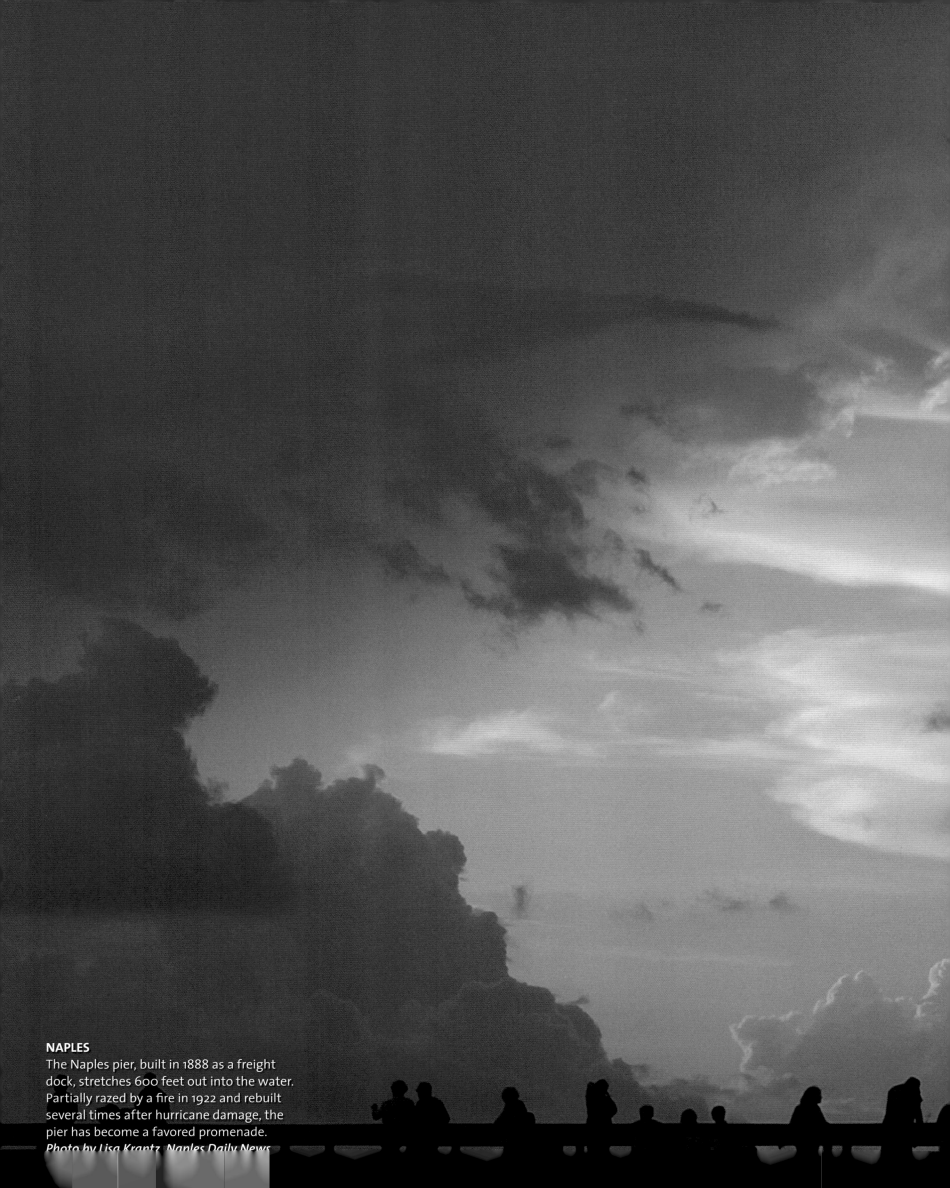

NAPLES
The Naples pier, built in 1888 as a freight
dock, stretches 600 feet out into the water.
Partially razed by a fire in 1922 and rebuilt
several times after hurricane damage, the
pier has become a favored promenade.
Photo by Lisa Krantz, Naples Daily News

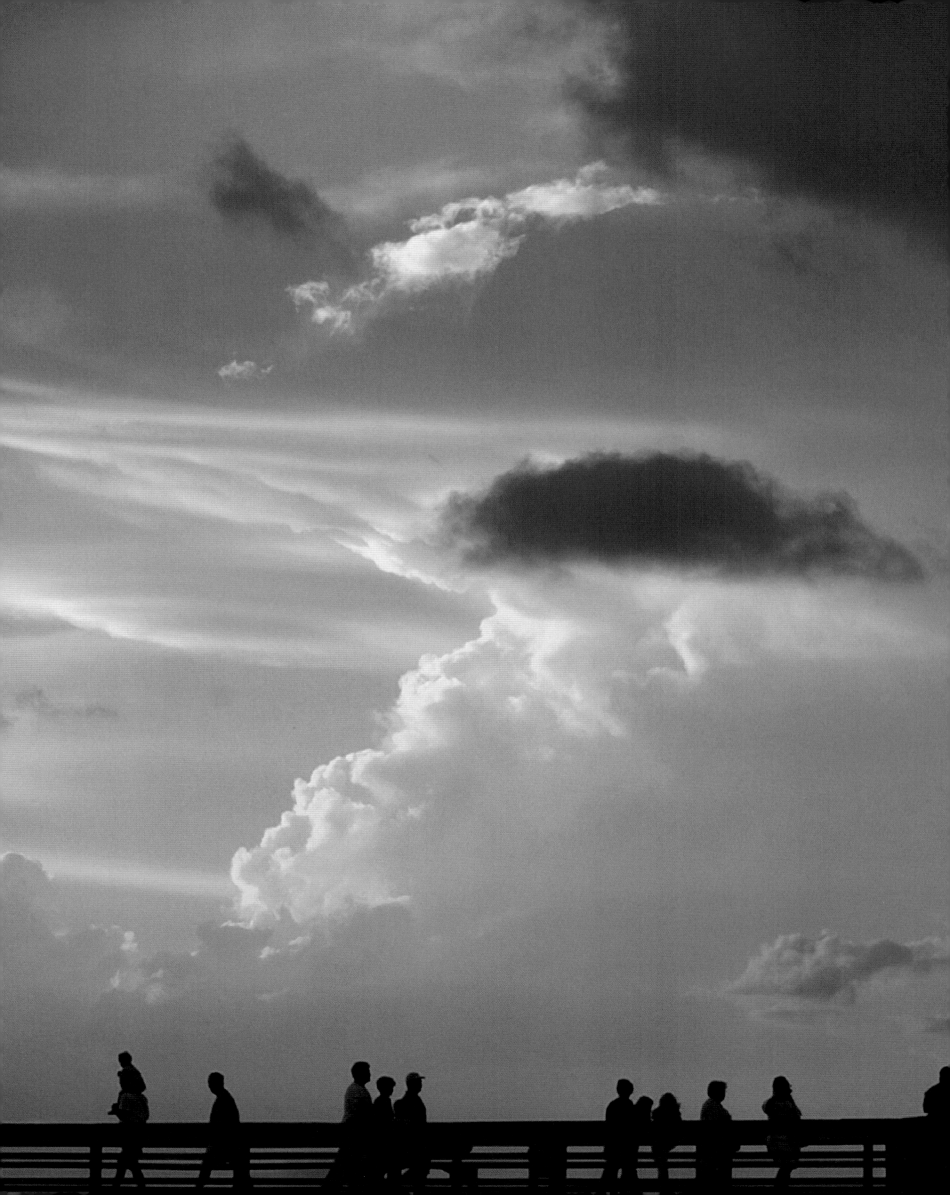

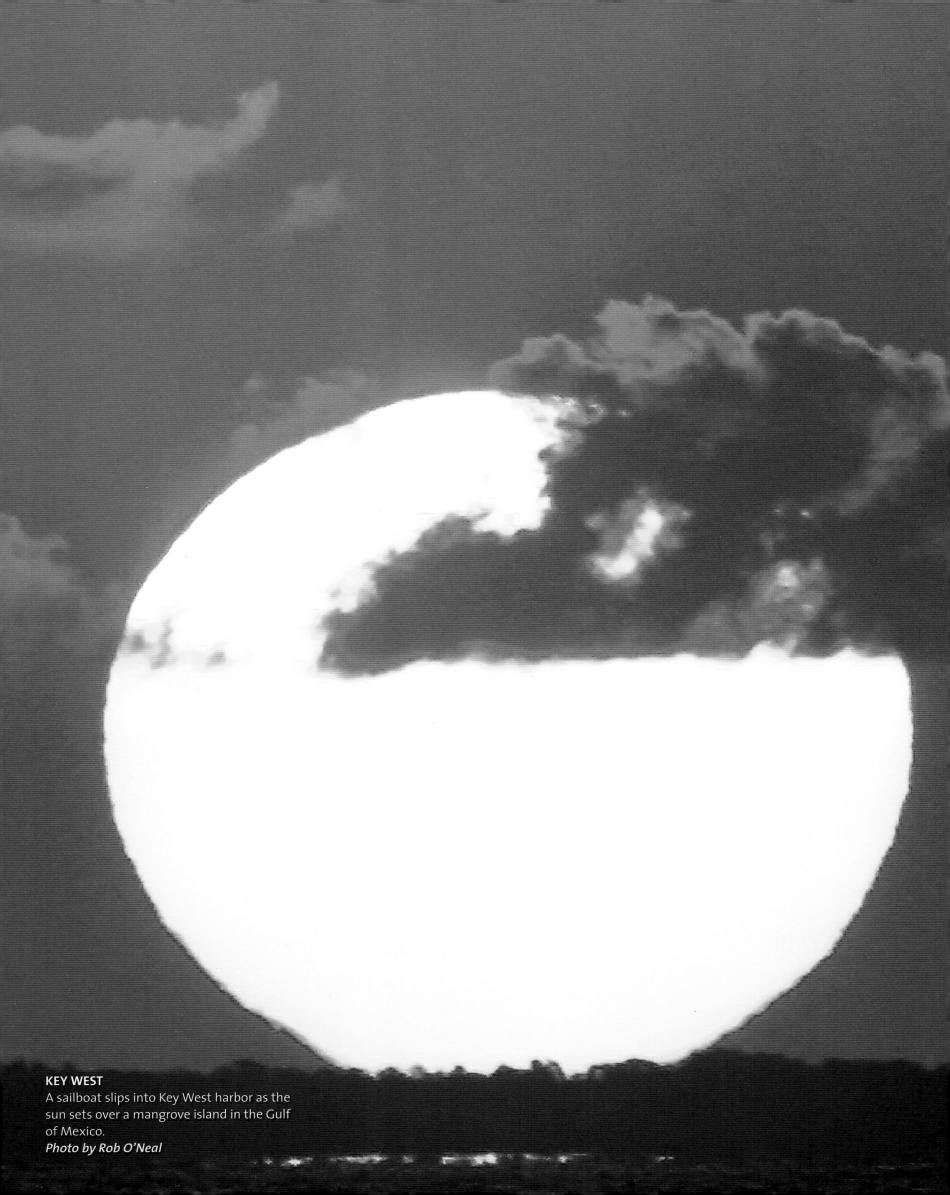

KEY WEST
A sailboat slips into Key West harbor as the sun sets over a mangrove island in the Gulf of Mexico.
Photo by Rob O'Neal

How It Worked

The week of May 12-18, 2003, more than 25,000 professional and amateur photographers spread out across the nation to shoot over a million digital photographs with the goal of capturing the essence of daily life in America.

The professional photographers were equipped with Adobe Photoshop and Adobe Album software, Olympus C-5050 digital cameras, and Lexar Media's high-speed compact flash cards.

The 1,000 professional contract photographers plus another 5,000 stringers and students sent their images via FTP (file transfer protocol) directly to the *America 24/7* website. Meanwhile, thousands of amateur photographers uploaded their images to Snapfish's servers.

At *America 24/7*'s Mission Control headquarters, located at CNET in San Francisco, dozens of picture editors from the nation's most prestigious publications culled the images down to 25,000 of the very best, using Photo Mechanic by Camera Bits. These photos were transferred into Webware's ActiveMedia Digital Asset Management (DAM) system, which served as a central image library and enabled the designers to track, search, distribute, and reformat the images for the creation of the 51 books, foreign language editions, web and magazine syndication, posters, and exhibitions.

Once in the DAM, images were optimized (and in some cases resampled to increase image resolution) using Adobe Photoshop. Adobe InDesign and Adobe InCopy were used to design and produce the 51 books, which were edited and reviewed in multiple locations around the world in the form of Adobe Acrobat PDFs. Epson Stylus printers were used for photo proofing and to produce large-format images for exhibitions. The companies providing support for the *America 24/7* project offer many of the essential components

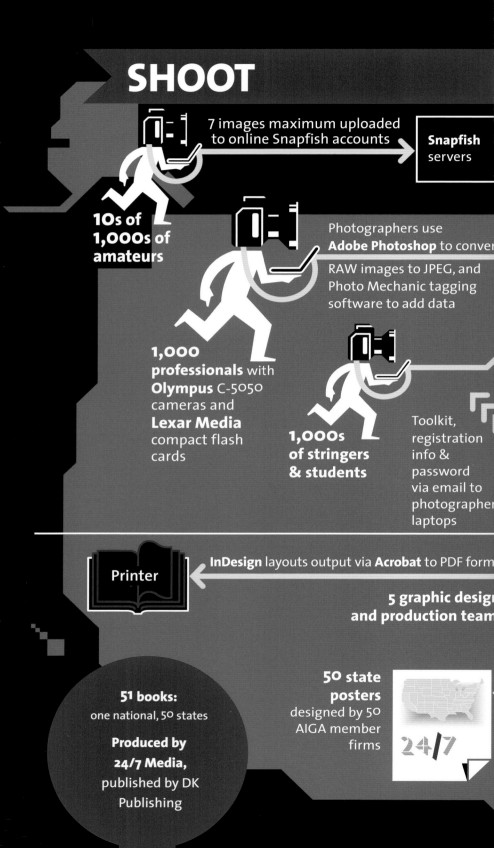

SHOOT

7 images maximum uploaded to online Snapfish accounts

Snapfish servers

10s of 1,000s of amateurs

Photographers use **Adobe Photoshop** to conver
RAW images to JPEG, and Photo Mechanic tagging software to add data

1,000 professionals with **Olympus** C-5050 cameras and **Lexar Media** compact flash cards

1,000s of stringers & students

Toolkit, registration info & password via email to photographer laptops

Printer

InDesign layouts output via **Acrobat** to PDF form

5 graphic desig and production team

51 books: one national, 50 states

Produced by 24/7 Media, published by DK Publishing

50 state posters designed by 50 AIGA member firms

24/7

DESIGN & PUBLISH

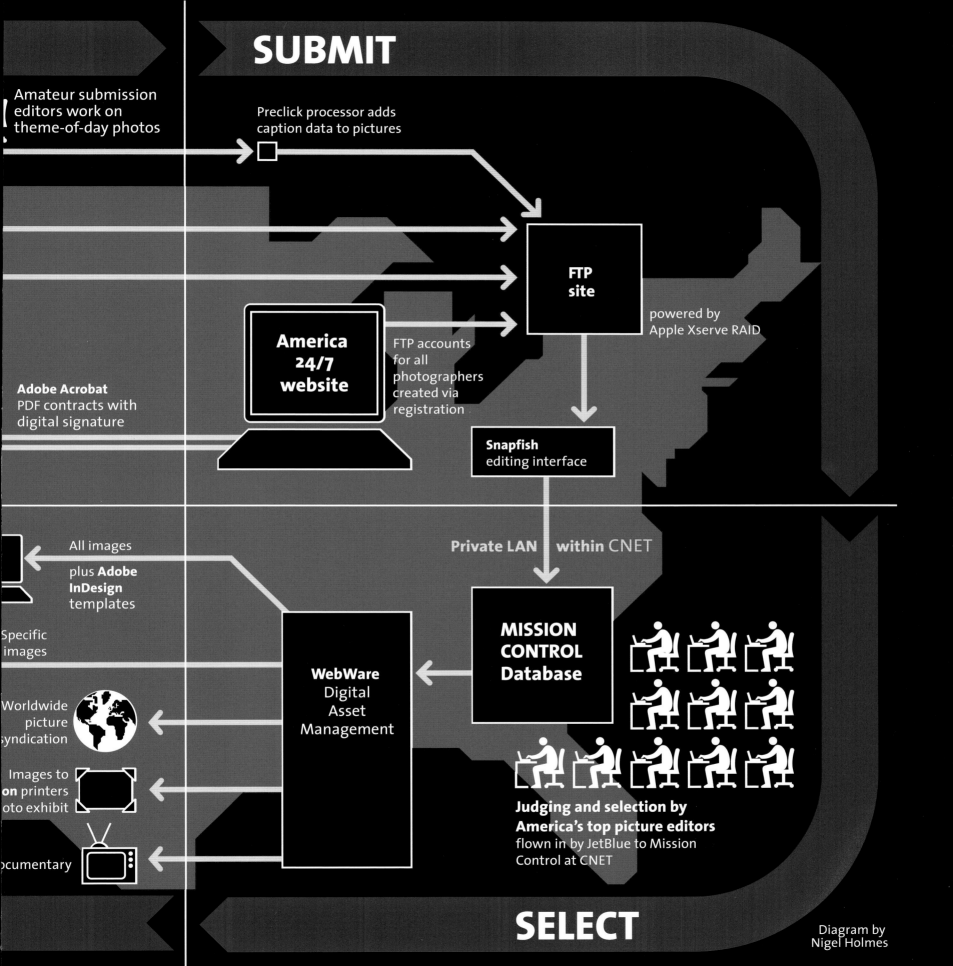

SUBMIT

Amateur submission editors work on theme-of-day photos

Preclick processor adds caption data to pictures

FTP site

powered by Apple Xserve RAID

America 24/7 website

FTP accounts for all photographers created via registration

Adobe Acrobat PDF contracts with digital signature

Snapfish editing interface

All images

plus **Adobe InDesign** templates

Specific images

Private LAN within CNET

MISSION CONTROL Database

WebWare Digital Asset Management

Worldwide picture syndication

Images to **on** printers oto exhibit

Judging and selection by America's top picture editors flown in by JetBlue to Mission Control at CNET

ocumentary

SELECT

Diagram by Nigel Holmes

About Our Sponsors

America 24/7 gave digital photographers of all levels the opportunity to share their visions of what it means to live in the United States. This project was made possible by a digital photography revolution that is dramatically changing and improving picture-taking for professionals and amateurs alike. And an Adobe product, Photoshop®, has been at the center of this sea change.

Adobe's products reflect our customers' passion for the creative process, be it the photographer, graphic designer, layout artist, or printer. Adobe is the Publishing and Imaging Software Partner for *America 24/7* and products such as Adobe InDesign®, Photoshop, Acrobat®, and Illustrator® were used to produce this stunning book in a matter of weeks. We hope that our software has helped do justice to the mythic images, contributed by well-known photographers and the inspired hobbyist.

Adobe is proud to be a lead sponsor of *America 24/7*, a project that celebrates the vibrancy of the American spirit: the same spirit that helped found Adobe and inspires our employees and customers to deliver the very best.

Bruce Chizen
President and CEO
Adobe Systems Incorporated

Olympus, a global technology leader in designing precision healthcare solutions and innovative consumer electronics, is proud to be the official digital camera sponsor of *America 24/7*. The opportunity to introduce Americans from coast to coast to the thrill, excitement, and possibility of digital photography makes the vision behind this book a perfect fit for Olympus, a leader in digital cameras since 1996.

For most people, the essence of digital photography is best grasped through firsthand experience with the technology, which is precisely what *America 24/7* is about. We understand that direct experience is the pathway to inspiration, and welcome opportunities like this sponsorship to bring the power of the digital experience into the lives of people everywhere. To Olympus, *America 24/7* offers a platform to help realize a core mission: to deliver and make accessible the power of the digital experience to millions of American photographers, amateurs, and professionals alike.

The 1,000 professional photographers contracted to shoot on the America 24/7 project were all equipped with Olympus C-5050 digital cameras. Like all Olympus products, the C-5050 is offered by a company well known for designing, manufacturing, and servicing products used by professionals to perform their work, every day. Olympus is a customer-centric company committed to working one-to-one with a diverse group of professionals. From biomedical researchers who use our clinical microscopes, to doctors who perform life-saving procedures with our endoscopes, to professional photographers who use cameras in their daily work, Olympus is a trusted brand.

The digital imaging technology involved with *America 24/7* has enabled the soul of America to be visually conveyed, not just by professional observers, but by the American public who participated in this project—the very people who collectively breath life into this country's existence each day.

We are proud to be enabling so many photographers to capture the pictures on these pages that tell the story of who we are as a nation. From sea to shining sea, digital imagery allows us to connect to one another in ways we never dreamed possible.

At Olympus, our ideas have proliferated as rapidly as technology has evolved. We have channeled these visions into breakthrough products and solutions to meet the demands of our changing world-products like microscopes, endoscopes, and digital voice recorders, supported by the highly regarded training, educational, and consulting services we offer our customers.

Today, 83 years after we introduced our first microscope, we remain as young, as curious, and as committed as ever.

Lexar Media has grown from the digital photography revolution, which is why we are proud to have supplied the digital memory cards used in the America 24/7 project. Lexar Media's high-performance memory cards utilize our unique and patented controller coupled with high-speed flash memory from Samsung, the world's largest flash memory supplier. This powerful combination brings out the ultimate performance of any digital camera.

Photographers who demand the most from their equipment choose our products for their advanced features like write speeds up to 40X, Write Acceleration technology for enabled cameras, and Image Rescue, which recovers previously deleted or lost images. Leading camera manufacturers bundle Lexar Media digital memory cards with their cameras because they value its performance and reliability.

Lexar Media is at the forefront of digital photography as it transforms picture-taking worldwide, and we will continue to be a leader with new and innovative solutions for professionals and amateurs alike.

Snapfish, which developed the technology behind the *America 24/7* amateur photo event, is a leading online photo service, with more than 5 million members and 100 million photos posted online. Snapfish enables both film and digital camera owners to share, print, and store their most important photo memories, at prices that cannot be equaled. Digital camera users upload photos into a password-protected online album for free. Users can also order film-quality prints on professional photographic paper for as low as 25¢. Film camera users get a full set of prints, plus online sharing and storage, for just $2.99 per roll.

Founded in 1995, eBay created a powerful platform for the sale of goods and services by a passionate community of individuals and businesses. On any given day, there are millions of items across thousands of categories for sale on eBay. eBay enables trade on a local, national and international basis with customized sites in markets around the world.

Through an array of services, such as its payment solution provider PayPal, eBay is enabling global e-commerce for an ever-growing online community.

JetBlue Airways is proud to be *America 24/7's* preferred carrier, flying photographers, photo editors, and organizers across the United States.

Winner of Condé Nast Traveler's Readers' Choice Awards for Best Domestic Airline 2002, JetBlue provides friendly service and low fares for travelers in 22 cities in nine states across America.

On behalf of JetBlue's 5,000 crew members, we're excited to be involved in this remarkable project, and for the opportunity to serve American travelers each and every day, coast to coast, 24/7.

DIGITAL POND

Digital Pond has been a leading creator of large graphic displays for museums, corporations, trade shows, retail environments and fine art since 1992.

We were proud to bring together our creative, print and display capabilities to produce signage and displays for mission control, critical retouching for numerous key images for the book, and art galleries for the New York Public Library and Bryant Park.

The Pond's team and SplashPic® Online service enabled us to nimbly design, produce and install over 200 large graphic panels in two NYC locations within the truly "24/7" production schedule of less than ten days.

WebWare Corporation is pleased to be a major sponsor of the America 24/7 project. We take pride in being part of a groundbreaking adventure that is stretching the boundaries—and the imagination—in digital photography, digital asset management, publishing, news, and global events.

Our ActiveMedia Enterprise™ digital asset management software is the "nerve center" of *America 24/7*, the central repository for managing, sharing, and collaborating on the project's photographs. From photo editors and book publishers to 24/7's media relations and marketing personnel, ActiveMedia provides the application support that links all facets of the project team to the content worldwide.

WebWare helps Global 2000 firms securely manage, reuse, and distribute media assets locally or globally. Its suite of ActiveMedia software products provide powerful media services platforms for integrating rich media into content management systems marketing and communication portals; web publishing systems; and e-commerce portals.

Google

Google's mission is to organize the world's information and make it universally accessible and useful.

With our focus on plucking just the right answer from an ocean of data, we were naturally drawn to the America 24/7 project. The book you hold is a compendium of images of American life distilled from thousands of photographs and infinite possibilities. Are you looking for emotion? Narrative? Shadows? Light? It's all here, thanks to a multitude of photographers and writers creating links between you, the reader, and a sea of wonderful stories. We celebrate the connections that constitute the human experience and are pleased to help engender them. And we're pleased to have been a small part of this project, which captures the results of that interaction so vividly, so dynamically, and so dramatically.

Special thanks to additional contributors: FileMaker, Apple, Camera Bits, LaCie, Now Software, Preclick, Outpost Digital, Xerox, Microsoft, WoodWing Software, net-linx Publishing Solutions, and Radical Media. The Savoy Hotel, San Francisco; The Pan Pacific, San Francisco; Four Seasons Hotel, San Francisco; and The Queen Anne Hotel. Photography editing facilities were generously hosted by CNET Networks, Inc.

Participating Photographers

Coordinator: Sherman Zent, Photo Editor, *St. Petersburg Times*

Lori Bale
Bruce R. Bennett
Lynn Berreitter
Gary Bogdon
Cheryl Anne Day-Swallow
Greg R. Drzazgowski
Carol Ellis, *Little Salt*
Joe Farkas
Jon M. Fletcher, *The Florida Times-Union*
John Flood
Brian Fogarty
Jamie Francis, *St. Petersburg Times*
Pete Gabardini
Jacek Gancarz, *Palm Beach Daily News*
Red Huber, *Orlando Sentinel*
D.J. Johnson, www.rave4.com
Kelly Jordan, *Daytona Beach News-Journal*
J. Arthur Jorgensen
Andrew Kaufman, Contact Press Images
Lisa Krantz, *Naples Daily News*
Ira Lewis
Chip Litherland, *Sarasota Herald-Tribune*
Craig Litten, *Tallahassee Democrat*

Melissa Lyttle
Preston Mack
Gary McCracken, *Pensacola News Journal*
John Moran
Julian Olivas
Rob O'Neal
Monica Ortiz
Beth Reynolds,
The Photo-Documentary Press, Inc.
Phil Sears, *Tallahassee Democrat*
Bob Self, *The Florida Times-Union*
Katie Spears
David Spencer, *The Palm Beach Post*
Raven Stone
Lexey Swall, *Naples Daily News*
Rafael Tongol
Angel Valentin*, *South Florida Sun-Sentinel*
Nuri Vallbona, *The Miami Herald*
Ben Van Hook
Dan Wagner

*Pulitzer Prize winner

Thumbnail Picture Credits

Credits for thumbnail photographs are listed by the page number and are in order from left to right.

22 Lisa Krantz, *Naples Daily News*
Bruce R. Bennett
Lisa Krantz, *Naples Daily News*
Jacek Gancarz, *Palm Beach Daily News*
Jacek Gancarz, *Palm Beach Daily News*
Lisa Krantz, *Naples Daily News*
Jamie Francis, *St. Petersburg Times*

23 Lisa Krantz, *Naples Daily News*
Jacek Gancarz, *Palm Beach Daily News*
Ben Van Hook
Lisa Krantz, *Naples Daily News*
Ben Van Hook
Lisa Krantz, *Naples Daily News*
Jacek Gancarz, *Palm Beach Daily News*

24 Gary Bogdon
Lisa Krantz, *Naples Daily News*
Ben Van Hook
Lisa Krantz, *Naples Daily News*
Ben Van Hook
Dan Wagner
Lisa Krantz, *Naples Daily News*

25 Lisa Krantz, *Naples Daily News*
Dan Wagner
Lisa Krantz, *Naples Daily News*
Rob Mattson, *Sarasota Herald-Tribune*
Dan Wagner
Craig Litten, *Tallahassee Democrat*
Gary Bogdon

28 Ben Van Hook
Jacek Gancarz, *Palm Beach Daily News*
Claudette Roehl
Claudette Roehl
Jacek Gancarz, *Palm Beach Daily News*
Jacek Gancarz, *Palm Beach Daily News*
Jacek Gancarz, *Palm Beach Daily News*

29 Jacek Gancarz, *Palm Beach Daily News*
Jon M. Fletcher, *The Florida Times-Union*
Jacek Gancarz, *Palm Beach Daily News*
Jon M. Fletcher, *The Florida Times-Union*
Gary Bogdon

Jon M. Fletcher, *The Florida Times-Union*
Kelly Jordan, *Daytona Beach News-Journal*

30 Nuri Vallbona, *The Miami Herald*
Lisa Krantz, *Naples Daily News*
Lisa Krantz, *Naples Daily News*
Lisa Krantz, *Naples Daily News*
Lisa Krantz, *Naples Daily News*
Lisa Krantz, *Naples Daily News*
Lisa Krantz, *Naples Daily News*

31 Lisa Krantz, *Naples Daily News*
Lisa Krantz, *Naples Daily Newss*
Lisa Krantz, *Naples Daily News*
Lisa Krantz, *Naples Daily News*
Lisa Krantz, *Naples Daily News*
Lisa Krantz, *Naples Daily News*
Nuri Vallbona, *The Miami Herald*

34 Ben Van Hook
Bruce R. Bennett
Bruce R. Bennett
Lori Bale
Chip Litherland, *Sarasota Herald-Tribune*
Ben Van Hook
D.J. Johnson, www.rave4.com

35 Carol Ellis, ri Bale
Ben Van Hook
Chip Litherland, *Sarasota Herald-Tribune*
Rob O'Neal
Rob O'Neal
Maria Ines Candia

38 Preston Mack
Carol Ellis, *Little Salt*
Carol Ellis, *Little Salt*
Jacek Gancarz, *Palm Beach Daily News*
Claudette Roehl
Craig Litten, *Tallahassee Democrat*
Preston Mack

39 Claudette Roehl
Preston Mack
Preston Mack
Rick Bethem

Preston Mack
Carol Ellis, *Little Salt*
Jacek Gancarz, *Palm Beach Daily News*

40 Ben Van Hook
Rob O'Neal
Ben Van Hook
Rob O'Neal
Ben Van Hook
Ben Van Hook
Ben Van Hook

41 Ben Van Hook
Melissa Lyttle
Ben Van Hook
Craig Litten, *Tallahassee Democrat*
Melissa Lyttle
Melissa Lyttle
Rob O'Neal

51 Gary McCracken, *Pensacola News Journal*
Phil Sears, *Tallahassee Democrat*
Gary McCracken, *Pensacola News Journal*
Craig Litten, *Tallahassee Democrat*
Gary McCracken, *Pensacola News Journal*
Gary McCracken, *Pensacola News Journal*
Gary McCracken, *Pensacola News Journal*

52 Gary Bogdon
Gary Bogdon
Gary Bogdon
Gary Bogdon
Gary Bogdon
Gary Bogdon
Gary Bogdon

54 Garth Francis, *The News-Press*
Andrew Kaufman, Contact Press Images
Nuri Vallbona, *The Miami Herald*
Andrew Kaufman, Contact Press Images
Andrew Kaufman, Contact Press Images
Andrew Kaufman, Contact Press Images
Andrew Kaufman, Contact Press Images

55 Garth Francis, *The News-Press*
Andrew Kaufman, Contact Press Images
J. Arthur Jorgensen
Beth Reynolds, The Photo-Documentary Press, Inc.
Andrew Kaufman, Contact Press Images
Beth Reynolds, The Photo-Documentary Press, Inc.
Andrew Kaufman, Contact Press Images

56 Phil Sears, *Tallahassee Democrat*
Rob O'Neal
Phil Sears, *Tallahassee Democrat*
Jacek Gancarz, *Palm Beach Daily News*
Andrew Kaufman, Contact Press Images
Kelly Jordan, *Daytona Beach News-Journal*
Andrew Kaufman, Contact Press Images

57 Carol Ellis, *Little Salt*
Kelly Jordan, *Daytona Beach News-Journal*
Ralph Arwood, Inside-Out Photography, Inc.
Phil Sears, *Tallahassee Democrat*
Carol Ellis, *Little Salt*
Ralph Arwood, Inside-Out Photography, Inc.
Rob O'Neal

60 Del Ihle
Matthew A. Baker
Red Huber, *Orlando Sentinel*
Matthew A. Baker
Matthew A. Baker
Del Ihle
Matthew A. Baker

61 Matthew A. Baker
Ralph Arwood, Inside-Out Photography, Inc.
Matthew A. Baker
Preston Mack
Red Huber, *Orlando Sentinel*
Scott Germain, WarbirdAeroPress.com
Rob Mattson, *Sarasota Herald-Tribune*

62 Richard Pearson
Jon M. Fletcher, *The Florida Times-Union*
Richard Pearson
Jon M. Fletcher, *The Florida Times-Union*
Nuri Vallbona, *The Miami Herald*

Jon M. Fletcher, *The Florida Times-Union*
Claude Desrochers, Desrochers Inc.

66 Judith Gefter
Jon M. Fletcher, *The Florida Times-Union*
Daniel F. Wilson
Ben Van Hook
Jon M. Fletcher, *The Florida Times-Union*
Ben Van Hook
Jon M. Fletcher, *The Florida Times-Union*

67 Jon M. Fletcher, *The Florida Times-Union*
Daniel F. Wilson
Jon M. Fletcher, *The Florida Times-Union*
Daniel F. Wilson
Warren Thompson
Jon M. Fletcher, *The Florida Times-Union*
Jamie Francis, *St. Petersburg Times*

68 Gaston De Cardenas
Craig Litten, *Tallahassee Democrat*
Daniel F. Wilson
Gaston De Cardenas
Craig Litten, *Tallahassee Democrat*
Gaston De Cardenas
Daniel F. Wilson

69 Francesco Casale
Ben Van Hook
Lexey Swall, *Naples Daily News*
Jacek Gancarz, *Palm Beach Daily News*
Lexey Swall, *Naples Daily News*
Ralph Arwood, Inside-Out Photography, Inc.
Gaston De Cardenas

70 David Spencer, *The Palm Beach Post*
David Spencer, *The Palm Beach Post*
John Moran
David Spencer, *The Palm Beach Post*
Jon M. Fletcher, *The Florida Times-Union*
John Moran
David Spencer, *The Palm Beach Post*

71 Ralph Arwood, Inside-Out Photography, Inc.
Jon M. Fletcher, *The Florida Times-Union*
Craig Litten, *Tallahassee Democrat*
Jon M. Fletcher, *The Florida Times-Union*
Ralph Arwood, Inside-Out Photography, Inc.
Ralph Arwood, Inside-Out Photography, Inc.
Robert Irizarry

72 Carol Ellis, *Little Salt*
Carol Ellis, *Little Salt*
Bruce R. Bennett
Bruce R. Bennett
John Moran
Bruce R. Bennett
Carol Ellis, *Little Salt*

73 Bruce R. Bennett
Carol Ellis, *Little Salt*
Daniel F. Wilson
Robert Irizarry
Bruce R. Bennett
Warren Thompson
Preston Mack

79 John Moran
Ben Van Hook
Jon M. Fletcher, *The Florida Times-Union*
Warren Thompson
John Moran
Jon M. Fletcher, *The Florida Times-Union*
Phil Sears, *Tallahassee Democrat*

80 Craig Litten, *Tallahassee Democrat*
Rafael Tongol
Carol Ellis, *Little Salt*
Craig Litten, *Tallahassee Democrat*
Craig Litten, *Tallahassee Democrat*
D.J. Johnson, www.rave4.com
Claude Desrochers, Desrochers Inc.

81 D.J. Johnson, www.rave4.com
Carol Ellis, *Little Salt*
Rob O'Neal
Rob O'Neal
Andrew Kaufman, Contact Press Images

Claude Desrochers, Desrochers Inc.
Rob O'Neal

82 Ben Van Hook
Jon M. Fletcher, *The Florida Times-Union*
D.J. Johnson, www.rave4.com
Jon M. Fletcher, *The Florida Times-Union*
Jon M. Fletcher, *The Florida Times-Union*
Ben Van Hook
Jon M. Fletcher, *The Florida Times-Union*

83 Phil Sears, *Tallahassee Democrat*
Jon M. Fletcher, *The Florida Times-Union*
Kelly Jordan, *Daytona Beach News-Journal*
Kelly Jordan, *Daytona Beach News-Journal*
Jon M. Fletcher, *The Florida Times-Union*
Jon M. Fletcher, *The Florida Times-Union*
Phil Sears, *Tallahassee Democrat*

84 Angel Valentin, *South Florida Sun-Sentinel*
Ben Van Hook
Jon M. Fletcher, *The Florida Times-Union*
Ben Van Hook
Ben Van Hook
Ben Van Hook
Chip Litherland, *Sarasota Herald-Tribune*

85 Greg R. Drzazgowski
Rob O'Neal
Bill Starling, *Mobile Register*
Chip Litherland, *Sarasota Herald-Tribune*
Jon M. Fletcher, *The Florida Times-Union*
Jon M. Fletcher, *The Florida Times-Union*
Greg R. Drzazgowski

86 Angel Valentin, *South Florida Sun-Sentinel*
Dan Wagner
Garth Francis, *The News-Press*
Dan Wagner
Dan Wagner
Jacek Gancarz, *Palm Beach Daily News*
Jacek Gancarz, *Palm Beach Daily News*

87 Lisa Krantz, *Naples Daily News*
Kelly Jordan, *Daytona Beach News-Journal*
Lisa Krantz, *Naples Daily News*
Jacek Gancarz, *Palm Beach Daily News*
Angel Valentin, *South Florida Sun-Sentinel*
Dan Wagner
Lisa Krantz, *Naples Daily News*

90 Andrew Kaufman, Contact Press Images
Beth Reynolds, The Photo-Documentary Press, Inc.
Lou Novick, LouNovick.com
Rob O'Neal
Jamie Francis, *St. Petersburg Times*
Beth Reynolds, The Photo-Documentary Press, Inc.
Beth Reynolds, The Photo-Documentary Press, Inc.

91 Craig Litten, *Tallahassee Democrat*
Craig Litten, *Tallahassee Democrat*
Rob O'Neal
Johannes Burge
Beth Reynolds, The Photo-Documentary Press, Inc.
Rob O'Neal
Rafael Tongol

93 Preston Mack
Lori Bale
Preston Mack
Lori Bale
Preston Mack
Preston Mack
Preston Mack

94 Kelly Jordan, *Daytona Beach News-Journal*
Beth Reynolds, The Photo-Documentary Press, Inc.
Beth Reynolds, The Photo-Documentary Press, Inc.
Beth Reynolds, The Photo-Documentary Press, Inc.
Angel Valentin, *South Florida Sun-Sentinel*
Ernie Pick
Beth Reynolds, The Photo-Documentary Press, Inc.

95 Cheryl Anne Day-Swallow
Beth Reynolds, The Photo-Documentary Press, Inc.
D.J. Johnson, www.rave4.com
Beth Reynolds, The Photo-Documentary Press, Inc.
Chase Olivieri

Beth Reynolds, The Photo-Documentary Press, Inc.
Preston Mack

98 David Spencer, *The Palm Beach Post*
Ben Van Hook
David Spencer, *The Palm Beach Post*
Monica Ortiz
Ben Van Hook
David Spencer, *The Palm Beach Post*
David Spencer, *The Palm Beach Post*

99 Preston Mack
David Spencer, *The Palm Beach Post*
David Spencer, *The Palm Beach Post*
Cheryl Anne Day-Swallow
Nuri Vallbona, *The Miami Herald*
Preston Mack
David Spencer, *The Palm Beach Post*

100 David Spencer, *The Palm Beach Post*
Kelly Jordan, *Daytona Beach News-Journal*
David Spencer, *The Palm Beach Post*
Bruce R. Bennett
David Spencer, *The Palm Beach Post*
Craig Litten, *Tallahassee Democrat*
David Spencer, *The Palm Beach Post*

101 David Spencer, *The Palm Beach Post*
Kelly Jordan, *Daytona Beach News-Journal*
David Spencer, *The Palm Beach Post*
Kelly Jordan, *Daytona Beach News-Journal*
Bruce R. Bennett
Gary Bogdon
Kelly Jordan, *Daytona Beach News-Journal*

104 David Spencer, *The Palm Beach Post*
David Spencer, *The Palm Beach Post*
Lou Novick, LouNovick.com
David Spencer, *The Palm Beach Post*
David Spencer, *The Palm Beach Post*
David Spencer, *The Palm Beach Post*
David Spencer, *The Palm Beach Post*

105 John Moran
Nuri Vallbona, *The Miami Herald*
Preston Mack
Rob O'Neal
Nuri Vallbona, *The Miami Herald*
Phil Sears, *Tallahassee Democrat*
Nuri Vallbona, *The Miami Herald*

106 Andrew Kaufman, Contact Press Images
Lori Bale
Angel Valentin, *South Florida Sun-Sentinel*
Ben Van Hook
Beth Reynolds, The Photo-Documentary Press, Inc.
Preston Mack
David Spencer, *The Palm Beach Post*

107 Melissa Lyttle
David Spencer, *The Palm Beach Post*
Rafael Tongol
Ben Van Hook
Melissa Lyttle
Preston Mack
Garth Francis, *The News-Press*

110 Lisa Krantz, *Naples Daily News*
Phil Sears, *Tallahassee Democrat*
Jon M. Fletcher, *The Florida Times-Union*
Jamie Francis, *St. Petersburg Times*
Chip Litherland, *Sarasota Herald-Tribune*
Phil Sears, *Tallahassee Democrat*
Lisa Krantz, *Naples Daily News*

111 Phil Sears, *Tallahassee Democrat*
Lisa Krantz, *Naples Daily News*
Jamie Francis, *St. Petersburg Times*
Lisa Krantz, *Naples Daily News*
Phil Sears, *Tallahassee Democrat*
Lisa Krantz, *Naples Daily News*
Phil Sears, *Tallahassee Democrat*

112 Preston Mack
Cheryl Anne Day-Swallow
Preston Mack
Preston Mack
Cheryl Anne Day-Swallow

Preston Mack
Preston Mack

116 David Spencer, *The Palm Beach Post*
Jacek Gancarz, *Palm Beach Daily News*
Carol Ellis, Little Salt
Daniel F. Wilson
Chip Litherland, *Sarasota Herald-Tribune*
Jacek Gancarz, *Palm Beach Daily News*
David Spencer, *The Palm Beach Post*

117 Greg R. Drzazgowski
Jacek Gancarz, *Palm Beach Daily News*
Jacek Gancarz, *Palm Beach Daily News*
Lisa Krantz, *Naples Daily News*
Phil Sears, *Tallahassee Democrat*
Lisa Krantz, *Naples Daily News*
Phil Sears, *Tallahassee Democrat*

118 Eduardo A. Molina
Cheryl Anne Day-Swallow
Andrew Kaufman, Contact Press Images
Lou Novick, LouNovick.com
Jacek Gancarz, *Palm Beach Daily News*
Andrew Kaufman, Contact Press Images
Phil Sears, *Tallahassee Democrat*

119 Andrew Kaufman, Contact Press Images
Jacek Gancarz, *Palm Beach Daily News*
Andrew Kaufman, Contact Press Images
Jacek Gancarz, Palm Beach Daily News
Jamie Francis, *St. Petersburg Times*
Jacek Gancarz, *Palm Beach Daily News*
Andrew Kaufman, Contact Press Images

121 Cheryl Anne Day-Swallow
Jon M. Fletcher, The Florida Times-Union
Jon M. Fletcher, *The Florida Times-Union*
Gary McCracken, *Pensacola News Journal*
Jon M. Fletcher, *The Florida Times-Union*
Gary McCracken, *Pensacola News Journal*
Jon M. Fletcher, *The Florida Times-Union*

124 David Spencer, *The Palm Beach Post*
Jamie Francis, *St. Petersburg Times*
Jon M. Fletcher, *The Florida Times-Union*
Jamie Francis, *St. Petersburg Times*
Garth Francis, *The News-Press*
David Spencer, *The Palm Beach Post*
John R. VanBeekum

125 Jacek Gancarz, *Palm Beach Daily News*
John R. VanBeekum
Jamie Francis, *St. Petersburg Times*
Jamie Francis, *St. Petersburg Times*
David Spencer, *The Palm Beach Post*
Nuri Vallbona, *The Miami Herald*
Jamie Francis, *St. Petersburg Times*

130 D.J. Johnson, www.rave4.com
Angel Valentin, *South Florida Sun-Sentinel*
D.J. Johnson, www.rave4.com
Greg R. Drzazgowski
Claude Desrochers, Desrochers Inc.
D.J. Johnson, www.rave4.com
Daniel F. Wilson

131 Johannes Burge
Judith Gefter
Judith Gefter
Maria Gayle
Jacek Gancarz, *Palm Beach Daily News*
Rob O'Neal
Gary Bogdon

132 Jamie Francis, *St. Petersburg Times*
Jacek Gancarz, *Palm Beach Daily News*
Andrew Kaufman, Contact Press Images
Andrew Kaufman, Contact Press Images
Gary Bogdon
Chip Litherland, *Sarasota Herald-Tribune*
Jacek Gancarz, *Palm Beach Daily News*

133 Jacek Gancarz, *Palm Beach Daily News*
Kelly Jordan, *Daytona Beach News-Journal*
Nuri Vallbona, *The Miami Herald*
Nuri Vallbona, *The Miami Herald*
Lisa Krantz, *Naples Daily News*

Warren Thompson
Bruce R. Bennett

134 Richard Pearson
Lexey Swall, *Naples Daily News*
D.J. Johnson, www.rave4.com
Cheryl Anne Day-Swallow
Carol Ellis, Little Salt
Gary Bogdon
Andrew Kaufman, Contact Press Images

138 Craig Litten, *Tallahassee Democrat*
Monica Ortiz
Lisa Krantz, *Naples Daily News*
Monica Ortiz
Lisa Krantz, *Naples Daily News*
Lisa Krantz, *Naples Daily News*
Lisa Krantz, *Naples Daily News*

139 Lisa Krantz, *Naples Daily News*
Lisa Krantz, *Naples Daily News*
Monica Ortiz
Monica Ortiz
Warren Thompson
Monica Ortiz
Warren Thompson

140 Daniel F. Wilson
Greg R. Drzazgowski
Cheryl Anne Day-Swallow
Greg R. Drzazgowski
Jaime Oppenheimer, *The Wichita Eagle*
Lori Bale
Phil Sears, *Tallahassee Democrat*

141 Lou Novick, LouNovick.com
Phil Sears, *Tallahassee Democrat*
Lou Novick, LouNovick.com
Rob O'Neal
Rob O'Neal
Rob O'Neal
Sherman Zent, *St. Petersburg Times*

142 Armando Solares
J. Arthur Jorgensen
J. Arthur Jorgensen
J. Arthur Jorgensen
Phil Sears, *Tallahassee Democrat*
Rafael Tongol
Sherman Zent, *St. Petersburg Times*

143 Lisa Krantz, *Naples Daily News*
Greg R. Drzazgowski
D.J. Johnson, www.rave4.com
Rob O'Neal
D.J. Johnson, www.rave4.com
Ralph Arwood, Inside-Out Photography, Inc.
Rob O'Neal

144 John Moran
Rafael Tongol
Cheryl Anne Day-Swallow
Craig Litten, *Tallahassee Democrat*
Jon M. Fletcher, *The Florida Times-Union*
Gary Bogdon
John Moran

145 Jon M. Fletcher, *The Florida Times-Union*
John Moran
Kelly Jordan, *Daytona Beach News-Journal*
Rob O'Neal
Craig Litten, *Tallahassee Democrat*
Rafael Tongol
Robert Irizarry

146 Chip Litherland, *Sarasota Herald-Tribune*
Phil Sears, *Tallahassee Democrat*
Del Ihle
Jacek Gancarz, *Palm Beach Daily News*
Preston Mack
Dan Wagner
Preston Mack

147 Dan Wagner
Phil Sears, *Tallahassee Democrat*
Bill Starling, *Mobile Register*
Dan Wagner
Bill Starling, *Mobile Register*
Bill Starling, *Mobile Register*
Preston Mack

Staff

The *America 24/7* series was imagined years ago by our friend Oscar Dystel, a publishing legend whose vision and enthusiasm have been a source of great inspiration.

We also wish to express our gratitude to our truly visionary publisher, DK.

Rick Smolan, Project Director
David Elliot Cohen, Project Director

Administrative
Katya Able, Operations Director
Gina Privitere, Communications Director
Chuck Gathard, Technology Director
Kim Shannon, Photographer Relations Director
Erin O'Connor, Photographer Relations Intern
Leslie Hunter, Partnership Director
Annie Polk, Publicity Manager
John McAlester, Website Manager
Alex Notides, Office Manager
C. Thomas Hardin, State Photography Coordinator

Design
Brad Zucroff, Creative Director
Karen Mullarkey, Photography Director
Judy Zimola, Production Manager
David Simoni, Production Designer
Mary Dias, Production Designer
Heidi Madison, Associate Picture Editor
Don McCartney, Production Designer
Diane Dempsey Murray, Production Designer
Jan Rogers, Associate Picture Editor
Bill Shore, Production Designer and Image Artist
Larry Nighswander, Senior Picture Editor
Bill Marr, Sarah Leen, Senior Picture Editors
Peter Truskier, Workflow Consultant
Jim Birkenseer, Workflow Consultant

Editorial
Maggie Canon, Managing Editor
Curt Sanburn, Senior Editor
Teresa L. Trego, Production Editor
Lea Aschkenas, Writer
Olivia Boler, Writer
Korey Capozza, Writer
Beverly Hanly, Writer
Bridgett Novak, Writer
Alison Owings, Writer
Fred Raker, Writer
Joe Wolff, Writer
Elise O'Keefe, Copy Chief
Daisy Hernández, Copy Editor
Jennifer Wolfe, Copy Editor

Infographic Design
Nigel Holmes

Literary Agent
Carol Mann, The Carol Mann Agency

Legal Counsel
Barry Reder, Coblentz, Patch, Duffy & Bass, LLP
Phil Feldman, Coblentz, Patch, Duffy & Bass, LLP
Gabe Perle, Ohlandt, Greeley, Ruggiero & Perle, LLP
Jon Hart, Dow, Lohnes & Albertson, PLLC
Mike Hays, Dow, Lohnes & Albertson, PLLC
Stephen Pollen, Warshaw Burstein, Cohen, Schlesinger & Kuh, LLP
Rick Pappas

Accounting and Finance
Rita Dulebohn, Accountant
Robert Powers, Calegari, Morris & Co. Accountants
Eugene Blumberg, Blumberg & Associates
Arthur Langhaus, KLS Professional Advisors Group, Inc.

Picture Editors
J. David Ake, Associated Press
Caren Alpert, formerly *Health* magazine
Simon Barnett, *Newsweek*
Caroline Couig, *San Jose Mercury News*
Mike Davis, formerly *National Geographic*
Michel duCille, *Washington Post*
Deborah Dragon, *Rolling Stone*
Victor Fisher, formerly Associated Press
Frank Folwell, *USA Today*
MaryAnne Golon, *Time*
Liz Grady, formerly *National Geographic*
Randall Greenwell, *San Francisco Chronicle*
C. Thomas Hardin, formerly *Louisville Courier-Journal*
Kathleen Hennessy, *San Francisco Chronicle*
Scot Jahn, *U.S. News & World Report*
Steve Jessmore, *Flint Journal*
John Kaplan, University of Florida
Kim Komenich, *San Francisco Chronicle*
Eliane Laffont, *Hachette Filipacchi Media*
Jean-Pierre Laffont, *Hachette Filipacchi Media*
Andrew Locke, MSNBC
Jose Lopez, *The New York Times*
Maria Mann, formerly AFP
Bill Marr, formerly *National Geographic*
Michele McNally, *Fortune*
James Merithew, *San Francisco Chronicle*
Eric Meskauskas, *New York Daily News*
Maddy Miller, *People* magazine
Michelle Molloy, *Newsweek*
Dolores Morrison, *New York Daily News*
Karen Mullarkey, formerly *Newsweek, Rolling Stone, Sports Illustrated*
Larry Nighswander, Ohio University School of Visual Communication
Jim Preston, *Baltimore Sun*
Sarah Rozen, formerly *Entertainment Weekly*
Mike Smith, *The New York Times*
Neal Ulevich, formerly Associated Press

Website and Digital Systems
Jeff Burchell, Applications Engineer

Television Documentary
Sandy Smolan, Producer/Director
Rick King, Producer/Director
Bill Medsker, Producer

Video News Release
Mike Cerre, Producer/Director

Digital Pond
Peter Hogg
Kris Knight
Roger Graham
Philip Bond
Frank De Pace
Lisa Li

Senior Advisors
Jennifer Erwitt, Strategic Advisor
Tom Walker, Creative Advisor
Megan Smith, Technology Advisor
Jon Kamen, Media and Partnership Advisor
Mark Greenberg, Partnership Advisor
Patti Richards, Publicity Advisor
Cotton Coulson, Mission Control Advisor

Executive Advisors
Sonia Land
George Craig
Carole Bidnick

Advisors
Chris Anderson
Samir Arora
Russell Brown
Craig Cline
Gayle Cline
Harlan Felt
George Fisher
Phillip Moffitt
Clement Mok
Laureen Seeger
Richard Saul Wurman

DK Publishing
Bill Barry
Joanna Bull
Therese Burke
Sarah Coltman
Christopher Davis
Todd Fries
Dick Heffernan
Jay Henry
Stuart Jackman
Stephanie Jackson
Chuck Lang
Sharon Lucas
Cathy Melnicki
Nicola Munro
Eunice Paterson
Andrew Welham

Colourscan
Jimmy Tsao
Eddie Chia
Richard Law
Josephine Yam
Paul Koh
Chee Cheng Yeong
Dan Kang

Chief Morale Officer
Goose, the dog